THE METROPOLITAN MUSEUM OF ART

The Renaissance in Italy and Spain

THE METROPOLITAN

INTRODUCTION

BY

Frederick Hartt

PAUL GOODLOE McINTIRE PROFESSOR EMERITUS
OF THE HISTORY OF ART UNIVERSITY OF VIRGINIA

MUSEUM OF ART

The Renaissance in Italy and Spain

THE METROPOLITAN MUSEUM OF ART, NEW YORK

PUBLISHED BY

THE METROPOLITAN MUSEUM OF ART
New York

PUBLISHER
Bradford D. Kelleher

EDITOR IN CHIEF
John P. O'Neill

EXECUTIVE EDITOR
Mark D. Greenberg

EDITORIAL STAFF
Sarah C. McPhee
Josephine Novak
Lucy A. O'Brien
Robert McD. Parker
Michael A. Wolohojian

DESIGNER
Mary Ann Joulwan

———

Commentaries written by the editorial staff.

Photography commissioned from Schecter Lee, assisted by
Lesley Heathcote: Plates 1, 3, 11, 14, 19, 21–23, 25, 34–37,
42, 43, 45, 48, 49, 54, 65, 69, 71, 77, 83, 88, 90, 91, 94–96, 98,
103, 106, 109, 110, 112–115, 120, 122, and the detail on
page 122. All other photographs by The Photograph Studio,
The Metropolitan Museum of Art.

Maps and time chart designed by Irmgard Lochner.

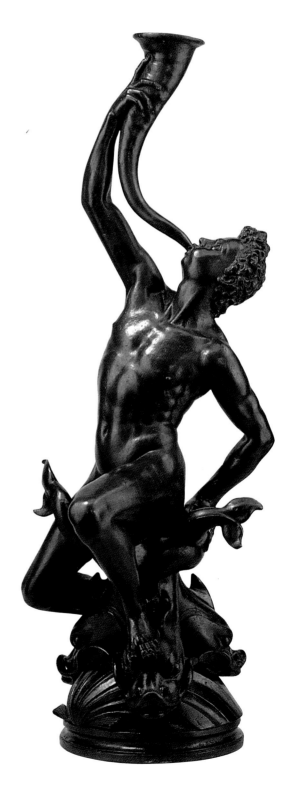

TITLE PAGE

The Birth of the Virgin (detail)
Master of the Barberini Panels (Giovanni Angelo di Antonio?)
School of the Marches, 1447–75
Tempera and oil on wood; 57 x 37⅞ in. (144.8 x 96.2 cm.)
Rogers and Gwynne Andrews Funds, 1935 (35.121)

THIS PAGE

Triton
Giovanni Bologna
Florence, 1529–1608
Bronze; H. 36 in. (91.5 cm.)
Bequest of Benjamin Altman, 1913 (14.40.689)

Library of Congress Cataloging-in-Publication Data

The Metropolitan Museum of Art (New York, N.Y.)
 The Renaissance in Italy and Spain.

 Includes index.
 1. Art, Italian. 2. Art, Renaissance—Italy.
3. Art, Spanish. 4. Art, Renaissance—Spain.
5. Art—New York (N.Y.) 6. Metropolitan Museum of
Art (New York, N.Y.) I. Metropolitan Museum of Art
(New York, N.Y.)
N6915.R635 1987 709'.45'07401471 85-18868
ISBN 0-87099-432-8 ISBN 0-87099-433-6 (pbk.)

Printed in Japan by Dai Nippon Printing Co., Ltd.
Composition by U.S. Lithograph, typographers, New York.

This series was conceived and originated jointly by The Metro-
politan Museum of Art and Fukutake Publishing Co., Ltd.
DNP (America) assisted in coordinating this project.

This volume, devoted to the arts of the Italian and Spanish Renaissance, is the fourth publication in a series of twelve volumes that, collectively, represent the scope of the Metropolitan Museum's holdings while selectively presenting the very finest objects from each of its curatorial departments.

This ambitious publication program was conceived as a way of presenting the collections of The Metropolitan Museum of Art to the widest possible audience. More detailed than a museum guide and broader in scope than the Museum's scholarly publications, this series presents paintings, drawings, prints, and photographs; sculpture, furniture, and decorative arts; costumes, arms, and armor—all integrated in such a way as to offer a unified and coherent view of the periods and cultures represented by the Museum's collections. The objects that have been selected for inclusion in the series constitute a small portion of the Metropolitan's holdings, but they admirably represent the range and excellence of the various curatorial departments. The texts relate each of the objects to the cultural milieu and period from which it derives, and incorporate the fruits of recent scholarship. The accompanying photographs, in many instances specially commissioned for this series, offer a splendid and detailed tour of the Museum.

We are particularly grateful to the late Mr. Tetsuhiko Fukutake, who, while president of Fukutake Publishing Company, Ltd., Japan, encouraged and supported this project. His dedication to the publication of this series contributed immeasurably to its success.

Since its founding, the Metropolitan Museum has been the recipient of extraordinary gifts and bequests. Its collection of Italian and Spanish Renaissance paintings, drawings, and prints has been enriched by such generous donors as Benjamin Altman, Jules Bache, Mr. and Mrs. H.O. Havemeyer, Robert Lehman, Jack and Belle Linsky, J. Pierpont Morgan, and Mr. and Mrs. Charles Wrightsman. The Museum's collection of sculpture, decorative objects, musical instruments, and arms and armor of the Italian and Spanish Renaissance has been augmented by the gifts of, among others, Benjamin Altman, George Blumenthal, Stephen V. Grancsay, C. Ruxton Love, J. Pierpont Morgan, and Irwin Untermyer.

In addition to gifts of works from these donors, special purchase funds have enabled the Museum to acquire works on its own. Among these are funds established by Harris Brisbane Dick, Isaac D. Fletcher, Frederick C. Hewitt, John Stewart Kennedy, Joseph Pulitzer, Jacob S. Rogers, and Elisha Whittelsey.

In order to present the most comprehensive picture of Italian and Spanish Renaissance art as it is represented at the Metropolitan, the editors of this volume have drawn on the collections of several of the Museum's curatorial departments and on the expertise of their staffs. For their help in preparing this volume, we are particularly grateful to Keith Christiansen of the Department of European Paintings, James Draper of the Department of European Sculpture and Decorative Arts, Janet Byrne of the Department of Prints and Photographs, Helen Mules of the Department of Drawings, Helmut Nickel of the Department of Arms and Armor, and Laurence Libin of the Department of Musical Instruments. Their help in reviewing the selections, photographs, and text was invaluable.

Philippe de Montebello
Director

THE RENAISSANCE
IN ITALY AND SPAIN

After an experience with the generally flat backgrounds and stylized figures of medieval art, a visit to a Renaissance gallery is a trip to a new planet. For the first time since antiquity, human beings and their environment look, for the most part, convincingly real. But this is not the familiar realism of the late nineteenth century in France, nor that of the seventeenth century in Holland. In Renaissance compositions the people are lined up in the foreground, often in ceremonial relation to one another on either side of a central seated sacred figure (see Plate 79). Even dramatic incidents proceed in organized fashion as in an opera or a ballet, every important figure shown clearly and in its entirety. Compositions are often so arranged as to display the geometrical forms on which they are based (see Plates 26, 39, 51, 53, 68). Everything has been predetermined.

The subjects of portraits are posed formally before contrived backgrounds, or no backgrounds at all (see Plates 19, 43, 102, 103, 104). Action seldom penetrates the landscape or architecture behind the figures, save for separate, small-scale incidents, and seems to have been devised as a backdrop for the drama. Every object, in the Early Renaissance at least, is brilliantly clear and precisely defined.

Obviously an art so naturalistic in detail and so artificial in conception was devised to satisfy the demands of a very special kind of society. Medieval art had largely been commissioned by monarchs, by nobles, and—above all—by the Church, whose doctrines it was intended to expound in form and color. But the art of the Renaissance, in Italy at least, was mostly ordered by the citizens of republics, which had much in common with the city-states of ancient Greece. The Italian peninsula was occupied by many autonomous states, large and small. Aside from a few princedoms, like the duchies of Milan, Mantua, and Ferrara (all formerly republics) in northern Italy, the only monarchies were the wide-flung papal territories in central Italy and the Kingdom of the Two Sicilies (which included Naples) in the south. Although their demand for works of art was great, significantly enough, these two authoritarian regions produced only an occasional artist of any stature (see Plate 36), and imported the others from the republics. The great "schools" (established regional groups of artists with their own local traditions and ideals) rose and flourished among the rich mercantile societies of the center and north, especially the dominant republics of Florence and Venice, and to a lesser degree those of Siena, Pisa, and Lucca. Artists in painting, sculpture, architecture, metalwork, textiles, and glass were respected members of the republican structure and frequently held office in the councils of state. Almost exclusively, they worked not to please themselves but on commission. They kept studios known as "shops," manned by teams of assistants and apprentices.

These masters migrated elsewhere in Italy or abroad according to demand. The commercial power of the Italian republics contrasted sharply with their internal instability (with the exception of Venice) and their military weakness. Venice had footholds throughout the eastern Mediterranean and the Adriatic, and Florentine banking firms dominated the financial structure of Western Europe. But all the republics had a well-grounded fear both of aggression from the fast-growing monarchies of northern and western Europe, and of internal revolution that might convert a republic into a temporary dictatorship or a permanent princedom. Florence, for example, expelled the Medici three times, only to see them return a few years later more powerful than before, finally establishing themselves as hereditary dukes.

Italian Renaissance art embodied visual symbols of the financial and commercial power and intellectual interests of the merchant and banking classes of the Italian republics, who financed even the religious art in their communities. These symbols were adopted, with some transformations, by the autocracies. The word "Renaissance," meaning "rebirth" (that is, the rebirth of antiquity), was not used in English to describe the culture of the period until the early nineteenth century. But as early as the fourteenth century, a rebirth of antiquity had occurred in the form of humanism in scholarship and in poetry. Italian writers, such as Petrarch and Boccaccio, knew not just the theological Latin literature of the Middle Ages but the great pagan poets and prose writers of ancient Rome, in the original. They prided themselves on writing their own poetry not only in Italian but also in Latin verse indistinguishable (or so they hoped) from ancient originals. Eventually many of them mastered Greek as well. The patrons of Renaissance art also poured their golden florins into the formation of libraries, which preserved in manuscript form the great works of ancient literature.

Although Italian art remained Gothic in architecture and sculpture, and Byzantine in painting throughout most of the thirteenth century, the influence of fragments of Roman architecture and sculpture was constantly felt throughout the later Middle Ages. By the time of Petrarch in the fourteenth century, Giotto had created a new pictorial style (see Plate 2), universally followed throughout the peninsula, blending elements derived from both Gothic and Byzantine sources with a fresh understanding of human life and character, a new narrative technique, and a new conception of form. Unanimously, the Italian artists of the Renaissance regarded him as the founder of their new vision. But it was not until the fifteenth century that all the arts began to turn systematically to Roman antiquity (they knew nothing of the Greeks) for their inspiration, so that ancient ideals were embodied in architecture and sculpture, combined with entirely original contemporary concepts (see Plates 35, 71, 74, 75, 76). Painting was on its own because there was little ancient painting to be seen.

The nineteenth-century historian Jakob Burckhardt wrote of

"the discovery of the world and of man" in his epochal *Civilization of the Renaissance in Italy*. But it was a discovery through the eyes of Christian tradition, undiminished in power and influence, and also through ancient literature, almost more than ancient art. Humanists, by means of their advice to artists and their close associations with patrons, exerted a strong influence over works of art. Both in subject and in style many works came directly from humanist tradition (see Plates 38, 74, 76, 109, 122).

Especially important was the Renaissance concept of *istoria* ("history"), which underlay all Italian narrative art of the fifteenth and sixteenth centuries. In the Renaissance, it must be remembered, works of art were not placed in their positions in churches or private dwellings because that was where they looked best. They were intended to convey a meaning, and that meaning was carefully structured. The subject of a work for a family chapel in a city or country church was set by the patron. An altarpiece—the painting or sculpture placed at the back of the altar table where Mass was said, often daily, for the departed souls of family members as much as for the living—generally depicted the Virgin and Child, or occasionally other saints, seated either alone or among a group of saints appropriate to the particular church, family, or both (see Plates 18, 79). The predella, a strip seldom more than a foot in height, running across the base of the altarpiece (see Plate 78), showed scenes relating to the figures in the main panel.

Madonnas and other sacred figures were also painted, modeled, and carved for private families, not as decorations or because the artist "liked" these subjects, but as devotional aids to remind the patron, as beautifully as possible, of the necessity of prayer, and to invoke saintly protection for the home (see Plates 22, 24, 25, 47, 48, 54, 89). *Istorie* for patrician families could also be drawn from the lives of the saints (see Plate 53), but more often their content was secular. In the case of secular works the artist's attention was never directed to episodes from contemporary life and seldom even to recent history. Often the scenes came from ancient literature (see Plate 62). Generally they formed a cycle, running right round a room, incorporated into the woodwork of the carved or inlaid wainscoting with which the finest Renaissance rooms were frequently lined. Such cycles, often intended to inculcate philosophical ideas or moral precepts in clearly intelligible form, must have been delightful. Alas, all save a very few in Venetian religious confraternities have now been broken up and the sections sold separately to museums or private collections, so that the narrative and formal sequence has been lost. Patrons whose lives were dedicated to banking, manufacture, and business must have delighted in the carefully worked-out proportion between the grouping of the figures, the space against which they were placed, and that of the rooms they enhanced.

Many humanists provided the ancient texts for Florentine *istorie*, but the leader was the learned Leon Battista Alberti, architect and writer on the arts and on family life who, despite his Florentine ancestry, preferred to spend his time in advisory positions at northern Italian courts or the Vatican. Alberti's *Treatise on Painting*, the first of its kind, written in Latin in 1435 and translated by its author into Italian in 1436, developed the theory of *istoria* and enunciated for the first time many other basic principles of Renaissance art, such as perspective, carefully worked out in every fifteenth-century Florentine painting, which rendered the depicted space immediately comprehensible, measurable, and harmonious. The special dignity accorded to humanists in the Renaissance may be felt in Francesco di Giorgio's drawing of a humanist kneeling between two muses, like a praying saint between two angels (see Plate 40).

To some Italian patricians, classicism came to be a mode of life.

The family palace (a word loosely applied to any urban mansion) was embellished with classical columns, arches, cornices, and pediments, sometimes with relief sculpture in classical style. New cities were designed in classical style according to a rational central plan, but few got past the dream stage; most were patchwork arrangements of Renaissance buildings inserted into updated medieval town plans. Nonetheless, the idea of the Renaissance palace and city penetrated as far as Spain (see Plate 90), and eventually provided the inspiration for Paris, Leningrad, parts of London, and Washington, D.C.

At all times in such a society the portrait was an object of cardinal importance. Alberti wrote of the "divine force" of painting "that puts in front of our eyes again those who for many and many years have been dead." Four or five hundred years after their deaths the Renaissance Italians do indeed live again in painting and in sculpture (see Plates 19, 34, 36, 43, 82, 94, 102, 103, 104, 115, 116, 117), not idealized, but just as they must have looked to their contemporaries. Unexpectedly, they even appear in monumental wall paintings and stand on the sidelines of long-past sacred events.

n the twentieth century we are accustomed to thinking of paintings as works done in oil-based pigments on canvas, and despite the endless variety of innovative techniques and materials in our time, oil on canvas is still the rule for most contemporary paintings. In the Early Renaissance oil was seldom used, and canvas was used only for processional banners, which had to be light. Mural paintings were done in fresco, from the Italian word for "fresh." As much plaster was applied to the wall as could be painted in a day, and while it was still damp, a portion of the image was painted from start to finish (see Plate 42). Any touch applied after drying was almost certain eventually to peel off. This piecemeal method ensured that the fresco became a part of the wall, and few have been detached for exhibition in museums. Fresco surface is characteristically grainy and matte, and no effects of transparency are possible, nor was the artist ever able to return and unify the entire effect. Obviously the fresco technique required much advance planning in the way of drawing.

So did the second major technique, tempera, which involved painting with colors bound in yolk of egg. These were then applied to a fine wooden panel previously prepared with gesso (plaster mixed with glue to form a smooth, white surface) on which first underdrawing, then various layers of paint were built up, before a final protective coat of varnish was added. Tempera was customary for altarpieces and for devotional pictures and was brought to a high degree of finish. Much experimentation in the second half of the fifteenth century was directed toward methods that would allow the artist greater ease and freedom. Generally the new techniques involved the introduction of oil on panel or on canvas. Although fresco was retained in the sixteenth century for very large mural paintings, tempera was renounced in favor of oil.

Sculpture in stone, preferably marble, was executed by the sculptor himself, with hammers, chisels, files, abrasives, and polishing materials, not by a professional stonecutter working from the sculptor's plaster models as in the nineteenth century. Much of the vitality of Renaissance marble surfaces (see Plates 21, 47, 48, 59, 71) is due to this direct contact of the sculptor with his material. Sculpture in bronze was prepared by means of an exact model in wax, around which a fire-resistant mold was made. When the mold was heated the wax ran out (the *cire-perdue*, or lost-wax, process) and molten bronze was poured in. This method worked perfectly for

small statues or groups (see Plates 20, 35, 74, 75, 76), but larger works had to be hollow, in fact as thin a shell as possible, not only in order to save bronze and reduce weight, but for greater strength. In such sculptures (see Plate 117) an elaborate disposable core had to be constructed inside the mold, leaving only a small space into which the bronze could be poured. The most economical of all means of sculpture was glazed terra-cotta ("baked earth"), developed by Luca della Robbia and his sons and assistants (see Plates 22, 23) from the techniques of pottery, which in the Renaissance was raised to the level of a fine art (see Plates 44, 45, 95). The original clay model, hollowed out, was "fired" directly without any casting; then, after glazing, fired again. The colors obtained were brilliant and the final work extremely resistant to weather. A frequently employed shortcut was direct painting of the terra-cotta, suitable only for sculpture in interiors.

The foundation of Renaissance art was drawing. The medieval master usually kept a pattern book in which he collected designs to be used as models for standard scenes in the repertory of religious subjects, or if he was an architect, a record of his own structural innovations and those of others he had seen in his travels. But he often proceeded directly in both painting and sculpture with no more preliminary drawing than needed to be done directly on the surface of the wall, panel, or block, as a preparation and a guide in his work. No living models were necessary; faces, hands, figures were done from memory, from imagination, or just as likely according to an inherited formula. The Renaissance artist, on the other hand, deeply concerned with visual reality, drew at all times, in the studio where his youthful assistants, invariably male, might serve him as models (see Plate 49), or outdoors where he could study animals or plants (see Plates 60, 84). Eventually the artist's interest in the construction of the human figure underlying its voluminous clothing in painting and sculpture, and in the beauty of the figure itself, became so overriding that it was the rule in every studio, as in art schools to this day, to draw from living nude models (see Plates 80, 81).

Generally the Renaissance artist made a number of trial-and-error sketches for his compositions (see Plates 61, 69), often squaring the definitive version for enlargement (see Plate 85) into a full-scale working drawing known as a "cartoon" (in Italian *cartone*, or "heavy paper"). Models were posed as they would appear in the final work (see Plates 69, 81), and parts of the body were sometimes redrawn several times until the artist was satisfied. The modern lead pencil and steel pen were unknown, but drawings were made, often on previously tinted paper, with points of lead or of silver (see Plates 49, 60), charcoal, black or red chalk, quill pen dipped in ink (see Plates 61, 70, 84), or brush dipped in a wash of ink (see Plates 40, 69, 85) or of white lead. Such was the fundamental importance of drawing that when, in the late sixteenth century, the Tuscan painter, architect, and first art historian Giorgio Vasari founded the first Italian Academy (not a school but a professional society of artists on the model of learned associations of philosophers and scientists), he called it the Accademia delle Arti del Disegno—Academy of the Arts of Drawing.

Also based on drawing was the art of engraving, which became popular in the fifteenth and sixteenth centuries with the rise of the printed book (often illustrated with engravings). The simplest method was the woodcut (see Plates 55, 56, 57), drawn on a wooden block, like that used for printing before movable type, then cut out, leaving the lines standing to take the ink. A more refined procedure, producing more delicate and flexible lines, was copper engraving, based on the techniques used to ornament the suits of armor that in the Renaissance had reached a stage of unprece-

dented richness (see Plates 105, 106), and on the niello work, in which incised lines were filled in with black, that had become popular in patrician homes (see Plate 37). A plate of polished copper was incised with the artist's drawing by means of a steel tool, then inked, then wiped, leaving the ink in the lines. A sheet of slightly moist paper was applied and pressed with a roller, coming up with the inked design in reverse. Not suitable for speed printing like the woodcut, copper engraving was sharper and more detailed, and could still produce a number of images at low cost, thus allowing wide distribution.

A highly prized art in the Renaissance was that of the portrait medallion, usually of a reigning prince, modeled by an important sculptor. Originally in bronze, such medallions were eventually made in precious metals and semiprecious stones, often decorated with gems, for sovereigns (see Plates 115, 116). Furniture in inlaid wood (see Plate 100) or in marble, alabaster, and semiprecious stones (see Plate 118) was raised to the level of art for the ornamentation of churches and palaces, along with magnificent objects in porcelain or even in rock crystal (see Plates 96, 119, 120).

he dramatic significance of Giotto on the Italian scene in the early fourteenth century can be illustrated by comparing the early-thirteenth-century *Madonna and Child* (Plate 1) by Berlinghiero, leading painter of the school of Lucca in the first decades of the thirteenth century, with the *Epiphany* (Plate 2) attributed to Giotto. Whether this little panel was painted by Giotto or by a close associate in his shop, as many scholars believe, the fresh, new quality of Giotto's style is very clear. Berlinghiero's exquisitely contoured and patterned icon follows traditional Byzantine models for devotional images, and the regulation gold background on which the halos are incised is consistent with the figures. Giotto's art pushes the gold into depth; indeed, the towering rock behind the shed where Mary lies reduces it to a backdrop and establishes a foreground stage for a drama taking place between figures unified by the conviction that the tiny child, now first shown to the Gentiles, is the Savior. The dramatic message is strengthened by the simplicity of the cylindrical or cubic forms modeled by light, as yet without specific source.

Giotto's humanity deeply affected the somewhat older contemporary sculptor from Pisa, Giovanni Pisano, sections of whose great dismantled pulpit, now largely reassembled in Pisa Cathedral, are in the Metropolitan (Plate 3). Giovanni achieved a new dramatic power in sculpture, partly through the intensity of his expressions, partly through the vigorous angularity of his forms. Florence's neighbor and bitter rival, Siena, took its time in accepting the new ideals of Giotto. The first solution was a kind of compromise between traditional Byzantine linear patterns and Giotto's humanity in the poetic style of Duccio and his followers, seen at its most expressive in the small diptych with the *Madonna and Child* in one panel and the *Crucifixion* in the other (Plate 4), made for private devotions. The elegant Francophile art of Simone Martini (Plate 6), who worked for years in the French-ruled kingdom of Naples and at the papal court in Avignon in southern France, blends Giotto's modeling with Gothic lines of brilliant precision. Simone's style persists in exaggerated form in the dense and crowded late-fourteenth-century *Adoration of the Magi* (Plate 8) by his Sienese follower Bartolo di Fredi, a far cry from the simplicity of Giotto's understanding of the subject. The Gothic style persisted in all its complexity of line, richness of surface, and profusion of detail in northern Italy, with an added ingredient of homely naturalism, in the art of Michelino

da Besozzo (Plate 12), and in Florence right up to and parallel with the Early Renaissance in that of Lorenzo Monaco (Plate 9), who contributed his own poetic imagination and lyrical grace.

The new naturalism of the Early Renaissance appeared first of all in Florentine sculpture in the work of Donatello and Nanni di Banco, and in suspension with the Gothic, in that of Lorenzo Ghiberti, right along with the Gothicism of Lorenzo Monaco and his contemporaries in painting. The sculptors, after all, created works for public display, intended to be seen by the man in the street, and their creations exemplified the attitude of resistance to conquest by Milan in the early fifteenth century, Naples in the second decade, and Milan again in the third, while the painters were commissioned to create works of mystical piety for the interiors of churches and chapels. Something of Donatello's aggressive power is echoed in the *David with the Head of Goliath*, by his northern Italian pupil, Bartolommeo Bellano (Plate 35).

The gap between painting and sculpture was bridged in the work of the short-lived Masaccio (1401–28), who for the first time achieved painted forms revealed in light proceeding from a distinct and recognizable source. After his death, Masaccio's style was taken up by two gifted followers, each extremely independent, Fra Angelico and Fra Filippo Lippi. Filippo's *Madonna and Child Enthroned, with Two Angels* (Plate 18), painted about ten years after Masaccio's death, is a perfect example of the new Renaissance style. This is the central panel from an altarpiece. The setting, which runs through the side panels as well, is based on the simple, classic forms of the new Renaissance churches then rising in Florence, although constructed of a richly veined marble intended to suggest the heavenly palace of the Virgin. The light, consistent in all three panels, comes from the left—probably the source of the lighting in the interior for which the work was painted—and sends architecture, figures, and drapery into three-dimensional reality, creating strong highlights and deep shadows. The chubby features and wistful expressions of the Virgin, her Child, and the two angels remind us that Filippo was later the teacher of the even more famous Botticelli. Filippo's sculpturesque naturalism encounters some difficulties in coping with the new problem of group portraiture (Plate 19). But this delightful painting of a young man and woman is not an attempt to depict a real situation. The lady, stiffly posed in profile as in all Florentine portraits of the time, is shown in a setting symbolic of her virginal state. At her window appears her suitor, presenting to her his coat of arms in token of his offer of marriage, while out the other window we look over the delicately painted trees and buildings, reminding us that Filippo was the earliest known Italian artist to represent window views. The graceful Madonna reliefs by Luca della Robbia (see Plate 22), Agostino di Duccio (see Plate 21), Antonio Rossellino (see Plate 47), and Benedetto da Maiano (see Plate 48), intended as devotional images for the homes of patrician families, carry personally interpreted aspects of the style established by Donatello into the second half of the fifteenth century.

As in the fourteenth century, Siena was hostile to Florentine ideas, but her best artists were innovators in their own way, especially Sassetta, one of the most sensitive landscape painters of the period. In his little *Journey of the Magi* (Plate 14), cut from a larger picture, morning light bathes rocky hills much like those still to be seen near Siena today, and a towering gateway, like those in the walls of Siena, has a fresh, pink glow.

The saltiest and most individual of all the fifteenth-century Sienese painters, and the one with the greatest talent for mystical expression, was Giovanni di Paolo, whose long life took him from Sassetta's world, in the early part of the century, into that of the fully developed Renaissance toward its close, when his linear style must have

seemed an anachronism. A predella panel representing *The Adoration of the Magi* (Plate 15) displays Giovanni's landscape fantasy in the background. Two more predella panels show the *Expulsion from Paradise* (Plate 16) and *Paradise* (Plate 17). The vision of the primordial universe is thrilling; the Lord soars over the concentric circles, his pointing finger piercing the sphere of the fixed stars, just outside the spheres of the heavens surrounding the rocky masses of earth, while on the right the angel, naked, as are Adam and Eve, expels them from the Garden of Eden. In contrast to the originality of the *Expulsion* panel, *Paradise* probably recapitulates a work by Fra Angelico: an exquisite garden where men and women, monks, nuns, and a pope embrace on a flowering lawn on which rabbits gambol, before a dainty orange grove.

The later fifteenth century saw the beginning of ominous social changes. A new wealthy class had gathered around the Medici family, who ruled the supposed republic like princes from a palace that though of moderate size, was crammed with works of art, ancient objects, and carved gems of the highest quality. Artistic currents were divided: Gothic was dead and forgotten, but so indeed was the monumental naturalism of Masaccio and his followers. Surprisingly, the favorite artist of Lorenzo the Magnificent was not Botticelli, whose *Primavera* and *Birth of Venus* were painted for Lorenzo's younger cousin, but Antonio Pollaiuolo, painter, sculptor, metalworker, and engraver. Pollaiuolo's astonishing *Battle of the Naked Men* (Plate 38) was the showpiece of the new art of copper engraving in Florence (Antonio hung an incised nameplate in Latin at the left), and the opening salvo of a new campaign to establish action as the principal theme of art. The composition is based on mayhem among ten young men, recently identified as a Renaissance conception of Roman gladiators. Each, while engaged in killing an opponent, is about to be dispatched by another, forming a linear interlace of mortal combat. The muscular and bony structure of the figures represents a momentous stride in the direction of the anatomical research on which High and Late Renaissance art was to be founded. Pollaiuolo's ideas and techniques were echoed at the turn of the century in the delicate engravings of Cristofano Robetta (see Plates 72, 73), who added landscape backgrounds imitated from the German Albrecht Dürer. Coming events are foreshadowed in Pollaiuolo's powerful drawing for a monument to Francesco Sforza, duke of Milan in the mid-fifteenth century (Plate 50), clad in contemporary armor but seated on a rearing horse like a Roman commander, triumphing over a prostrate female figure that represented the neighboring city of Verona. Again the composition is formed by the interaction between figures, this time raised to colossal scale. The pouncing of the outlines (little holes used to transfer the design) suggests that the drawing was translated into a small painting as a model to be sent to Milan. The commission was given to Leonardo da Vinci but was never completed.

Botticelli is universally loved for his mythological pictures, but most of his paintings depict religious subjects, whose intensity reflects the movements of popular fervor sweeping Italy toward the end of the century, and whose poetry contrasts strongly with the fierce naturalism of Pollaiuolo. The little *Annunciation* (Plate 51) shows the moment at which, as the words of the archangel Gabriel strike the ear of the Virgin Mary, the Incarnation of Christ was believed to have taken place within her. The miracle is dramatized by the nine rays of divine light that pierce the wall of the room instead of accompanying Gabriel through the open door. Mary seems to have been working on the Veil of the Temple, conspicuously hanging over the back of the inlaid bench behind her. The emphasis on feminine handiwork, the setting in the antechamber of the bed-

room in a Florentine villa, together with the submissive kneeling position of the Virgin suggest that the picture was made for a female patron, probably as a reminder that, according to the doctrine of Saint Antonine, archbishop of Florence at mid-century, the Christ Child is born again in the hearts of those who follow Christ's precepts. The exquisite compositional grace, linear movement, and coloring form a perfect vehicle to convey the magic of the moment. A similar intensity of emotion radiates from another small devotional work picturing the Last Communion of Saint Jerome (Plate 52), which the ninety-year-old saint insisted on receiving, not on his deathbed but on his knees. Botticelli has omitted many narrative details that could only have muddied the clarity of the message, staged in an interior of medieval simplicity, through whose windows we see only the clear blue of heaven.

Very different in feeling and effect is the *Three Miracles of Saint Zenobius* (Plate 53), one of four long, horizontal panels painted for the interior of some Florentine house, and depicting scenes from the legend of the fifth-century bishop of Florence. Each panel, united by continuous backgrounds of Florentine Renaissance architecture, is presented in three principal episodes, sharply demarcated by space, which is used to signify time. In Botticelli's imagination these miracles are narrated in a dreamlike setting; even the architecture is as airless as an architect's elevation. The frenzied mood of Botticelli's late religious works betrays the influence of the Dominican monk Girolamo Savonarola, whose preaching incited the populace against the worldliness of the Renaissance, filling the cathedral with as many as fourteen thousand hearers for a single rabble-rousing sermon (see Plate 55), and bringing about a "bonfire of vanities," in which, not only splendid garments, jewels, and false hair, but worldly books, and doubtless many works of art of which the friar disapproved, were given to the flames. Through his sermons and his writing (see Plate 56), Savonarola's influence became so strong that he was able to bring about the expulsion of the Medici in 1494, two years after the death of Lorenzo the Magnificent. For six years he was virtual dictator of Florence, wielding control over a Grand Council of five hundred that shouted approval of his decrees until he too fell victim to the flames, having incurred the enmity of the pope.

Parallel with the scientific trend led by Pollaiuolo, and the poetic current inspired by Botticelli, was a third tendency, that of pure prose, dominated by Domenico del Ghirlandaio. His interpretations of religious iconography in terms of Florentine upper-middle-class life, and his carefully descriptive portraits of prosperous Florentines, brought Ghirlandaio many a well-heeled client. Tasteful and controlled, he was an expert painter, making up for his limited imagination by sensitive observation, sober composition and drawing, smooth surfaces, silvery light, and brilliant, clear color. His *Portrait of a Lady* (Plate 43) shows why he was so successful. The blond curls, the erect pose for which Florentine women were famous, and the splendid costume and jewelry witness the social position of the cool, self-possessed sitter.

Both the Gothic and the Byzantine lasted longer in Venice, because of her trade with still-Gothic Germany and, until its collapse in 1453, with the Byzantine Empire. Gothic and Byzantine are blended in the sumptuous colors and rich linear patterns of the late-fourteenth-century *Madonna and Child with Two Donors* (Plate 7) by Lorenzo Veneziano, a predecessor of the great Venetian colorists of the next two centuries. Both in Venice itself and in its subject city of Padua, it took the actual presence of several Florentine artists, no-

tably Donatello and Filippo Lippi, to establish Florentine ideals and principles. The subtly constructed *Knight on Horseback* (Plate 70), by the early-fifteenth-century Venetian painter Michele Giambono, shows knowledge of Florentine foreshortening. But partly through her material splendor, and partly through her position seemingly afloat on lagoons in an environment of sea air, glittering water, and distant mountains, Venice enjoyed latent possibilities that were to lead her in directions quite opposite to those of Florence; in fact, to an unprecedented understanding of color and light.

Among the earliest major Renaissance masters of the Venetian region was Andrea Mantegna who, in his late twenties, probably while living in nearby Padua, painted *The Adoration of the Shepherds* (Plate 26). In its stony hardness, this small painting reflects Mantegna's knowledge of the sculpture of Donatello, whom he, when still a boy, had watched at work in Padua. Everything in a Mantegna is measured and defined—the figures, the drapery, the rocks, every curve in the road and stream, the distant landscape, even the clouds in the polished blue sky. Garments are brightly colored in red, blue, or yellow, and highlights applied with the Byzantine technique of tiny lines of actual gold. New life is suggested by the bright fruit of the orange trees, one of whose branches is broken, and by the new shoots rising from the pruned plane tree in the middle distance. In 1459, Mantegna became the first of the princely Renaissance artists when he accepted the job of court painter to the Gonzaga family, marquises of Mantua. This small but wealthy principality in the center of the northern Italian plain, the birthplace of Virgil, was known for its classical learning and magnificent art collections. Mantegna's two engravings of the *Battle of the Sea Gods* (Plates 27, 28), intended to be seen together, are typical of his classicism at a moment when he engaged in the actual excavation of Roman antiquities in northern Italy. The two engravings imitate the effect of Roman sculpture in high relief, with a control not only of anatomy but of the beauty of the nude figure far beyond the command of Pollaiuolo, whose work Mantegna must have seen on his trips to Florence. The otherwise unexplained old woman with dangling breasts, holding a tablet shaped like that in Pollaiuolo's *Battle of the Naked Men* and labeled *INVIDIA* ("Envy"), could be a challenge to Mantegna's Florentine rival. We have no clue as to just what is going on, or why these muscular divinities and tritons, astride sea horses and scaly monsters, are attacking each other with everything from horses' skulls to bunches of fish.

Mantegna's intellectual style had a wide influence throughout the plain of the Po. Nowhere was it stronger than in the rich city of Ferrara, whose Este dukes were closely allied to the Gonzaga of Mantua by ties of blood and friendship. But in Ferrara the style underwent an odd change, trading Mantegna's cool logic for a tormented fantasy. The early *Portrait of a Ferrarese Nobleman* (Plate 34) by Cosimo Tura, one of the three major Ferrarese painters, is rendered in customary strict profile. Anywhere from sixteen to twenty years old, the subject, who may have been an Este prince, is represented with linear precision and a cold analysis of the aristocratic expression, as well as a painstaking definition of every lock of hair and every link in the gold chain. The tiny tondo *The Flight into Egypt* (Plate 33) is generally considered to be a part of Tura's major work, the Roverella altarpiece. The landscape fantasy of Tura's maturity, indeed of the work of his contemporaries in Ferrara as well, is an interesting escape on the part of these imaginative painters from the uniform flatness of their actual surroundings.

In the words of art historian Bernard Berenson, Giovanni Bellini (Mantegna's brother-in-law and member of a family of paint-

ers) "for forty years carried Venetian painting from triumph to triumph." His early *Madonna and Child* (Plate 24) shows Mantegna's sculptural quality in every detail of figure and distant landscape. The ledge on which the Child stands, a common device in fifteenth-century painting, leaves the actual position of the Virgin unexplained, which probably bothered no one—any more than did the attachment of the swag of fruits and flowers. Both swag and landscape are as much symbolic as real. The castle on the hill suggests Mary's epithet of "Tower of David," the harbor on the right, her title of "port in a shipwreck." Mantegna's emphasis on measurement gives way to a subtle poetry, characteristic of Giovanni Bellini's art from youth to old age. This picture was painted in tempera, in contrast to the oil *Madonna and Child* (Plate 25) painted some twenty years later. In both works, the figures are placed behind a window ledge and before a landscape background, in this case half concealed by a partly drawn curtain—a standard prop in Venetian devotional pictures. The still underlying sculptural quality of faces, figures, drapery, and landscape is veiled by a new understanding of color. The oil medium facilitates transparencies enhanced by superimposed glazes that deepen and enrich the shadows within which light seems suspended; they heighten the shimmer of the Virgin's blue cloak and the Child's golden curls and suggest the softness of summer air between us, the towers of the hill town, and the distant range of Venetian Alps.

According to Vasari, the oil technique was brought to Venice by a painter from Sicily, Antonello da Messina, who had acquired his knowledge in the Netherlands. We now know that Antonello, who spent more than a year in Venice in the mid-1470s, never went to the Netherlands, but when working at the court of Milan, he must have known the Netherlandish painter Petrus Christus. So in all probability this Sicilian was able to reveal to the Venetians the usefulness of oil in enriching the delicacy of color and light to which Venetian artists were innately sensitive. It was not long until all the leading Venetian masters deserted the relative dryness of tempera. Antonello's *Portrait of a Young Man* (Plate 36), probably painted before his arrival in Venice, shows not only his own understanding of the inner glow of light but his exquisite reserve of expression and control of form. The art historian Richard Offner once suggested that the sculptural clarity of such faces, not to speak of the "archaic" smile, might have resulted from Antonello's study of Greek sculpture in Sicily. The influence of both Bellini and Antonello is clear in the tiny portraits (see Plates 66, 67) now attributed to the little-known miniaturist Jacometto Veneziano, who brilliantly exploited the possibilities of the new style in the rendering of light on faces and landscape backgrounds.

A striking contrast is offered by Giovanni Bellini's contemporary, the conservative Carlo Crivelli. After punishment for adultery with the wife of a sailor, the young painter left Venice for good, and made his living by painting in the towns along the Adriatic coast, although he inscribed "Venetus" next to his signature on many paintings. He absorbed the intellectualism of Mantegna only in part, retaining into the 1490s such Gothicisms as the gold background and raised, modeled gesso halos. His astringent linear style was able to convey intense emotion. His *Pietà* (Plate 32) is one of nine harrowing renderings of this favorite fifteenth-century subject that are still preserved. Intended originally to remind the faithful at Mass of the sacrifice of Christ perpetuated in the Eucharist, the theme assumed, in this period of warfare and plague, the character of a reminder that Christ had suffered as the spectators had, and that his relatives and friends had grieved as they did. The combination of sharp contours and powerful modeling projects the bones and swollen veins of Christ, even his gaping wounds,

with the same force as the agonized expressions of the Virgin, Mary Magdalen, and John the Evangelist.

A different and deeply poetic treatment of the agony of Christ is seen in a picture by the last of the great fifteenth-century Venetians in the collection, Vittore Carpaccio. *The Meditation on the Passion* (Plate 68) is transfigured by the magic of the long afternoon light that bathes the scene. What careful analysis went into every Carpaccio painting may be guessed from his drawings, always concerned with the equipoise of form and light. The *Studies of a Seated Youth in Armor* (Plate 69), in brush on blue paper—doubtless intended for one of the master's paintings of St. George and the dragon—define form and light with such delicacy that the grace of the youthful model is felt even through the shining steel.

Since there was little Byzantine monumental sculpture, foreign influence on the sculpture of northern Italy came from France and Germany. The lovely *Angel of the Annunciation* (Plate 10), by an unidentified Venetian master, displays the abundant drapery forms typical of Northern Gothic sculpture at the time. But it also has a certain Florentine sense of proportion and dignity of stance, as well as facial forms reminiscent of Florentine art, probably due to the presence in Venice of the Florentines Pietro and Niccolò Lamberti. Free from Florentine influence, however, is the rich and splendid *Enthroned Virgin and Child* (Plate 11) from Milan, whose crowded composition and exuberant drapery folds recall the contemporary painting style of Michelino da Besozzo. The architectural ornaments of the throne are still Gothic, but the pensive face reveals a tender humanity characteristic of the Early Renaissance. Bartolommeo Bellano's *David with the Head of Goliath* (Plate 35), on the other hand, is outspokenly Florentine in the swaggering pose, and every detail is a direct imitation of Donatello, with whom he worked for years.

Surprisingly, northern Italian sculptors of the second half of the fifteenth century abandoned both the Gothic and the Renaissance in their admiration for antiquity. Andrea Bregno, a Lombard born on the shores of Lake Como, north of Milan, developed a solemn and rather stiff classicism in Rome. His *Saint Andrew* (Plate 59), carved for an altarpiece in Old Saint Peter's, is portrayed with all the dignity of a Roman senator in a toga. Not only did Bregno study the faces and drapery forms of Roman and Early Christian sculpture but, in the enframing pilasters, he imitated the delicate architectural ornament of the time of the Emperor Augustus. By the end of the century, northern Italian classicism had intensified to a surprising degree. Tullio Lombardo was the leading Venetian sculptor at the turn of the century, responsible for classical compositions and figures of extraordinary smoothness and chill. His *Adam* (Plate 71), "noble and nude and antique," to borrow a phrase from Swinburne, stands in a long tradition of large-scale nude Adams and Eves and was preceded by many years by an over-life-size pair carved by Antonio Rizzo for the Palazzo Ducale in Venice. The Mantuan sculptor, Pietro Bonacolsi, who worked for the cultivated court of the dowager Marchioness Isabella d'Este, patroness of some of the most important Italian masters, produced small bronzes of such fidelity to ancient models in their smoothness and beauty that he became known simply as Antico. His *Paris* (Plate 75) is one of the finest examples of the small bronze figures beloved by the Renaissance, especially striking with its gilded hair and silvered eyes. A more orgiastic aspect of ancient lore enlivens the sparkling bronzes of the Paduan Andrea Riccio, pupil of Bellano, whose *Satyr* (Plate 74) overflows with animal energy. Renaissance emula-

tion of antiquity reaches a climax in the *Spinario* (Plate 76), a slightly altered version of a Hellenistic bronze, by Antonello Gagini, the leading sculptor from Messina, in Sicily.

A rich cultural center throughout the Renaissance was the principality of Urbino, high in the mountains of central Italy. Since its rulers, the Montefeltro family, owed their prosperity to their military prowess—which not only rendered their armies desirable to other Italian states including the papacy, but attracted students of the art of war from as far away as England—one would have expected Urbino to become a new Sparta. Instead, it was a new Athens, due to the intellectual and artistic interests of the first duke, Federigo (1422–82), who invited artists, poets, musicians, and humanists (including Leon Battista Alberti) from all over Europe to his court. It should be remembered that Raphael was born and brought up at Urbino, and probably spent much of his boyhood in the intellectual atmosphere of the court. Something of the quality of Federigo's palace, which still stands, and much of the simple elegance of the life that once went on within its Renaissance halls and porticoes may be seen in *The Birth of the Virgin* (Plate 39), whose setting resembles this very palace, although the classical reliefs on erotic themes, incongruous with the sacred event, are probably imaginary. Despite three different proposals of a name for the artist, his identity remains a mystery. This and the companion piece, *The Presentation in the Temple*, now in the Boston Museum of Fine Arts, are among the earliest Renaissance pictures to show figures and architectural surroundings at the same scale. The artist has set the birth of the Virgin and the Child's first bath deep in the pictorial space, placing his emphasis on the graceful ladies who have come to congratulate the mother, as if they were the court ladies who attended the birth of an heir. The style owes nothing to Mantegna, but the facial types, the flow of drapery, and the distant landscape incur a real debt to Florence, and especially to the art of Filippo Lippi. The rarified quality of Federigo's artistic demands are further witnessed by two little studies (*studioli*) he had built, one in his palace at Urbino itself, the other at Gubbio, within the Montefeltro dominions. The Gubbio *studiolo* (Plate 41) is a miracle of intarsia, or inlaid wood. The actual doors of the cabinets containing the duke's most precious manuscripts and his musical and scientific instruments, are represented in such accurate perspective that only the coloring, the natural tones of the tiny strips of wood, prevents the illusion from being total.

Social and political changes transforming Italy at the close of the fifteenth and the beginning of the sixteenth centuries placed new demands on the artist, and fostered a new style, known today as the High Renaissance. Short-lived though the style was in central Italy—hardly more than twenty years—its greatest masters, Leonardo da Vinci, Michelangelo, and Raphael, established enduring norms of grandeur, harmony, and unity. The first cataclysm to overwhelm Renaissance Italy was the invasion of the French in 1494. Under Charles VIII, they seized the duchy of Milan and swept south to Naples. In the upheaval, the Medici family was expelled from Florence, and the republic, at first dominated by Savonarola, was later placed under a lifetime *gonfaloniere*, or standard bearer, Piero Soderini, who awarded majestic commissions to Leonardo and to Michelangelo.

The dangers overshadowing the Italian states at the hands of the unified European monarchies inspired a new military assertiveness, which was echoed by a new emphasis on action in art. Leonardo, associated with his older contemporary, Pollaiuolo, in the scientific current of late-fifteenth-century art and thought, was not only a major artist but a pioneer scientist of extraordinary ability and knowledge, interested not only in animal and plant life

(see Plate 60) but even more in motion as a cosmic principle. This harmony of motion underlies all High Renaissance design. Leonardo's drawing of the *Studies for a Nativity* (Plate 61) explores various possibilities of interrelationships in terms of motion between the kneeling Madonna, the Child, and the infant Saint John. It was probably made for the famous *Madonna of the Rocks* now in the Louvre. To preserve the energy of a fleeting moment from which the final composition was to be derived, the poses are rapidly sketched with a pen in several variations.

Leonardo's fascination with animal life found an echo in the art of his Florentine contemporary Piero di Cosimo, whose imaginative reevocation of presumed stages in the life of early humanity (cheerfully incompatible with the biblical account) were, according to the art historian Erwin Panofsky, probably based on the writings of the Roman author Lucretius. Doubtless intended to run around the wainscoting of a room in a patrician Florentine house, they present a startling change from the moral or saintly narratives customary for such cycles. A reflection of Leonardo's ideas can be discerned in the two panels by the Umbrian master Perugino (Plate 77), taken from a large *ancona* (many-paneled altarpiece) destined for the church of the Santissima Annunziata in Florence, and a commission originally offered to Leonardo himself. The great but volatile genius had made a cartoon for a *Madonna and Child with Saint Anne*, a subject he repeated in a cartoon now in the National Gallery in London and a painting now in the Louvre, but, characteristically, he left Florence without starting the painting. The project was turned over first to Filippino Lippi, and after his death, to Perugino. The new breadth and sweep of the figures, the new emphasis on motion, and the new classic dignity of the forms are characteristic of the work of a number of Florentine artists working in these early days of Soderini's republic.

Perugino's one-time pupil, Raphael, felt the impact of the Florentine High Renaissance as soon as he established himself in Florence in 1504, a successful and influential master at the age of twenty-one. The probability that the comparatively dull faces of the two female saints were finished by pupils does not detract from the grandeur of the design of the *Colonna Altarpiece* (Plate 79), painted for Perugia, in which figures, steps, and canopy interact as elements in a single dynamic structure set in deep space. The two consoles at either side suggest Raphael's familiarity with Michelangelo's earliest design for the tomb of Pope Julius II. The new style can be seen not only in the simplicity of the architectural elements but in the volume of the figures, especially the half-length God the Father blessing in the lunette between two angels, from whom float spiral ribbons carrying the energies of the composition into the blue of heaven. The panels of the predella, little scenes of great poetic charm, extend atmospheric space to the point of infinity. *The Agony in the Garden* (Plate 78) is unexpectedly shown as a moment of quiet prayer against a soft evening landscape. In the searching pen line of Raphael's *Nude Male Figure* (Plate 80), we see the basis of Raphael's art in drawing. Indeed for any panel painting or fresco, large or small, he drew every figure, sometimes every head, either from life or from small mannequins.

The simplicity and grandeur of the Florentine High Renaissance style penetrated to every part of the Florentine dominions, even to the subject city of Cortona in southern Tuscany, whose leading artist was Luca Signorelli. The breadth of Signorelli's style, and his intense anatomical interests, revealed in the *Last Judgment* frescoes in Orvieto, betray the influence of Leonardo, Michelangelo, and Raphael. His *Madonna and Child* (Plate 54), painted for a Cortonese family and depicted with sculptural austerity and hardness, sit before a symbolic background of active child angels, shining with

rays of light, like simulated sculpture in tiny medallions. The border of Roman ornamentation is dominated by two carefully labeled but unexplained portrait busts of Julius Caesar and the Emperor Domitian.

he year 1503 saw the elevation of Cardinal Giuliano della Rovere to the throne of Saint Peter. The new pope was a man of boundless ambition and energy despite his sixty years. He chose the name Julius II and saw himself as a Christianized Caesar, destined to transform the papacy into a new Roman empire that would be able to compete with the monarchies for dominion over the entire Italian peninsula. His eventually successful campaign to expel the French from Italy represented only one aspect of his ambition. The warrior pontiff was also driven by a messianic urge to "renew the Church in head and members," the mission he gave to the Lateran Council near the end of his reign. For ten years Julius was the most powerful political figure in Europe. Although his death in 1513 prevented him from fully realizing his dreams, which included ejecting the Spanish from southern Italy, he subdued the power of Venice, brought Florence into the papal fold (by exiling poor Soderini), reestablished the Medici family under Cardinal Giovanni de' Medici (who later succeeded him as Pope Leo X), and set the boundaries of the papal states for centuries to come. His building program involved the reconstruction of Saint Peter's in Rome to make it the largest church in Christendom, the extension of the Vatican to make it the largest palace in history, and the replanning and reconstruction of major sections of the papal city. He inspired the High Renaissance style with a new vision of classical beauty and Christian spirituality and summoned the greatest artists in Italy, including Michelangelo and Raphael, to carry out his dreams.

The sublime presentation of the new vision of salvation through the Church was painted by Michelangelo in fresco on the ceiling of the Sistine Chapel, from 1508 to 1512. Illustrating nine scenes from the Book of Genesis, the work is decorated with the oak garlands of the Rovere family (who ruled Urbino after the Montefeltros). The garlands are upheld by twenty superbly athletic male nudes seated over the thrones of seven prophets and five sibyls who foretold the coming of Christ. The nine biblical scenes in the center illustrate the Creation of the World and the Creation and Fall of Man. A sheet of red chalk studies for the Libyan Sibyl (Plate 81), the finest work by Michelangelo in America, was drawn from a muscular male nude model, as was customary in the artist's mature work. Michelangelo first drew the figure, then, either with a finger or an instrument, richly modeled the effect on the back muscles of holding up the great book the Sibyl is about to close as she gazes downward toward the altar. He then sketched the left shoulder in detail, and then other points of stress, such as the left foot bearing the weight of the body, the big toe twice. Finally, in the lower left corner, he redrew and feminized the face, in preparation for the actual painting. Never since pagan antiquity had there been such a hymn to the magnificence of the human body, and yet this nude is a revelation of divine will—in Michelangelo's own words, a "mortal veil of divine intention."

The Roman version of the High Renaissance was in turn brought back by Michelangelo in 1516 to a different Florence, now under the direct rule of Pope Leo X through younger family members. In 1519, the government passed to the Pope's cousin, Cardinal Giulio de' Medici (himself crowned pope as Clement VII in 1523), although the facade of a republic was maintained. Martin Luther had begun the division of Western Christianity, but the splendid *Holy Family with the Infant Saint John* by Andrea del Sarto (Plate 89), the most gifted of all Florentine High Renaissance painters save Michelangelo, still celebrated the universal sway of the Catholic Church under Florentine popes. St. John the Baptist, patron saint of Florence, presents to the Christ Child and the Virgin, symbol of the Church, a globe of the world surmounted by a cross. Tragically, in 1527, some three years before the hypothetical date of this painting, German Lutheran and Spanish Catholic troops, supposedly attacking in the service of Emperor Charles V, had run amok in the streets of Rome, outdoing each other in atrocities. Churches and palaces, including the Vatican, were sacked and devastated, the pope held prisoner in Castel Sant' Angelo, and the High Renaissance died in blood and fire. No hint of this disaster can be detected in the loveliness of Andrea del Sarto's painting, jubilant in form, color, and mood.

Well before the Sack of Rome, the harmony of the High Renaissance social order had been threatened. The triumphal entry of Cardinal Giovanni de' Medici into Florence in 1512 was preceded by the Sack of Prato, the neighboring town, by Spanish troops. Clearly, Florentine independence was at an end, and the republic survived in name only. In response to these disruptions, a new style of art, known today as Mannerism, soon appeared, led by the painters Pontormo and Rosso Fiorentino in Florence, and in Siena by Beccafumi. The Mannerists rejected most of the qualities that had been essential to the High Renaissance. The strange, the novel, the unexpected were preferred to the normative, the serene. The leading proponent of the later Mannerist style in Florence was Pontormo's adopted son and pupil, Agnolo Bronzino, a brilliant draftsman and colorist, able to produce surfaces of astonishing clarity and smoothness, in contrast to the richness and softness found in the works of Andrea del Sarto. Bronzino's *Portrait of a Young Man* (Plate 94) is one of the finest portraits from this mature stage of Mannerist style. The tense pose of the haughty youth dressed in Spanish black, his left hand on his hip, his right balancing a half-open book, the icy calm of the mouth, and above all, the withdrawn gaze (Bronzino has emphasized the cast in the left eye) contrast with the ease and grace of High Renaissance figures, as does the disunited architecture of the setting, each element clearly defined yet leading nowhere. The more one looks at the painting, the more disturbing it becomes, until one notices the principal ornament of the pedestal on which the book rests—an eyeless, mouthless mask, carved as if composed of crumpled rags. In Renaissance symbolism, masks stand for false dreams; this one is a nightmare. In 1545, Michelangelo, by this time a refugee in Rome from the government by assassination that kept Florence in subjection, wrote:

> Not to see, not to hear, is great good fortune,
> As long as the terror and the shame shall last....

Mannerist renderings of the human figure substitute elegance of line, and sometimes sinuous twists, for the naturalism of the Early Renaissance and the nobility of the High Renaissance. At first sight, the *Standing Nude Male* (Plate 121) by Taddeo Zuccaro, prince of late Roman Mannerism, might be taken for a High Renaissance drawing, until we note the lack of spring and lift in the pose, the equality of stress on every limb and muscle, and the stiff contour into which the figure seems to have been fitted. And obviously Mannerist in its affected grace is the *Orpheus* (Plate 122) by the minor Roman sculptor Cristoforo Stati, who worked in Florence where, at the very end of the century, the Camerata, a new school of musical composition, was to take shape.

In the chaos of the 1530s and 40s, authority was the only re-

course. The Holy Roman Empire, a shadowy entity in the Early and High Renaissance, assumed stern reality once the Austrian Habsburg emperor had become, through dynastic marriages, king of Spain and Portugal, ruler of much of Europe, and overlord of Latin America. The first monarch to reign over so large an empire since antiquity, Charles V imposed an uneasy peace upon Italy in 1530, in superficial harmony with the once humbled but now reinstated Clement VII. Rebellious Florence was besieged and conquered and became a Medici duchy. *The Entry of Christ into Jerusalem* (Plate 96), a lovely rock crystal plaque chiseled by Valerio Belli for Clement in 1537, doubtless symbolizes his return to power in Rome. The brilliant medallion (Plate 116) by the Milanese sculptor Leone Leoni shows the emperor crowned with laurel after his victory over the Moors in Africa, his haughty profile exemplifying the rigidity of the new absolutism that put an end to Renaissance freedom. Only through imperial support could the ruthless Cosimo I de' Medici maintain his power as second duke of Florence and first grand duke of Tuscany. His profile (see Plate 115), in armor that is more symbolic than useful after the universal adoption of muskets and artillery, echoes that of the emperor. Cosimo's son and successor, Francesco I, appears with similar armor and military bearing in a majestic portrait bust by the Flemish-born sculptor Giovanni Bologna (Plate 117). There is irony in this portrait, too, since Francesco was an inefficient ruler, and more of a studious recluse than a soldier. But the image of temporal authority was maintained, as it was in the sphere of religion, in this era of warfare between Catholics in Latin and Central Europe and Protestants in north Germany and the northern Netherlands. The Counter-Reformation, by means of the Council of Trent, which met at intervals from 1547 to 1563, codified Catholic faith and ritual in reaction to Protestantism. Images of divine vengeance and the imposition of ultimate authority abound in Italian art of the mid-sixteenth century, culminating in Michelangelo's world-famous *Last Judgment*.

ne turns with relief to Venice, which, with Genoa, survived the destruction of the Italian republics. Its official title, the Most Serene Republic of Saint Mark, may not reflect the rigidity of its oligarchical government, but the word *Serenissima* could not have been applied to any other sixteenth-century Italian state. The *Portrait of a Man* (Plate 82) by Titian has all the harmony and dignity of the High Renaissance, and exemplifies the ideals of gentlemanly conduct set forth in the influential *Book of the Courtier* by Baldassare Castiglione, writer at the court of Urbino and friend of Raphael. Formerly attributed to Titian's master, Giorgione, the painting is composed according to Titian's principle of superimposed or interlocking triangles. It is not "drawn" in the Florentine sense. Fewer than thirty drawings by Titian have been preserved, as compared with several hundred by Michelangelo, probably because he relied little on preliminary studies. In his *Group of Trees* (Plate 84), it is not contour defining exact shapes that interests Titian, but light, establishing volumes in space, glorying in its own radiance, and indicated by clusters of rapid pen strokes. In the portrait, light plays across the simplified forms of the young man's features, beard, and costume, and quivers in the shadowed air behind him. Titian's resonant color effects were achieved by innumerable superimposed glazes: He is said to have recommended thirty or forty.

Titian maintained his leadership of the Venetian School for nearly three-quarters of a century. In his own personality and daily life he exemplifies the immense changes wrought in the position of successful artists in the Late Renaissance by the transformation of sixteenth-century society. During his maturity and old age, Titian, like Michelangelo, achieved a status of influence, power, and wealth to which no fifteenth-century artist, not even Mantegna, could have aspired. He accomplished this largely because he was able to satisfy the tastes of European monarchs and aristocrats who needed *istoria* for their splendid palaces, just as the fifteenth-century patriciate had needed it for their more austere dwellings. But the new *istoria* was vastly different. Episodes of ancient heroism and saintly miracles went out of fashion with the demise of the republics. The new *istoria* indulged unexpectedly in ancient erotic mythology for domestic decoration. These works were often commissioned by the same individuals who ordered images of passionate mysticism for public altarpieces. Titian's coloristic splendor and his ability to endow his subjects with dignity and strength caught the eye of Charles V at the time of his second visit to Bologna in 1533. He ordered portraits of himself and his family, called Titian twice to the imperial court at Augsburg, and made him a count of the Holy Roman Empire, with a hereditary title and a lifetime income. The story is told, probably apocryphal but significant nonetheless, that during an official visit to Titian's studio the painter dropped his brush, and the emperor of much of the known world stooped to pick it up for him.

Titian and his assistants also turned out innumerable nude Venuses and other erotic subjects for royal, princely, or noble patrons throughout Europe. Often several replicas of the same composition were made; the artist produced four almost exactly similar paintings of Venus and Adonis (see Plate 98) over a wide time span, and four of a recumbent Venus whose abundant charms are being scrutinized by a musician (see Plate 99). Titian developed his own highly original working methods. Usually starting with a ground of bole, a red oxide of iron often found in clay, mixed with gesso and spread over the whole canvas to impart warmth to succeeding layers of pigment, he brushed rapidly in stages, leaving the background in free bursts of tone like broken symphonic chords, and modeling the foreground elements of nude flesh and rich fabric. Often he turned an unfinished picture to the wall for a month or two, then, in his own words, looked at it "as if it were his worst enemy." *Venus and the Lute Player* is one of these canvases, left incomplete when the artist died; the head of Venus and the cupid were finished at a much later date.

The sensuous splendor of Titian was transformed into a science by the much younger Paolo Veronese. His sumptuous interpretations of Venetian life in the guise of sacred stories, and his mythological works, were realized by means of dividing his canvases into major areas, each richly colored with its own basic underpaint, on which foundation he could build a structure of lighter and darker values of the same hue, as well as of delicate oppositions of contrasting hues. His system was reinforced by his sensitivity to color, realized in close harmonies and cunningly resolved dissonances. Veronese was not overly gifted with spiritual insight, but he was unsurpassed in decorative ability. In *Mars and Venus United by Love* (Plate 109), nude flesh shines against the subdued resonance of bronze armor, bright blond tresses against black hair and beard, rose-colored shimmering taffeta against deeper green foliage and slate-blue sky.

Also precalculated, but in a different way and with different goals, stands the art of Jacopo Tintoretto, whose vast compositions, generally for the walls and ceilings of the halls of religious confraternities, were built on geometrical shapes painted in light colors on dark backgrounds as a shortcut to enable him to pour out at breakneck speed the full power of his imagination. We might compare the procedure to drawing with colored chalks on a blackboard. Tintoretto's method was not always wise, since in time the

dark underpaint tends to blacken the outer, brighter layers of color, but it did permit him to cover an astonishing acreage of canvas with his transcendental visions. Often he painted for the mere cost of the materials, and at his death his impoverished widow had to seek a pension from the Venetian government. Tintoretto was always at his best when he could send his figures hurtling through space. Not a person in his *Miracle of the Loaves and Fishes* (Plate 112) is earthbound, despite the setting required by the subject.

Throughout the Venetian region, the art of intarsia was richly developed as a means of reproducing in the woodwork of chapels and choir stalls the kind of compositions so successful in painting. The Venetian painter Lorenzo Lotto designed a splendid intarsia cycle for the cathedral at Bergamo, and under his influence Fra Damiano of Bergamo provided a grand panel for a chapel of the Sacrament at La Bastie d'Urfé in France, with architecture designed by Vignola, to provide a spatial setting for *The Institution of the Eucharist* (Plate 97). Fra Damiano pushed the art of intarsia to its utmost limits in the delineation of the towering architecture of the upper portion of the room and in the rich landscape background. The moment chosen for representations of the Last Supper was usually Christ's announcement of the betrayal by Judas, but as early as the fifteenth century, the Netherlandish Dieric Bouts had shown the Lord elevating an actual Host, and in his *Last Supper*, Leonardo suggested not only the betrayal, but also the consecration of bread and wine. However, with the Council of Trent, to which Claude d'Urfé was French ambassador, the emphasis shifted to the Institution of the Eucharist, to underscore the Catholic doctrine of the Real Presence of Christ in the Consecrated Host, maintained by the Catholic Church to this day, but attacked by Protestant reformers in the sixteenth century. The Institution of the Eucharist is represented in all the Last Suppers by Tintoretto.

The sturdy individuals who populated and governed the *Serenissima* and its far-flung dominions, strikingly different from the apprehensive subjects of the Medici dukes, enjoyed having themselves painted as forthright and dignified. The array of sixteenth-century portraits from Venice and its mainland cities runs the gamut from convincing transcriptions of external appearance to imaginative penetrations of inner life and feelings. The Lombard city of Brescia, acquired by Venice in the early fifteenth century, produced a school of expert portraitists. Well-composed, -drawn, and -painted, the two portraits by Moretto da Brescia and his pupil Giovanni Moroni (Plates 102, 103) show the virtues and the limitations of this Lombard School. Paris Bordon, a pupil of Titian somewhat influenced by Tuscan Mannerism, interpreted the portrait as a dramatization of the sitter's life. The *Portrait of a Man in Armor with Two Pages* (Plate 104), glowing with Titianesque color, juxtaposes the pensive face of the sitter, who later died in battle, with the conflict for which his pages are preparing him with ritual solemnity. Even more moving is the religious experience depicted in the portrait of *Fra Gregorio Belo of Vicenza* (Plate 83) by Lorenzo Lotto, a master of Venetian psychological exploration. Reading his prayerbook and beating his breast in penitence, Fra Gregorio meditates on the Crucifixion, which takes place in the background against the darkened sky, as if in his own thoughts.

By a stroke of good fortune, The Metropolitan Museum of Art was able to acquire not only a brilliant portrait by Veronese of the leading Venetian sculptor Alessandro Vittoria (Plate 111) holding a model for one of his statues of Saint Sebastian, but a bronze version of that very statue (Plate 110), lithe and shimmering, showing how the Venetians were able to exploit the anatomical discoveries of the Florentines, particularly Michelangelo. That such a portrait was painted indicates the new status assumed by artists in the sixteenth century.

Our final school of Italian painting is that which for a few decades flourished in the Po Valley city of Parma, which seesawed in the sixteenth century between the Milanese, the French, and the states of the Church. Two great painters divide the honors: the High Renaissance artist Correggio and the Mannerist Parmigianino, fourteen years his junior. As a young man, Correggio was deeply impressed by the brilliant colors of Mantegna, whose work he had studied on repeated visits to Mantua, and by the dark shadows of Leonardo. Both are evident in his early *Saints Peter, Martha, Mary Magdalen, and Leonard* (Plate 86), nonetheless a highly original picture in its humanity, grace, and sweetness. That Correggio knew the work of Michelangelo and Raphael is certain, for he quoted them often. He could have studied prints and drawings after the Roman paintings, but it seems more likely that his mastery of Roman style derived from knowledge of the originals. But just as he never directly copied Mantegna or Leonardo, so Correggio moved in his own direction, away from Rome, into flights of personal fantasy, converting entire domes into cloudlands populated by attractive saints and angels. Correggio's mature visionary style is shown in a late drawing of the *Annunciation* (Plate 85), a model, squared for reproduction, for a fresco in an archway of a church in Parma. Form and space are dissolved in light and cloud. The artist's intention was to obliterate the boundary between reality and vision, and in so doing he seems almost to have crossed the line between Renaissance and Baroque.

he autocratic states of Europe, including Spain, experienced no indigenous Renaissance in the visual arts. But by the beginning of the sixteenth century, imported Italian ideas were fashionable everywhere, grafted onto native, usually Gothic forms. Spain invited Italian masters, particularly architects and stonecarvers, to give a new aspect to traditional themes. The elegant patio from Vélez Blanco (Plate 90), deriving from Italian tradition and executed by Italian craftsmen, is a case in point. At mid-century, under King Philip II, Spain was to develop its own simple and grand Late Renaissance architectural style, exemplified by the majestic monastery-palace of the Escorial. But it was the experience and tastes developed in such hybrid structures as the courtyard from Vélez Blanco that laid the groundwork for the new style. Spanish painting, however, was not highly regarded, even in Spain. There was no field for it and little interest. The one great painter operating in Spain in the later sixteenth century was El Greco (1541–1614), born in Crete and trained in Rome and Venice. But sculpture, important for the towering, complex altarpieces of Counter-Reformation churches, was another matter. Such brilliant Mannerist sculptors as Alonso Berruguete (ca. 1488–1561) and Diego de Siloé (1495–1563) have every claim to high artistic quality. Much of the tormented elegance of their work survives in *The Holy Family with Saints Anne and Joachim* (Plate 114) by Diego de Pesquera, which, despite its reliance on Michelangelo and other Italians, is original in the intensity of its movement, of both masses and tones.

In its problems and its solutions, the Renaissance remains intensely attractive to the late twentieth century. If the disturbed nature of Mannerism is especially accessible to our own tormented era, the ideal perfection of the High Renaissance is a refuge, and the ceaseless experimentation of the Early Renaissance an inspiration. Never, perhaps, in the intervening centuries has this vital and often contradictory period inspired as much interest as it does today.

Frederick Hartt

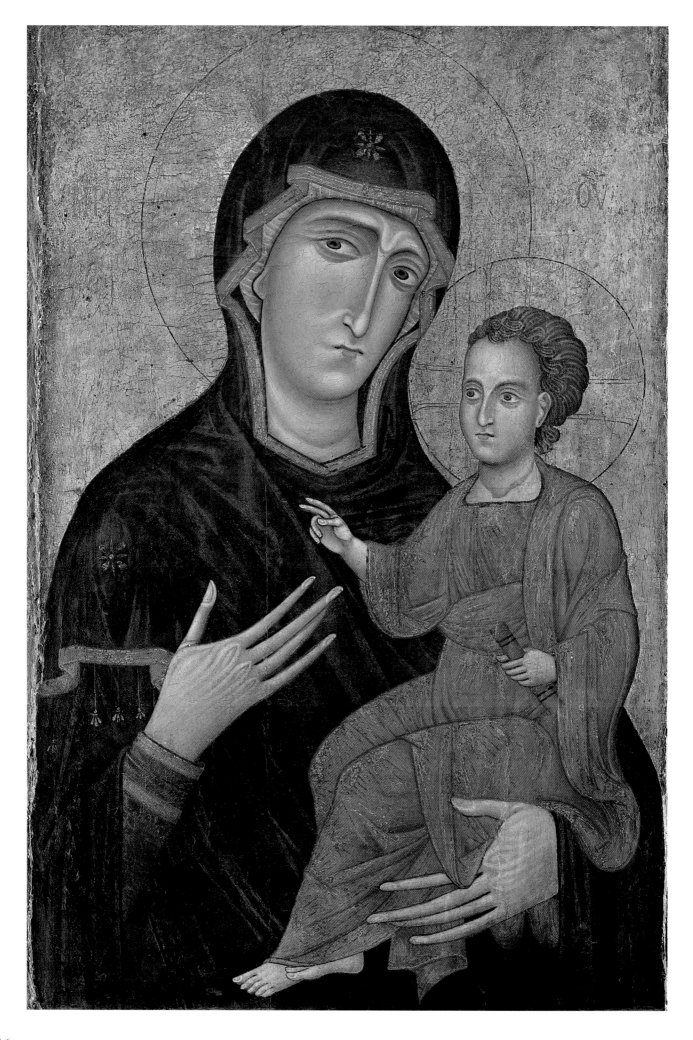

16

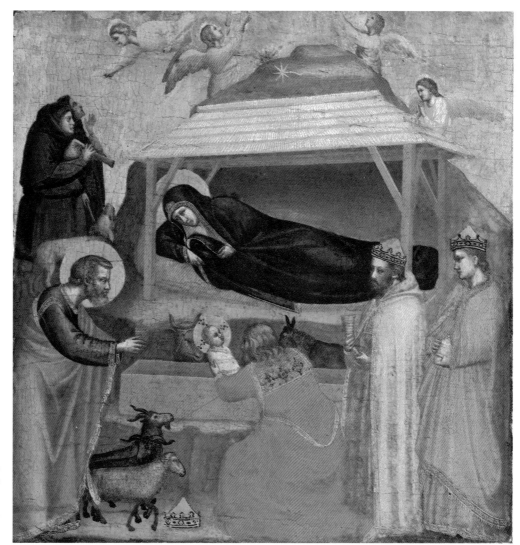

BERLINGHIERO

Madonna and Child

Lucca was the center of Tuscan cultural and commercial activity in the eleventh century, until it was overtaken by Pisa, Florence, and Siena. Its flourishing school of Romanesque art was deeply influenced by the Neo-Hellenism of Byzantine painting that reached Italy after the fall of Constantinople in 1204. Berlinghiero, because of the union of old and new styles he effected in his work, was of great importance in the early thirteenth century.

This *Madonna and Child* is one of only three works that can be securely attributed to Berlinghiero. The composition, like the inscription in Greek on either side of the Madonna, provides a clear example of the Byzantine influence on Tuscan art of the period. Berlinghiero shows the infant Christ in the crook of the left arm of the Madonna, with his right hand raised in blessing, following a Byzantine formula for the *Hodegetria*, or "Indicator of the Way." Typical of the artist, and of the Romanesque School that shaped him, are the expressive faces of the Madonna and Christ.

GIOTTO

The Epiphany

It is not only the naturalism of Giotto's art that places him among the founders of Renaissance painting; it is also the way in which expression is interpreted in deeply human terms, with an economy of means. In *The Epiphany*, which combines a depiction of the Adoration of the Magi with one of the Annunciation to the Shepherds, Giotto makes the gesture of the kneeling magus the focus of his composition. The magus, who has removed his crown and kneels to lift the infant Christ from his manger, is set apart from his fellow travelers, who form a single compositional unit on the right. The glances and gestures of the other figures, who form a semicircle around the magus and Christ, are all directed at this action. Behind the principal scene, isolated against a gold background, two shepherds respond with awe to the announcement of the divine birth.

3 *Pilasters with Angels*, 1302–10
Giovanni Pisano
Pisa, ca. 1248–d. after 1314
Marble; each H. 33½ in. (85.1 cm.)
Frederick C. Hewitt Fund, 1910
(10.203.1,2)

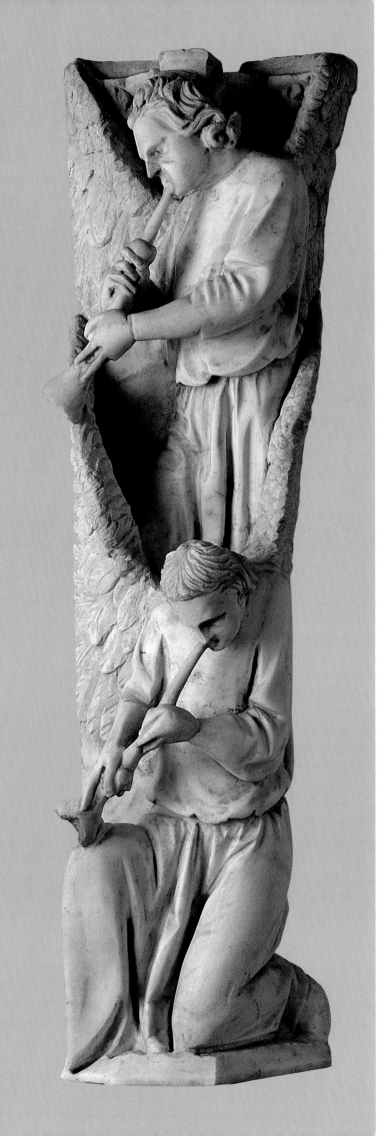

GIOVANNI PISANO
Pilasters with Angels

Giovanni Pisano was, along with his father, Nicola, among the most important Italian sculptors of the early Gothic period. Reproduced here are two pilasters executed for the pulpit of the cathedral at Pisa by Giovanni Pisano and his workshop. Carved of Carrara marble, each pilaster represents paired angels blowing long trumpets. Originally set on the parapet of the tall pulpit, they flanked scenes of the Last Judgment.

The angels' features are deeply undercut to be seen from a distance. Although the figures conform to the vertical shape of the pilaster, the sculptor has subtly varied their poses, creating a rhythmic effect. Their elongated limbs can be seen under their simplified drapery. The figures were originally painted, and small traces of the polychromy remain.

The pulpit was dismantled soon after a devastating fire in the cathedral in 1595. While some of the sculpture was incorporated into the new Baroque pulpit, other fragments, such as the angels, were placed in storage and later dispersed. In the nineteenth century, the Pisano pulpit was partially reconstructed and returned to the cathedral.

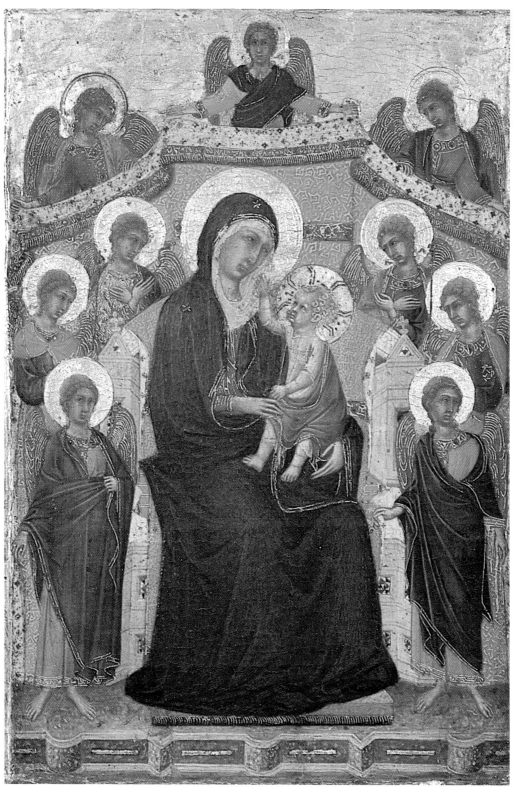

4 Madonna and Child; Crucifixion, ca. 1320
Follower of Duccio di Buoninsegna
Siena, first quarter of 14th c.
Tempera on panel; each
15 x 10⅝ in. (38.1 x 27 cm.)
Robert Lehman Collection, 1975
(1975.1.1,2)

FOLLOWER OF DUCCIO
Madonna and Child; Crucifixion

Small, intimate, and tender, with a strong decorative element, these Sienese panels stand in relation to Giotto's dramatic and dignified work (Plate 2) as a miniature stands to a fresco. The light, rather elongated figures in the Sienese works have none of the breadth and weight of Giotto's figures but are marked instead by a gentle delicacy. And rather than moving in a coherent, three-dimensional space, they

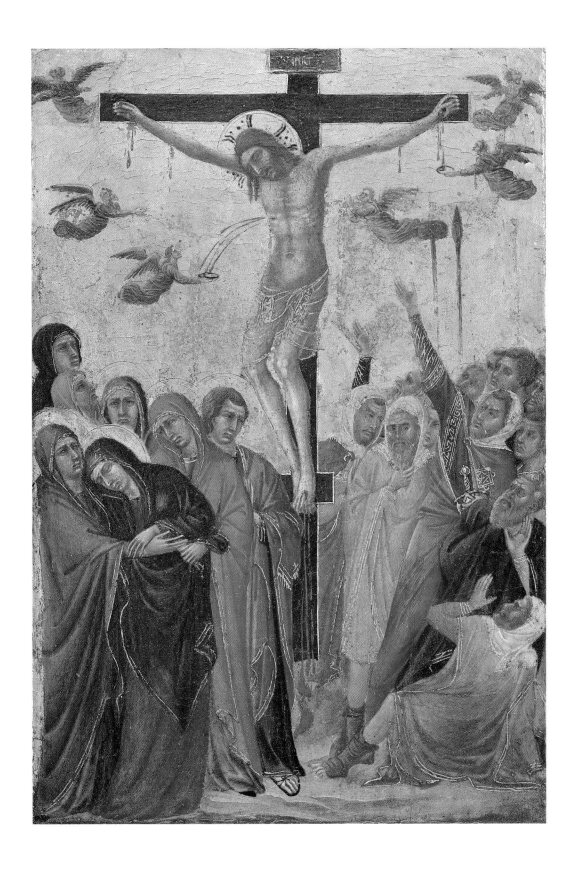

are poised on the surface of the panels. Note, for example, how the angels surrounding the cross in the *Crucifixion* form a semicircular pattern at the top of the picture. The gold edges of the drapery also form abstract linear patterns that are especially evident in the gold trim of the enthroned Virgin's cloak, which follows the curve of her head and cascades down in a flowing line over her arm, the infant Christ's leg, and her lap. The intense colors of the altarpiece are used to create surface patterns, too, ranging from the amassed colors of the figures' drapery to the bright red of Christ's blood set off against the gold background. Finally, the artist has delighted in the meticulously rendered patterns decorating the throne and background in the *Madonna and Child*.

MAN OF SORROWS

"Man of Sorrows" is the name given to nonnarrative, devotional images of Christ displaying his wounds and holding or accompanied by the Instruments of the Passion.

In this enamel plaque, thought to have been executed in central Italy in the third quarter of the fourteenth century, Christ stands in his tomb with his eyes closed and arms outstretched, displaying his wounds. Behind him, on either side, are the lance that pierced his side and the vinegar-soaked sponge that he was offered. The five stars may refer to his five wounds. Flanking the tomb in the front are a monk and a flagellant, both kneeling with their hands joined in supplication. The flagellant wears a hood, and a veil conceals his face. These figures are highly unusual in a representation of the Man of Sorrows, in which Christ is traditionally depicted either alone or with Mary and John the Evangelist.

The blue background and the arches of this plaque were executed in the champlevé technique, in which the enamel is laid in grooves cut into the surface, fired, and then polished. The beautiful figure of Christ is totally gilded, with enamel on the nimbus only.

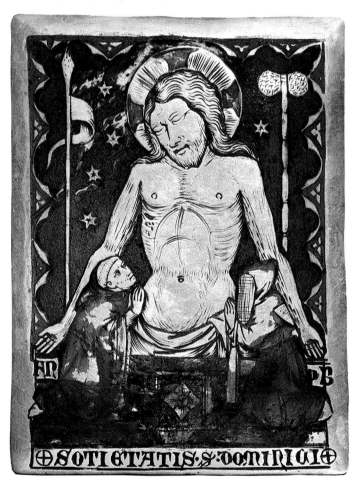

5 *Man of Sorrows (Imago Pietatis)*
Central Italy, 1375–1400
Translucent and champlevé
enamel on copper gilt,
4⅛ x 3⅛ in. (10.3 x 7.8 cm.)
Gift of Georges E. Seligmann,
in memory of his wife, Edna,
his father, Simon Seligmann, and
his brother, René, 1982 (1982.480)

SIMONE MARTINI
Saint Andrew

At the end of the thirteenth century, the two great centers of pictorial innovation were the Tuscan cities of Florence and Siena, and the two agents of change were Giotto and Duccio. Of Duccio's successors in Siena, none was more influential than Simone Martini, who was born about 1283. It was, indeed, through Simone Martini that a Gothic style of extraordinary descriptive subtlety and decorative beauty spread throughout Europe. Successful in his own day, Simone was a man of the world and, for his time, much traveled. He worked in Pisa, Orvieto, and at the Angevin court in Naples, and spent his final years at the papal court in Avignon, a friend of the poet Petrarch and other notables of the age.

Saint Andrew is one of five panels of a folding altarpiece, and it is an excellent example of the delicacy and richness of Simone's work. The features of the aged but vigorous saint are described with remarkable sensitivity; especially notable is the drawing of the hands holding his writings. No less beautiful is the way the elaborate, rhythmic folds of the pink cloak have been modeled in green to create a shot effect. The tooled frame is original.

6 *Saint Andrew*, early 14th c.
Simone Martini
Siena, act. by 1315–d. 1344
Tempera on wood, gold ground;
painted surface 22½ x 14⅞ in.
(57.2 x 37.8 cm.)
Gift of George Blumenthal, 1941
(41.100.23)

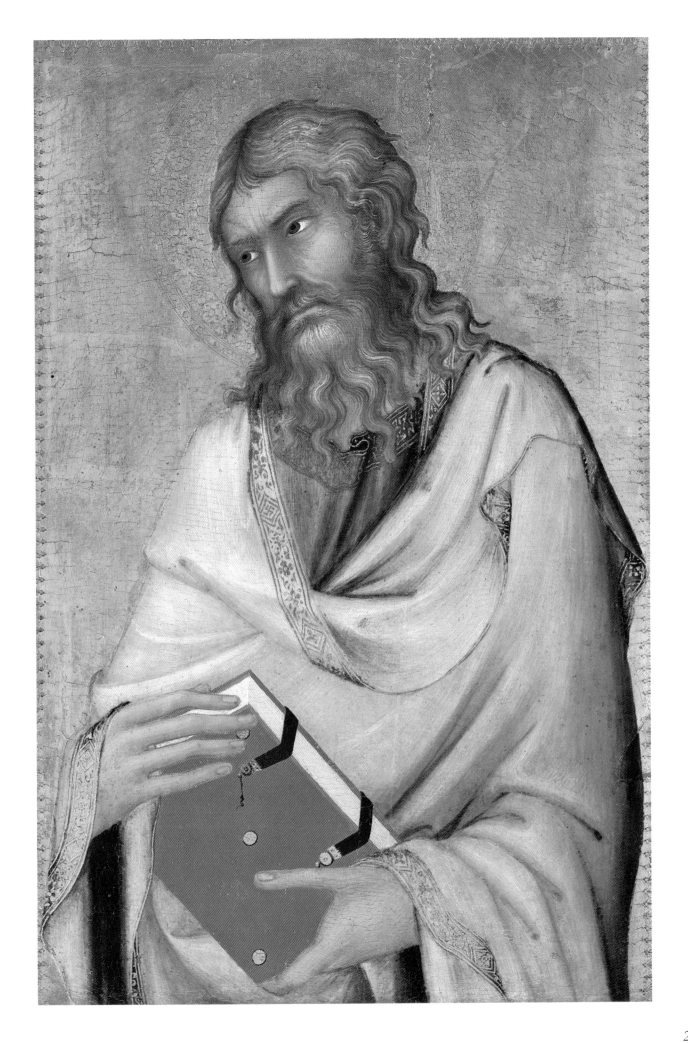

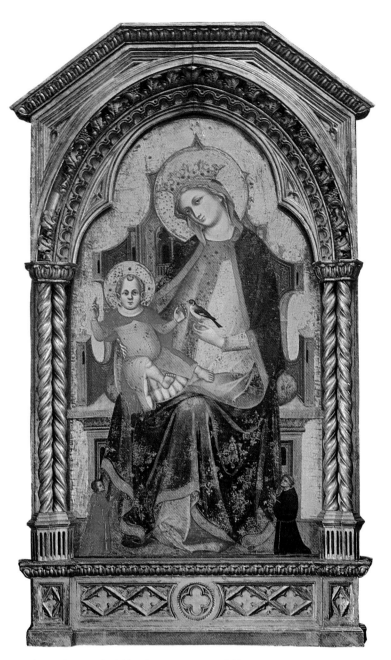

LORENZO VENEZIANO
Madonna and Child

Many Renaissance pictures included collateral figures, usually donors or saints, in addition to those that formed the subject of the work. This painting of the Virgin and Child includes two donors—a merchant and a Franciscan friar. Their extremely small size reflects their relative importance: It was not until later in the Renaissance that such attendant figures were depicted on the same scale as the major ones.

Lorenzo's panel gives full expression to the Venetian love of opulence and decoration, seen in the luxuriant richness of color and pattern in this work. The Virgin's cloak and robe, cascading to the ground in full, deep folds, is richly patterned, and the Christ Child's gold robe is lined with fur. Even the throne is highly elaborate in both surface decoration and shape, and its outline forms a complex decorative pattern against the gold ground.

This is generally considered to be one of Lorenzo's early works. In his later paintings his perspective is more accomplished and the figures are fuller and more weighty, with greater evidence of the human body beneath the drapery.

7 Madonna and Child with Two Donors, ca. 1360
Lorenzo Veneziano
Venice, act. 1356–72
Tempera on panel;
42½ x 25½ in. (108 x 64.7 cm.)
Robert Lehman Collection, 1975 (1975.1.78)

BARTOLO DI FREDI
Adoration of the Magi

During his lifetime, Bartolo di Fredi was very popular in Siena. His work carries echoes of the paintings of Simone Martini, which were created half a century earlier. Like Simone, Bartolo introduced a greater realism into his paintings—especially noticeable in the dour faces of the soldiers and the posture of the horses in this work—while at the same time carrying forward many of the traditions of the Sienese School. He was a prolific worker, producing both paintings and frescoes. Although the quality of his work was uneven, the *Adoration of the Magi,* painted in about 1380, is one of his best and most mature works. It has a brightened palette, and his somewhat robust style is more refined.

This *Adoration* is a fragment of a polyptych containing a series of pictures that told segments of a story. The separation of panels designed to be seen together was not uncommon. It was frequently done by owners and dealers to produce two salable works instead of just one, and another example of this practice is the Sassetta *Journey of the Magi* in The Metropolitan Museum's collection (Plate 14). Bartolo's *Adoration* has been lopped off both at the top and on the left side, as can be seen by the truncated horse and rider in the top left-hand corner and the incomplete figures of the soldiers in the left foreground.

8 Adoration of the Magi, ca. 1380
Bartolo di Fredi Battilori
Siena, ca. 1330–1410
Tempera on panel;
78¾ x 47¼ in. (200 x 120 cm.)
Robert Lehman Collection, 1975
(1975.1.16)

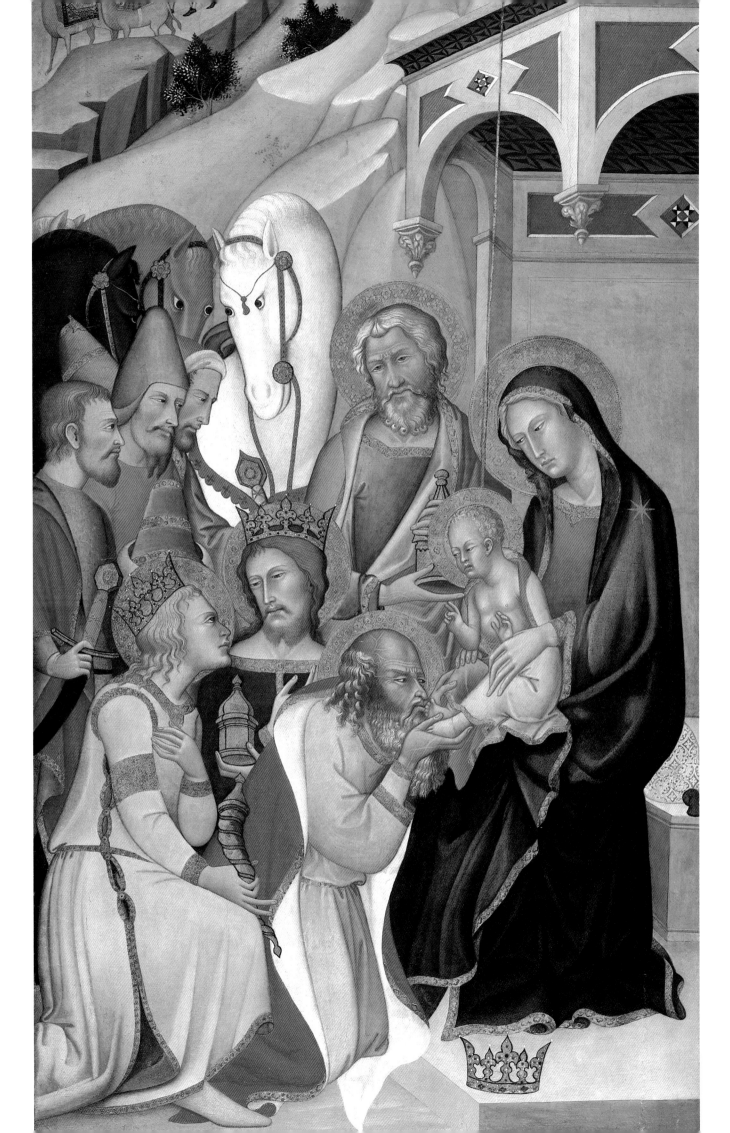

LORENZO MONACO
Nativity

In the fourteenth century, the city of Florence was torn by a series of social and economic crises. These included the failures of the Peruzzi and Bardi banks and, in 1348, the bubonic plague—an event that wiped out three quarters of the population, by some accounts, and had a profound effect on the psyche of the surviving population. The latter half of the fourteenth century was characterized by a mood of penitence that is reflected in the literature and painting of the period. The efforts to revive the realism of ancient painting, made by Giotto at the beginning of the century, were replaced by a Neo-Byzantine transcendentalism in which figures float weightlessly above a supernatural gold ground.

Lorenzo Monaco, born Piero di Giovanni in Siena in 1370, arrived in the atmosphere of postplague Florence about 1387–88. Working at the end of the fourteenth century, he sought to fuse the naturalism of Giotto with the decorative tradition of the International Gothic style, which was then current across Europe. In so doing, he gave life to a moribund tradition.

Framed in the elongated quatrefoil arch of Gothic architecture, this predella panel demonstrates the way Lorenzo combined the precepts of contemporary painting, in the International Style, with the naturalism of Giotto still lingering in Florence. Lorenzo was considered perhaps the most important painter in Florence before Masolino and Masaccio.

The artist chose a natural setting in which to place the biblical characters. The figures have weight, and natural light defines their contours and those of the craggy landscape in which they are placed. Of Sienese inspiration are the gold-tooled halos and aureoles that surround the holy figures and the gold fringe that borders the drapery.

9 *Nativity*, ca. 1413
Lorenzo Monaco
(Piero di Giovanni)
Siena, 1370/72–1425/26
Tempera on panel;
8½ x 11¾ in.
(21.6 x 29.8 cm.)
Robert Lehman Collection,
1975 (1975.1.66)

Opposite: detail

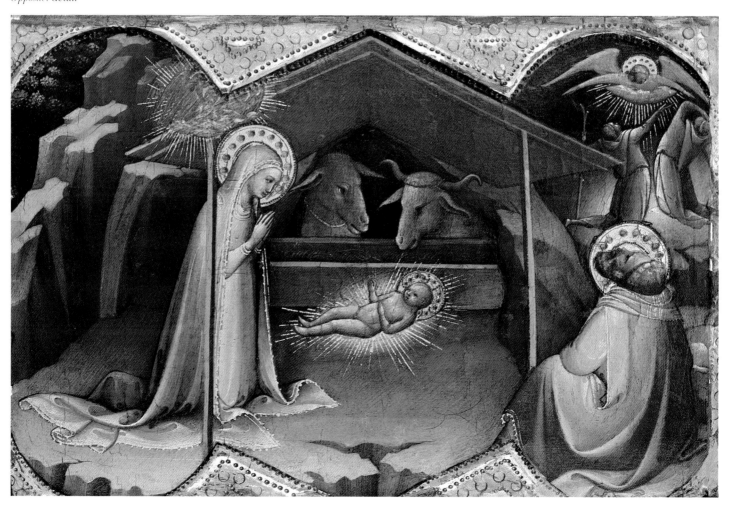

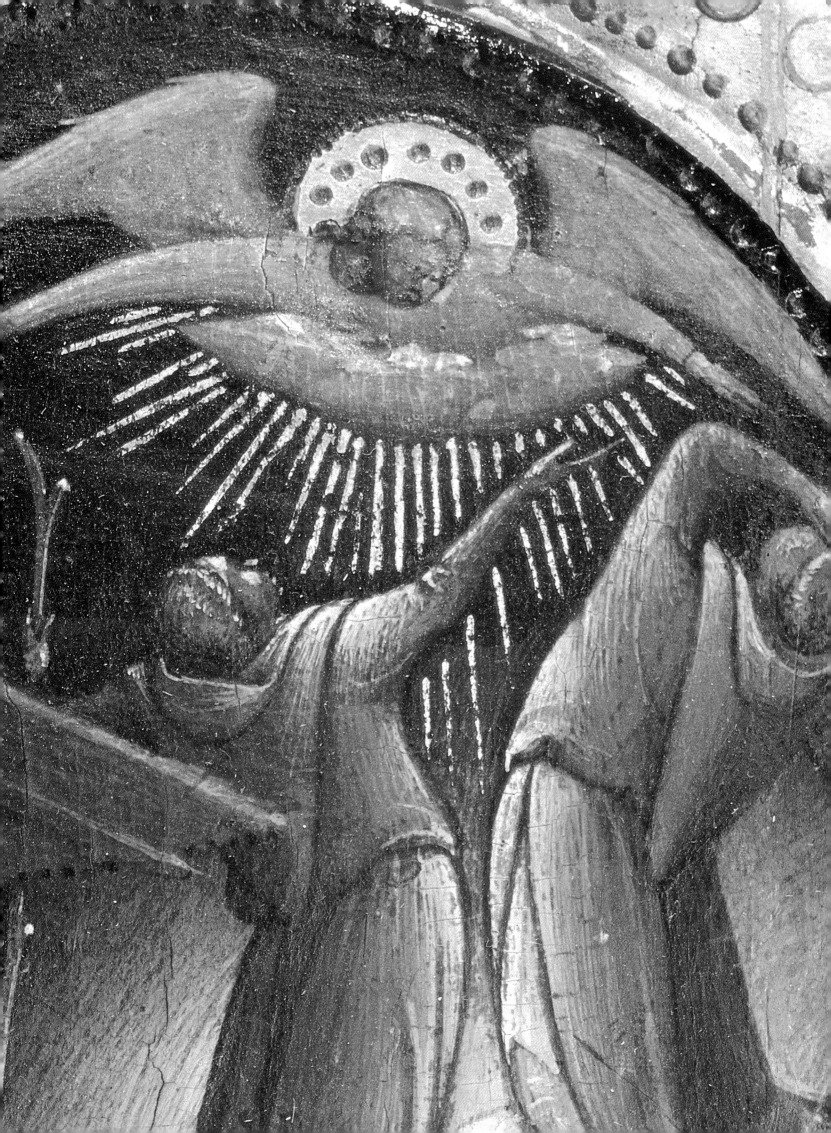

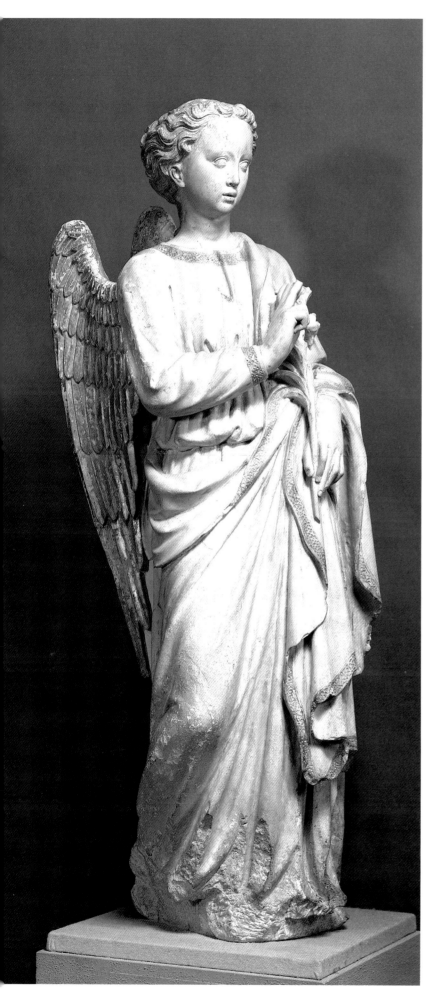

ANGEL OF THE ANNUNCIATION

Although the history of this exquisite statue is unknown, the style of the sculpture and the material, Istrian limestone, suggest an attribution to a Venetian master and a date in the second quarter of the fifteenth century. The angel stands gracefully in a slight *contrapposto*, with the weight on his left leg and his right knee slightly bent. His pose, with a lily in his left hand and his right hand raised in a speaking gesture, indicates that he is the Angel of the Annunciation to the Virgin. His delicately carved face is framed by gilded hair gently pulled back and gathered at the nape of the neck. Traces of gilding also decorate the border of his mantle. Imbued with all the sophistication and elegance that characterize fifteenth-century Venetian art, the angel nevertheless retains Gothic features, especially in the rich and subtly modeled drapery.

10 Angel of the Annunciation
Venice, ca. 1425–50
Istrian limestone, painted and
gilded; H. 37¼ in. (94.6 cm.)
The Cloisters Collection, 1967
(67.236)

ENTHRONED VIRGIN AND CHILD

The unknown artist who carved this piece may well have been part of the workforce that built the cathedral in Milan. Begun in 1386, the cathedral was essentially completed by 1431, but for over fifty years it attracted artists and artisans from France, Germany, and other parts of Italy. This relief, depicting the Madonna and infant Christ surrounded by angels, is an example of the resulting confluence of artistic trends in northern Italy. The work clearly shows the mingling of styles that affected many local artists. The angularity of northern Gothic design has been softened by Italian influence, but its presence is still strong. The northern influence is especially evident in the linear treatment of the folds in the clothing and in the curling hair of the angels.

11 Enthroned Virgin and Child with
Crowning and Musical Angels
Milan, early 15th c.
Limestone relief;
H. 32¼ in. (81.9 cm.)
Bequest of Irwin Untermyer,
1973 (1974.126.4)

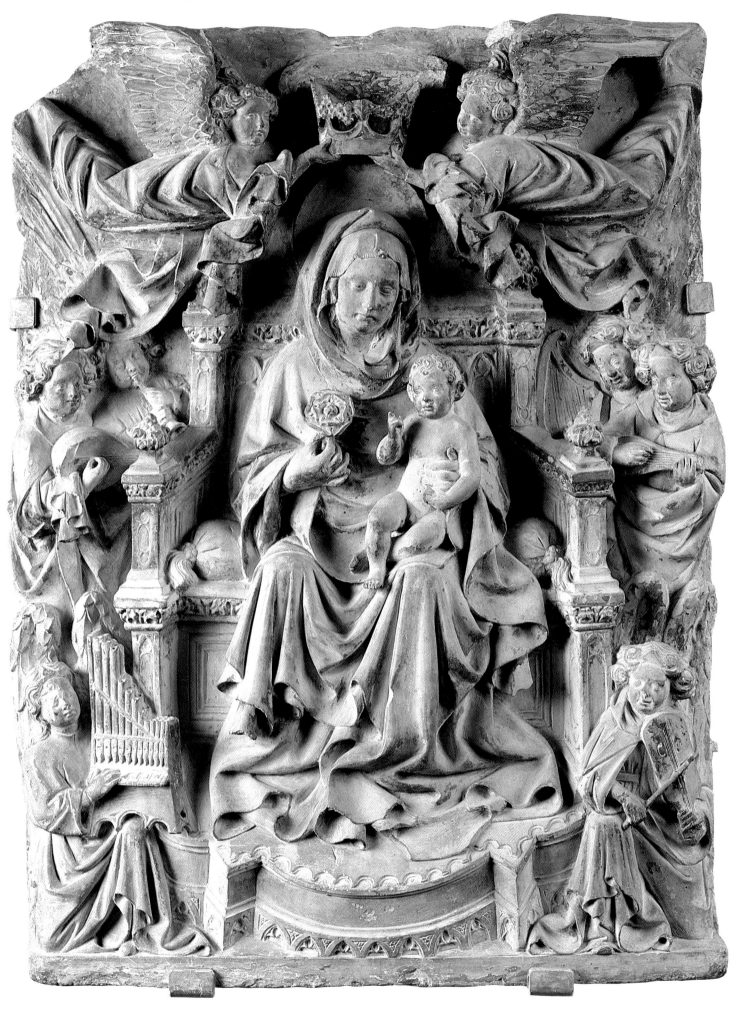

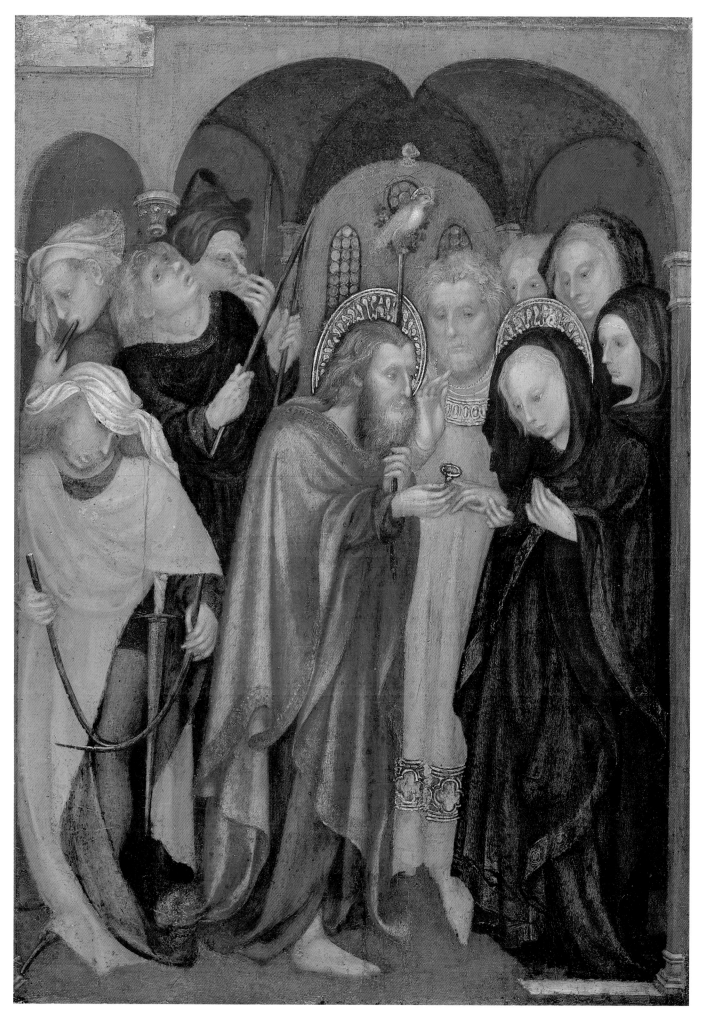

30

12 *The Marriage of the Virgin*
Michelino Molinari da Besozzo
Northern Italy, act. by 1388–d. 1450
Tempera on wood, raised gold ornament;
25⅝ x 18¾ in. (65.1 x 47.6 cm.)
Maitland F. Griggs Collection, Bequest
of Maitland F. Griggs, 1943 (43.98.7)

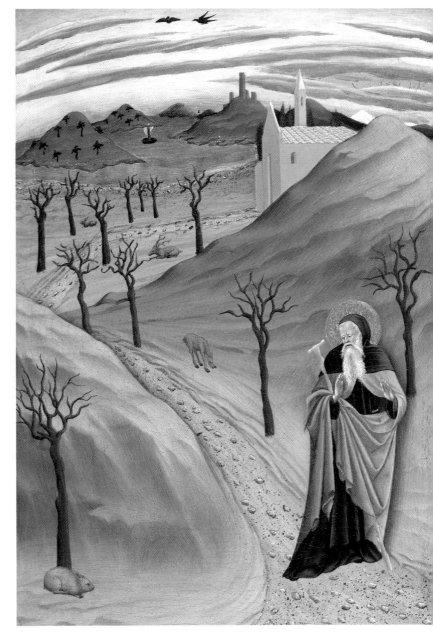

MICHELINO DA BESOZZO
The Marriage of the Virgin

Michelino da Besozzo was one of the most famous artists of his day—praised by the humanist Umberto Decembrio as "the most distinguished artist of our time." He was principally active in Milan, where he worked for the Visconti family and was employed designing windows for the cathedral. His visit to Venice in 1410 was of great importance for the development of Venetian painting in the following two decades.

Despite his contemporary fame, little of his work has survived. Indeed, aside from a small painting showing the mystic marriage of Saint Catherine to Christ, in the Pinacoteca of Siena, this is the only picture that can be ascribed to him with certainty. It shows a youthful and somewhat shy Virgin receiving a ring from an elderly Joseph, who was selected as her spouse when his staff miraculously burst into flower upon being placed on an altar together with those of the other suitors. Michelino shows the rejected suitors comically breaking their staffs in despair—one suitor even chews on his. The composition is laid out like an illuminated page —Michelino was a gifted illustrator—with the main arch decoratively distended to frame the wedding couple, while the small arch to the left effectively isolates the group of suitors. The soft, curving forms are typical of the International Gothic style he championed.

13 *The Temptation of Saint Anthony Abbot*, ca. 1444
Sassetta (Stefano di Giovanni)
Siena, ca. 1392–d. 1450/51
Tempera on panel;
18⅝ x 13½ in. (47.3 x 34.3 cm.)
Robert Lehman Collection, 1975 (1975.1.27)

SASSETTA
The Temptation of Saint Anthony Abbot

At the end of the fourteenth century, when Siena's cultural and political influence in central Italy had begun to wane, the city produced a final burst of genius in Sassetta, the greatest Sienese painter of the period. While basically a conservative, adhering to the firmly established style and intentions of Sienese art, Sassetta selected those aspects of the Renaissance developments in art that could be incorporated within his traditional limits. He understood the principles of anatomy and perspective, but he did not allow them to dictate the form of his composition. Above all, he brought to his paintings a liveliness and narrative charm and a magical blend of reality and fantasy.

The Temptation of Saint Anthony Abbot, dated around 1444, is all that remains of a larger work. It depicts a scene from the legend in which Saint Anthony (ca. 250–350), the founder of monasticism, took himself to the solitary wilderness of the Egyptian desert, only to be bombarded with temptations sent by the Devil to distract him from his sanctity. The Devil originally appeared in person in this painting, in the foreground space between the tiny rabbit on the left and the figure of Saint Anthony, but he was painted over. As portrayed by Sassetta, the desert, with its unlikely winter-stripped trees, is an adaptation of a winter scene in the Tuscan hills, rendered somewhat eerie by the clarity of the curving, cloud-streaked sky and the bare trees with their tentaclelike branches.

14 *The Journey of the Magi*, ca. 1435
Sassetta (Stefano di Giovanni)
Siena, ca. 1392–d. 1450/51
Tempera on wood;
8½ x 11¾ in. (21.6 x 29.8 cm.)
Maitland F. Griggs Collection,
Bequest of Maitland F. Griggs, 1943
(43.98.1)

Opposite: detail

SASSETTA
The Journey of the Magi

This picture, which shows the three magi—identified by their gold halos—and their retinue journeying to Bethlehem, is a fragment of a larger composition. The lower portion is in the Chigi-Saraceni collection, Siena, and shows the magi dismounting to worship the Christ Child. The upper edge of the roof of the stable is just visible along the bottom right edge of the Museum's picture. The star floated directly above it. Painted in the mid-1430s, the composition was inspired by Gentile da Fabriano's celebrated altarpiece in the Uffizi Galleries, Florence, where the retinue of the magi was treated with unsurpassed vividness. Sassetta has lavished some of the same descriptive care on his scene. The figures wear a variety of detailed aristocratic costumes. One of the men holds a hunting falcon on his arm, and a monkey rides on the back of one of the donkeys. The two ostriches on the hill in the left background have been explained as symbolizing Christ's miraculous birth, while the single file of cranes darting across the sky is an analogue to the voyage of the magi.

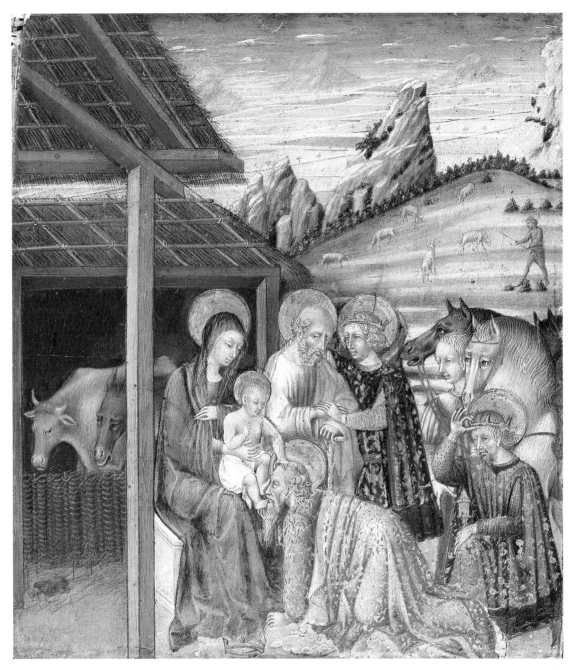

15 *The Adoration of the Magi*, 1460 or later
Giovanni di Paolo
(Giovanni di Paolo di Grazia)
Siena, act. by 1420–d. 1482
Tempera and gold on wood;
10⅝ x 9⅛ in. (27 x 23.2 cm.)
The Jack and Belle Linsky Collection,
1982 (1982.60.4)

GIOVANNI DI PAOLO

The Adoration of the Magi

In the 1440s, Giovanni di Paolo developed a style of painting in Siena that differs in almost every way from the style then current in Florence. Akin to the International Gothic style, Giovanni's art is dreamlike rather than naturalistic; his figures are weightless and attenuated, and his colors are of a gemlike intensity.

This picture, one of three extant panels belonging to the predella of an altarpiece, was painted by Giovanni di Paolo approximately fifteen years after the predella panels in Plates 16 and 17. In this representation of the Adoration of the

Magi the eldest magus has doffed his crown and leans to kiss the Christ Child's foot in adoration, while the magus to the right, also kneeling, holds a gold gift in one hand and with the other prepares to remove his crown as well. The youngest magus stands with one arm around Joseph's shoulder and the other resting on the old man's hand—a gesture that adds an intimate human note. Unlike the flattened backgrounds of Giovanni's *Expulsion* and *Paradise*, the background here is composed of fields receding into the distance. The middle ground is occupied by a shepherd tending his flock.

GIOVANNI DI PAOLO
Expulsion from Paradise

The painting illustrated here depicts the expulsion of Adam and Eve from Paradise. On the right-hand side of the panel an angel pushes Adam and Eve out of a lush, rich paradise. On the left, God—framed by a host of angels and surrounded by a blaze of light—points toward the earth, the place of Adam and Eve's banishment. The earth is represented in the traditional medieval manner. It is shaped roughly like the letter T, with Europe and Asia forming the top bar and Africa the stem, and is surrounded by the concentric circles of the universe, which in turn are surrounded by the signs of the zodiac. An arid, flat place, the earth stands in great contrast to Paradise.

Delicate in rendering and intense in color, this panel is an extraordinary, mystical depiction of the biblical story. It is a fragment from the predella of an altarpiece painted for the church of San Domenico in Siena and now in the Uffizi Galleries in Florence. Giovanni di Paolo's *Paradise* (Plate 17), also in the Metropolitan, is from the same predella.

16 *Expulsion from Paradise*, ca. 1445
Giovanni di Paolo
(Giovanni di Paolo di Grazia)
Siena, act. by 1420–d. 1482
Tempera on panel;
17¹⁵⁄₁₆ x 20½ in. (45.6 x 52 cm.)
Robert Lehman Collection, 1975
(1975.1.31)

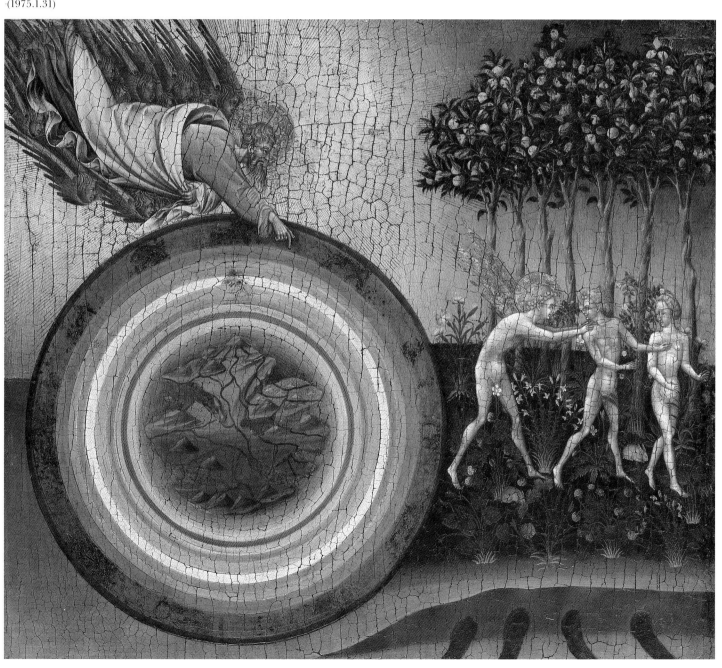

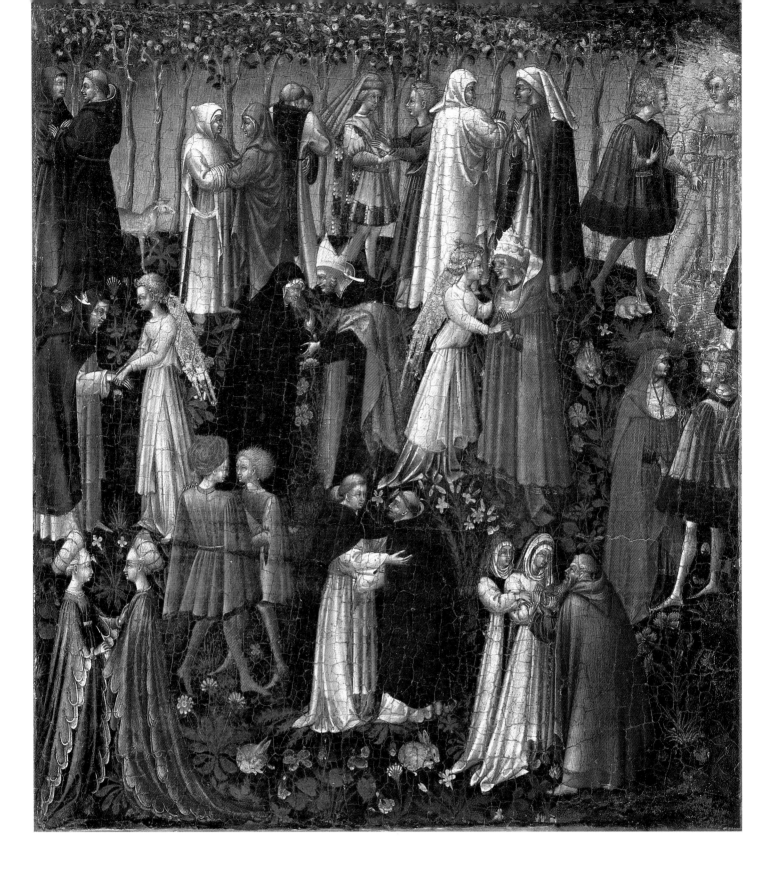

GIOVANNI DI PAOLO
Paradise

This painting of Paradise is from the same altarpiece predella as the *Expulsion from Paradise* (Plate 16), and the rich, green landscape here is very similar to the one in which the artist depicts Adam and Eve in that panel. Although the composition derives from a panel by Fra Angelico, Giovanni has endowed it with his unique traits. The bright colors and the oversize flora and fauna of the landscape give the picture the unreal quality of a tapestry. The figures,

who embrace each other, are rendered with a great intensity of feeling.

Some of the figures in this representation of souls greeting each other or being welcomed by angels can be identified. The Dominican friar with a white dove near his head is probably the Blessed Ambrogio Sansedoni, one of Siena's patron saints. The bishop embracing the old woman is Saint Augustine greeting his mother, Saint Monica.

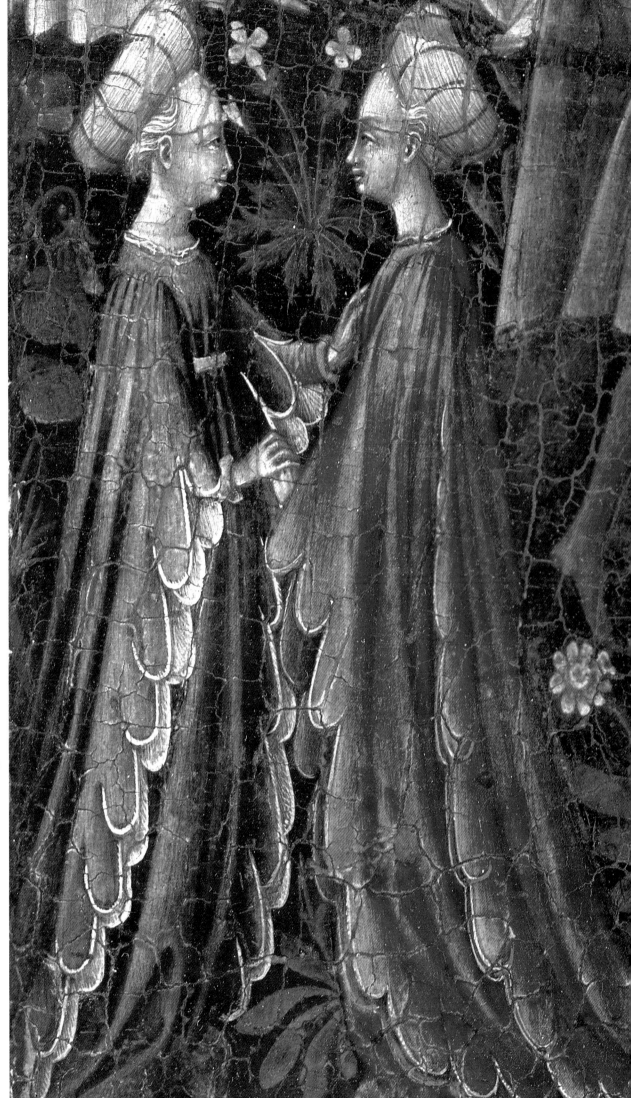

17 Paradise, ca. 1445
Giovanni di Paolo
(Giovanni di Paolo di Grazia)
Siena, act. by 1420–d. 1482
Tempera on canvas, transferred
from wood; painted surface
17½ x 15⅛ in. (44.5 x 38.4 cm.)
Rogers Fund, 1906 (06.1046)

Right: detail

*19 Portrait of a Man and Woman
at a Casement*, ca. 1440
Fra Filippo Lippi
Florence, ca. 1406–d. 1469
Tempera on wood;
25¼ x 16½ in. (64.1 x 41.9 cm.)
Marquand Collection, Gift of
Henry G. Marquand, 1889
(89.15.19)

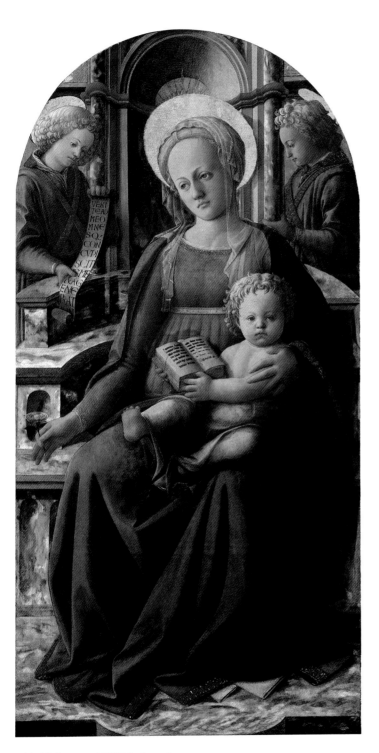

FRA FILIPPO LIPPI
Madonna and Child Enthroned

This early work by Filippo Lippi dates to about 1437. It is the center panel of a triptych. The wings, which are in the Accademia Albertina in Turin, show full-length standing figures of the Fathers of the Church. Although composed of three separate arched panels, this triptych was unified by a continuous wall and uniform lighting. The figures and the elaborate marble throne have the massive quality typical of Lippi's early work. The angel at the left holds a scroll inscribed partly in Gothic and partly in Humanist script with a verse from Ecclesiastes: "Come over to me, all ye that desire me, and be filled with my fruits."

FRA FILIPPO LIPPI
Portrait of a Man and Woman at a Casement

During the first half of the fifteenth century, Florentine portraits invariably showed their subjects in profile. Fra Filippo Lippi's eccentric-looking panel was painted about 1440, possibly to commemorate a marriage, and it is the earliest Italian portrait with an interior setting. The man holds the arms of the Florentine family of Scolari and has been identified as Lorenzo de Ranieri Scolari (1407–78); his wife was Agnola de Bernardo Sapiti. She is fashionably dressed in the French style (*alla parigina*), with the word *leal[ta]*, or "fidelity," embroidered in gold and embellished with pearls on her sleeve.

The meticulously rendered landscape seen through the window seems to be indebted to Flemish painting.

*18 Madonna and Child Enthroned,
with Two Angels*, ca. 1437
Fra Filippo Lippi
Florence, ca. 1406–d. 1469
Tempera and gold on wood,
transferred from wood;
48¼ x 24¾ in. (122.6 x 62.9 cm.)
The Jules Bache Collection, 1949
(49.7.9)

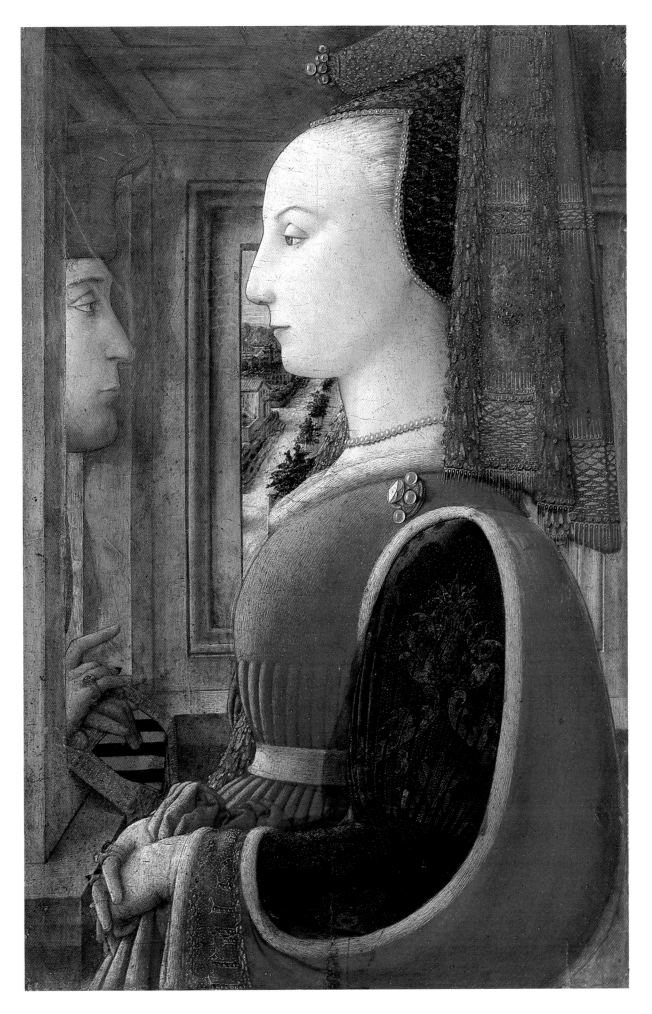

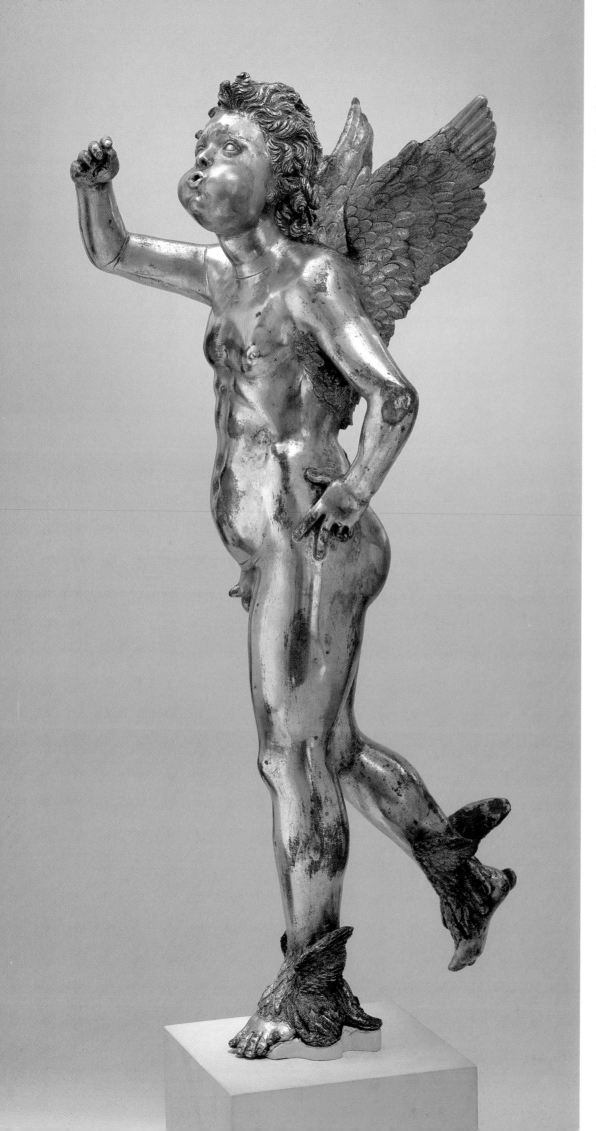

20 *Fountain Figure of a Winged Infant*
Florence, ca. 1440
Gilt bronze; H. 24¼ in. (61.5 cm.)
Purchase, Mrs. Samuel Reed Gift,
Gifts of Thomas Emery and
Mrs. Lionel F. Straus, in memory of
her husband, by exchange; and
Louis V. Bell Fund, 1983 (1983.356)

21 *The Youthful Christ with His
Mother Enthroned*, ca. 1460
Agostino di Duccio
Florence, 1418–81
Marble;
16¾ x 25⅛ in. (42.5 x 63.8 cm.)
John Stewart Kennedy Fund,
1914 (14.45)

FOUNTAIN FIGURE OF A WINGED INFANT

This figure of a winged infant originally crowned a fountain in a fifteenth-century garden or courtyard. Within its body, copper piping conducted a jet of water from left foot to mouth, from which the water spouted forth to propel a windmill, or whirligig, held in the figure's right hand. A precedent for the pose is found in a work by Donatello—the most fertile genius in Florentine sculpture of the fifteenth century—namely, his *Dancing Angel* (1429) on the Baptistery font in Siena. The cast of the figure shown here is heavy, with the arms cast solid in the rudimentary manner typical of Early Renaissance bronzes. A goldsmith must have assisted the sculptor with the elaborate chasing of the wings.

The sculpture has a singularly mysterious combination of attributes. It bears the wings of a Cupid, feathered feet such as might be associated with Mercury, and a fleecy tail that suggests a satyr. In a Renaissance garden, fountain figures were often part of an elaborate allegorical program. This winged infant undoubtedly had a particular iconographical significance, but it may only emerge when its original owner and situation are known.

AGOSTINO DI DUCCIO
The Youthful Christ with His Mother Enthroned

In his relief of *The Youthful Christ with His Mother Enthroned*, Agostino di Duccio treats a Christian subject with pagan overtones. The young Christ is beardless, as he sometimes appears in Byzantine art; the Virgin is shown as *sedes sapientiae*, or "the seat of wisdom," the sphinxes on her throne being emblems of wisdom; and the angels with a circular wreath may derive from Byzantine ivory carving.

Agostino, a Florentine, had ample opportunity to study Byzantine art along the Adriatic coast between the time of his employment at Rimini (by 1449), where he made a series of reliefs for the Tempio Malatestiano, and at Perugia (1457–62), where he produced the figures on the facade of the Oratory of San Bernardino. The abstract surface patterns and attenuated figures in the present relief relate more to the work at Perugia than to that at Rimini. Agostino's relief is a good reminder not only that Greco-Roman art was perceived in its classical character but that Byzantine contributions continued to be valued. At the same time, the lively play of the angels' draperies and the hilly townscape briskly sketched at the left edge leave no doubt that Agostino shared in the trend toward naturalism that was the dominant pursuit of fifteenth-century Florentine artists.

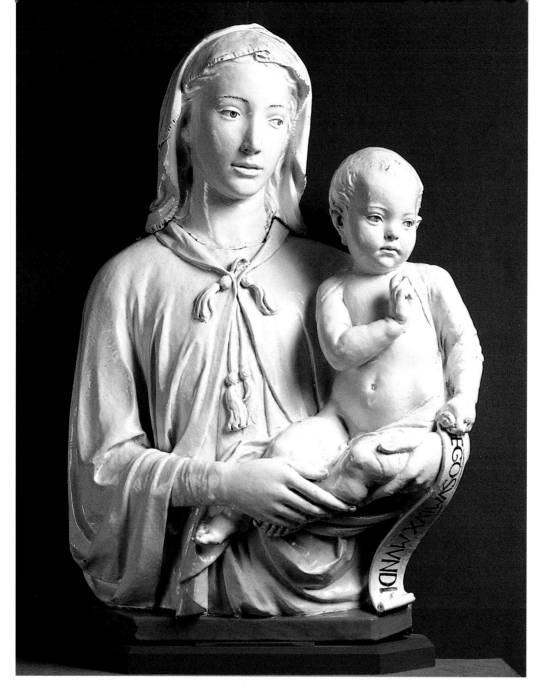

22 *Madonna and Child with a Scroll,*
ca. 1455
Luca della Robbia
Florence, 1399–1482
Glazed terra-cotta;
31¼ x 22 in. (79.4 x 55.9 cm.)
Bequest of Benjamin Altman,
1913 (14.40.685)

LUCA AND ANDREA DELLA ROBBIA

Luca della Robbia was one of the greatest sculptors in Early Renaissance Florence, in the same league as Donatello and Ghiberti. His reputation was ensured with the marble *cantoria,* or "singing gallery," with its intensely lyrical reliefs of child musicians, which he began in 1431 for the Cathedral of Florence.

Luca's works are characterized by a combination of gravity and fresh innocence that continues to exert great appeal after five centuries. He also developed the ceramic technique for sculptural purposes that is associated with his name. His terra-cotta compositions were coated with pigments that vitrified when the pieces were refired, providing diversity of color and a durable surface that could withstand the elements if placed outdoors. Occasionally he combined glazed terra-cotta elements with marble elements in the same work, notably in tomb decorations.

The generous forms of the *Madonna and Child with a Scroll* show Luca della Robbia in the period of his most monu-mental work, which was made in around 1455. The white glazed surface is relieved by the blue-black used for the eye-brows, the inscription *"Ego sum lux mundi"* ("I am the light of the world") on the scroll, and the characteristic azure used for the molding.

Long before his death, Luca had entrusted the secret of his technique and the leadership of his workshop to his nephew, Andrea, whose tondo with the allegorical figure of Prudence is one of his best works. While faithful to the canon of his uncle's style, it is nonetheless distinguishable as Andrea's, being slightly drier in modeling and in emotional appeal. Andrea employed a particularly harmonious range of colored glazes for the vegetation in the garland enframe-ment, including grapes, quinces, pine cones, and cucumbers. The tondo is one of four by Andrea that depict the cardinal virtues, related to a series made by Luca for the ceiling of the chapel of the Cardinal of Portugal in the church of San Miniato, Florence.

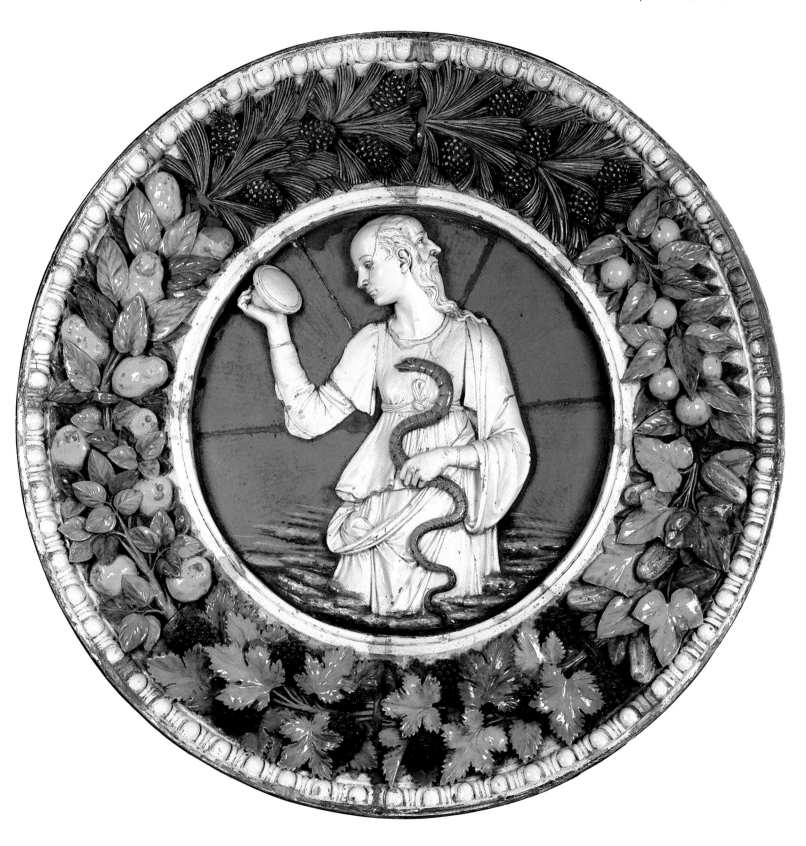

GIOVANNI BELLINI

One of the great geniuses of the Renaissance, Giovanni Bellini came from a family of painters. He developed the style—at once sumptuous in color and noble in mood—that we identify with Venetian art of the Renaissance. This style was continued in the work of such artists as his famous pupils Giorgione and Titian.

The devotional panel reproduced in Plate 24, a relatively early work, is almost hieratic in composition. The figures are centrally placed and face front, with the neatly dressed child standing on a parapet. Yet despite the formal composition, the figures themselves are not stiff, and this work is one of Bellini's most effective and poetic compositions. The Virgin holds the Child protectively. Her headdress falls in a smooth, uninterrupted line; her head is slightly tilted; and Christ holds her hand in a human gesture. The figures are fully modeled, even sculptural, suggesting the influence of Bellini's brother-in-law, the great Paduan painter Andrea Mantegna (see Plate 26). Mantegna's influence, as well as that of Flemish painting, is also felt in the clearly rendered landscape in the background and in the decorative swag of fruit behind the Virgin's head. The gourd on the parapet is the traditional symbol of the Resurrection.

The Madonna and Child in Plate 25 was painted perhaps two decades after that in Plate 24, and although its constituent elements—the mother and child behind a parapet with a distant landscape—are the same, the effect is different. The forms are larger and simpler, and the light is more intense and focused. A rust-colored cloth of honor has been introduced to confer an effect of great intimacy, enhanced by the gaze of the Virgin toward the viewer. Although the silhouette of the Madonna is aligned with the vertical axis of the picture, the position both of the Child and the cloth of honor introduce an asymmetry that at this date was extremely daring. The landscape, composed of barren trees, newly tilled fields, green hills, a few houses, and a ruined tower against a view of the Alps, is used to establish a balance. The autumnal landscape is also employed to underscore the still, poignant mood of the picture, in which the helpless figure of Christ is affectionately supported by his mother.

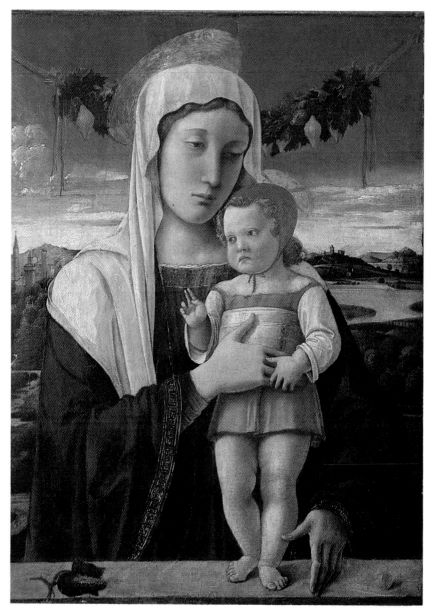

24 Madonna and Child, ca. 1460
Giovanni Bellini
Venice, ca. 1430–1516
Tempera on panel;
21¹⁵⁄₁₆ x 15⅝ in.
(55.7 x 39.8 cm.)
Robert Lehman Collection,
1975 (1975.1.81)

25 Madonna and Child, 1480s
Giovanni Bellini
Venice, ca. 1430–1516
Oil on wood;
35 x 28 in. (88.9 x 71.1 cm.)
Rogers Fund, 1908 (08.183.1)

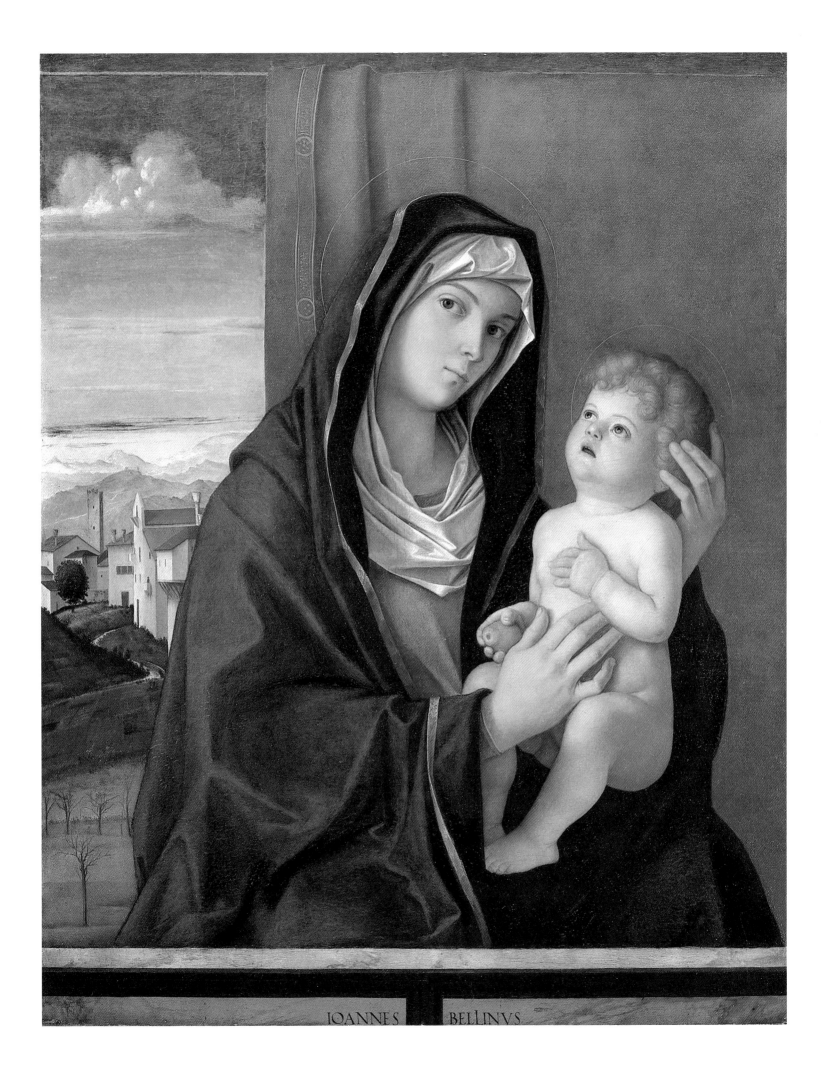

IOANNES BELLINVS

26 *The Adoration of the Shepherds*
Andrea Mantegna
Padua, ca. 1430–d. 1506
Tempera on canvas, transferred from wood;
15¾ x 21⅞ in. (40 x 55.6 cm.)
Purchase, Anonymous Gift, 1932 (32.130.2)

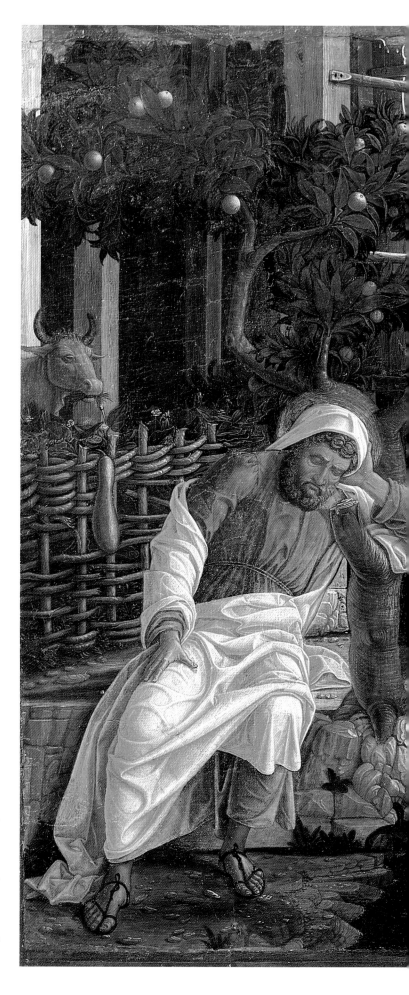

ANDREA MANTEGNA

The Adoration of the Shepherds

Andrea Mantegna was one of the great prodigies of Italian painting, establishing his reputation when he was barely twenty years old. *The Adoration of the Shepherds* is among his earliest works and may have been painted for the Este court in Ferrara, where Mantegna is known to have worked in 1449. The Estes were great patrons of Flemish painting, and it is likely that the detailed background of Mantegna's picture, with a minute representation of an angel announcing Christ's birth to a shepherd, and the rustic features of the two shepherds in the foreground derive from Mantegna's knowledge of Flemish pictures. The meticulous description of each surface and the delicately gold-highlighted faces of the cherubs are hallmarks of Mantegna's style.

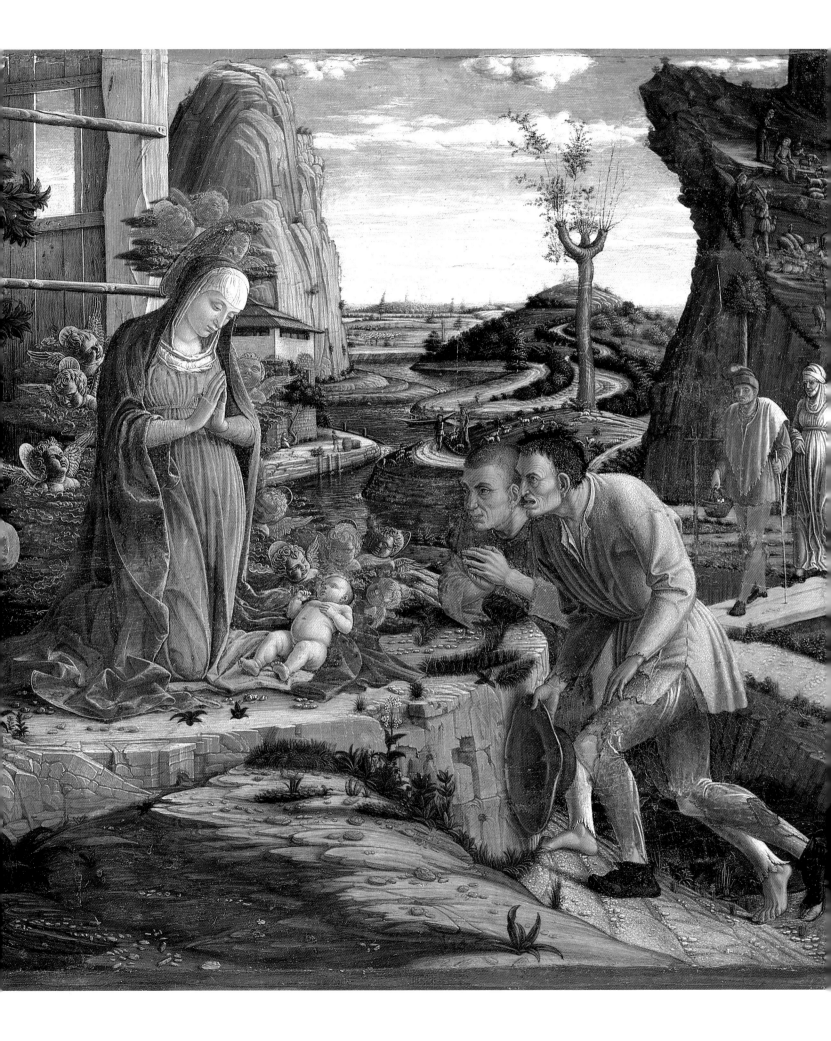

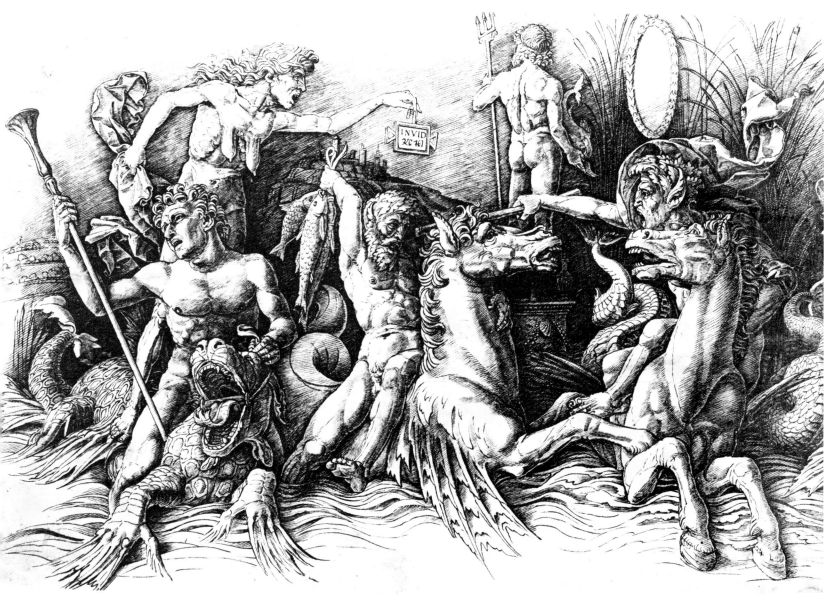

27 *Battle of the Sea Gods* (left),
ca. 1485–90
Andrea Mantegna
Padua, ca. 1430–d. 1506
Engraving; 11 x 16⅞ in.
(27.9 x 42.9 cm.)
Rogers Fund, 1918 (18.12)

ANDREA MANTEGNA
Battle of the Sea Gods

In addition to his accomplishments as a painter, Andrea Mantegna was influential in the early history of printmaking. He introduced painterly effects to the medium through the use of a penlike instrument known as a graver, which allowed for greater exactitude and the introduction of shadow effects.

Mantegna's preoccupation with classical archaeology and sculptural forms, manifest in his paintings, is perhaps even more evident in his engravings, where tones are monochro-

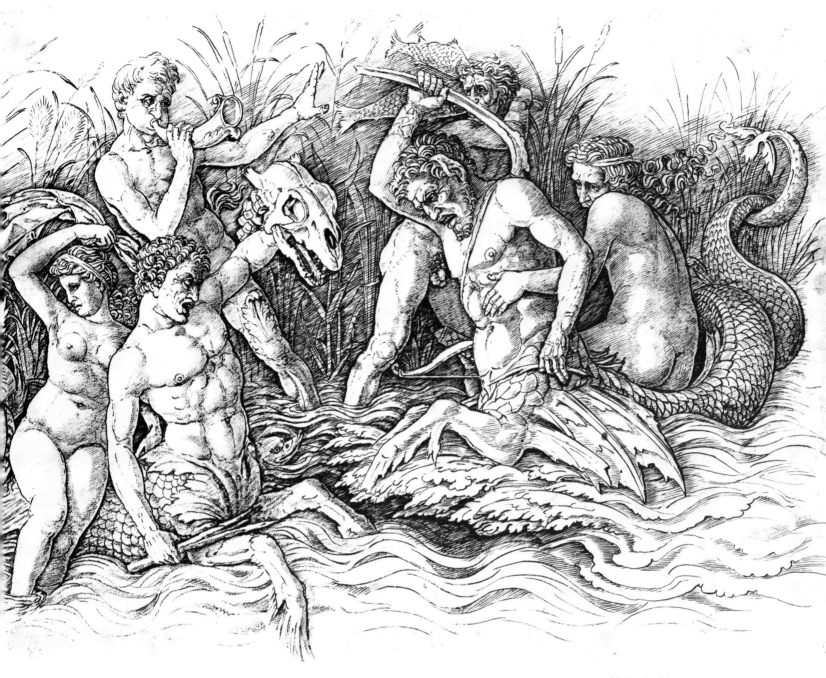

matic and contours are physically edged and defined. Mantegna was a contemporary of Antonio Pollaiuolo (see Plate 38), whom he must have met when he visited Florence in 1466. As Pollaiuolo's *Battle of the Naked Men* disseminated an anatomy lesson in the guise of a mythological battle scene, so Mantegna peoples a similar battle with the statuary of his beloved ancient world.

Men with the bodies of serpents engage in violent combat, wielding clubs and standards, with heroes astride elab-orately finned creatures of the sea. Curls and drapery both stand erect as if endowed with their own stony stiffness, and contours are outlined as if the figures were made of marble cracked with age. At the rear of the battle, with static, sculptured stance, a bearded Neptune presides. Hair bound in a fillet, dolphin and trident in hands, he stands atop a pedestal festooned with carved shells. Even the profiles and expressions are unmistakable as those that decorate surviving Roman sarcophagi.

CARLO CRIVELLI
Altarpiece

The three panels shown here formed part of one of Carlo Crivelli's elaborate polyptychs. The piece would have been arranged with the Madonna and Child enthroned, at center, flanked by many saints, of whom Saints George and Dominic are but two.

This is one of Crivelli's comparatively early works, and the figures demonstrate the characteristic aspects of his style: an elaborately tooled gold background, with bright colors, precious materials, and iconographic symbols; and a hyperrealistic delineation of form that allows veins to bulge in three-dimensional reality.

Saint George stands victorious on tapered Gothic feet above the carcass of an elaborately imagined dragon. Saint Dominic wears the habit of his order and holds a lily, symbol of purity, in his right hand and a breviary in his left. The Madonna, seated on a marble throne, clutches a Christ Child who runs across her lap, perhaps in pursuit of a bird (symbol of His passion) contained in a lateral panel.

CARLO CRIVELLI
Pietà

A picture of intense expressive power, this Pietà seems to have been painted by Crivelli in 1476 as the crowning element for a large Gothic altarpiece. The other panels, formerly in the church of San Domenico in the Marchigian town of Ascoli Piceno, are now in the National Gallery, London. Although by this date such Gothic polyptychs were no longer in vogue in Florence, they were still produced in Venice, and in provincial regions such as the Marches, where Crivelli worked, they remained the norm. Crivelli made a virtue of this retardataire form, playing off the sharp, angular contours of his figures against a patterned gold background. For all that, his picture is decisively realistic. He has not shied from the graphic description of the wounds of Christ or the anguish of the attendant figures, who are arranged to echo the arched shape of the panel. It is indicative of his realistic intention that the left hand of Christ obtrudes illusionistically over the edge of the marble sarcophagus into the viewer's space.

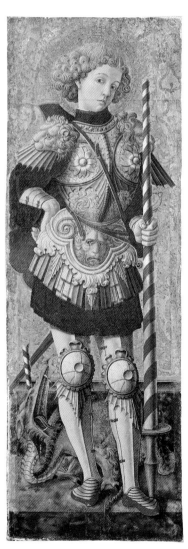

29 Saint George, ca. 1472
Carlo Crivelli
Venice, act. by 1457–d. 1495
Tempera on wood, tooled gold ground;
38 x 13¼ in. (96.5 x 33.7 cm.)
Rogers Fund, 1905 (05.41.2)

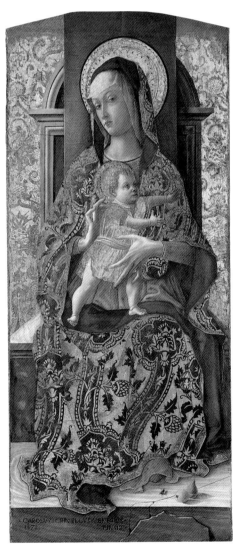

30 Madonna and Child, ca. 1472
Carlo Crivelli
Venice, act. by 1457–d. 1495
Tempera on wood, tooled gold ground;
painted surface 38¾ x 17¼ in.
(98.4 x 43.8 cm.) The Jack and Belle Linsky
Collection, 1982 (1982.60.5)

31 Saint Dominic, ca. 1472
Carlo Crivelli
Venice, act. by 1457–d. 1495
Tempera on wood, tooled gold ground;
38¼ x 12¾ in. (97.2 x 32.4 cm.)
Rogers Fund, 1905 (05.41.1)

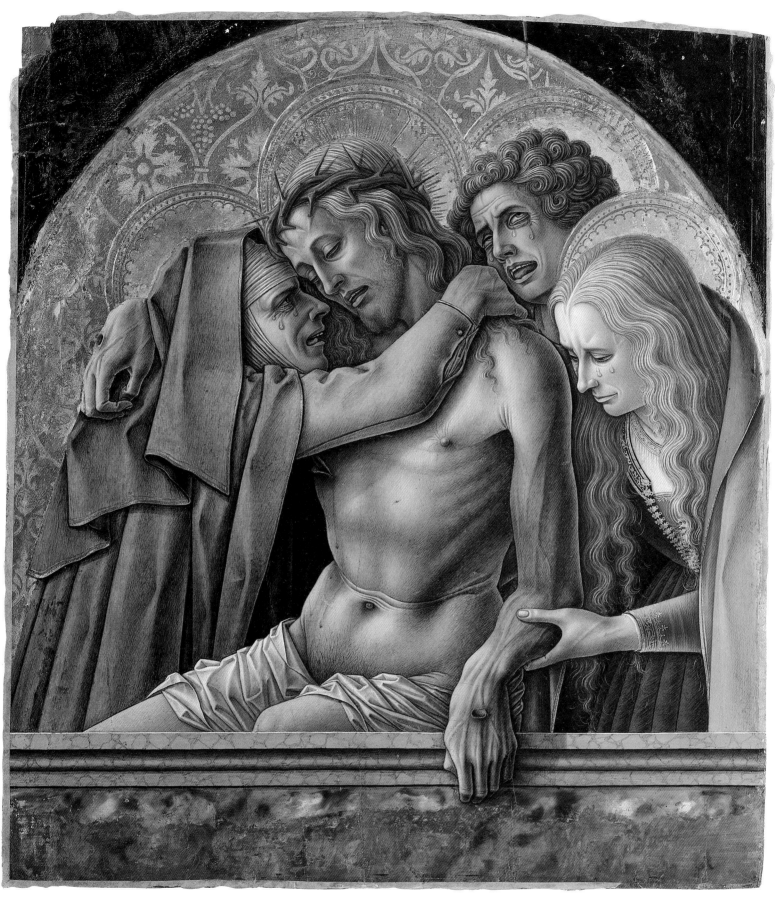

32 Pietà, 1476
Carlo Crivelli
Venice, act. by 1457–d. 1495
Tempera on wood, tooled gold ground;
overall 28¼ x 25⅜ in. (71.7 x 64.5 cm.)
John Stewart Kennedy Fund, 1913 (13.178)

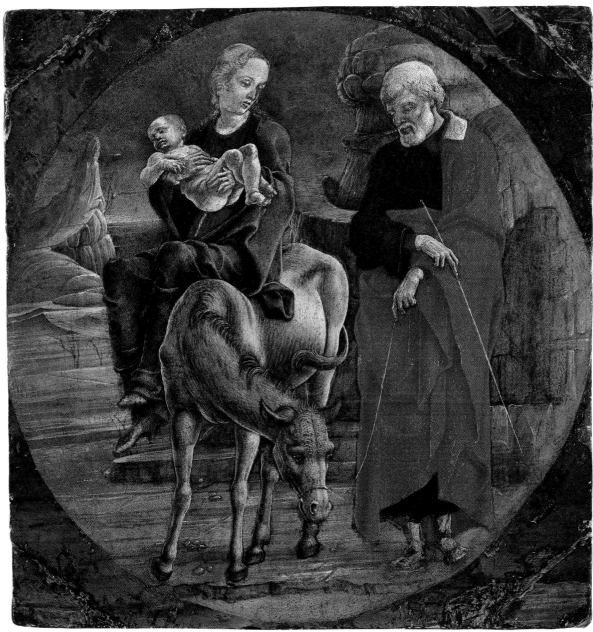

33 *The Flight into Egypt*, ca. 1474
Cosimo Tura
Ferrara, act. by 1451–d. 1495
Tempera on wood; painted surface
15¼ x 15 in. (38.7 x 38.1 cm.)
The Jules Bache Collection, 1949
(49.7.17)

34 *Portrait of a Ferrarese Nobleman*
Cosimo Tura
Ferrara, act. by 1451–d. 1495
Tempera on wood; painted surface
10¾ x 5⅝ in. (27.3 x 14.3 cm.)
Bequest of Benjamin Altman, 1913
(14.40.649)

COSIMO TURA

Like Mantegna and Crivelli, Cosimo Tura was trained in Padua, and like them, he derived from this experience a remarkable technical facility and a highly evolved decorative instinct. These traits made him eminently suited to his varied tasks in Ferrara, where he was employed as court artist beginning in 1451. Little of his work for the Este court has survived, and today Tura is primarily known through fragments from altarpieces. *The Flight into Egypt*, one of three tondos by Tura dealing with the infancy of Christ, seems to have formed the predella of one such altarpiece: It has been identified as part of the great Roverella altarpiece painted for the church of San Giorgio fuori le Mura, Ferrara, in the 1470s. One beautiful aspect of this picture is the poignant

contrast established between the magical pink sky and the nightmarish rock formations on the one hand, and the isolated figures and their spindly limbed donkey in the foreground on the other.

The *Portrait of a Ferrarese Nobleman* may show a member of the Este family—his features resemble somewhat those of Ercole d'Este. Although the picture has frequently been considered to be Tura's only extant independent portrait, it is almost certainly a fragment from an altarpiece. The original panel, closely circumscribing the sitter's features, has been enlarged to create the curiously elongated format. The painting remains, nonetheless, one of Tura's most beautiful achievements in portraiture.

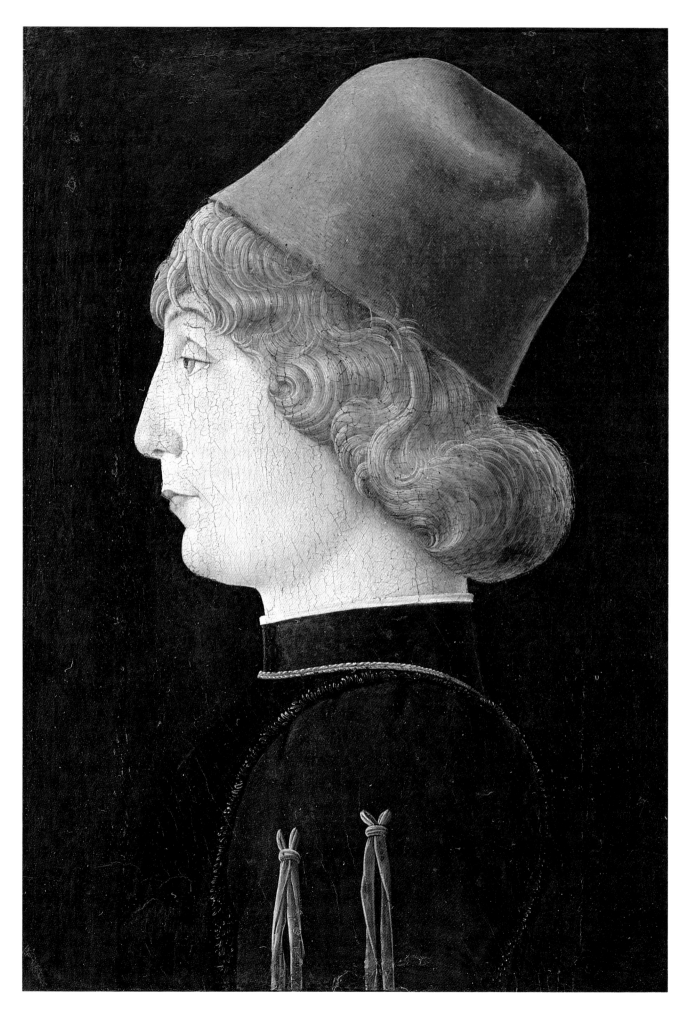

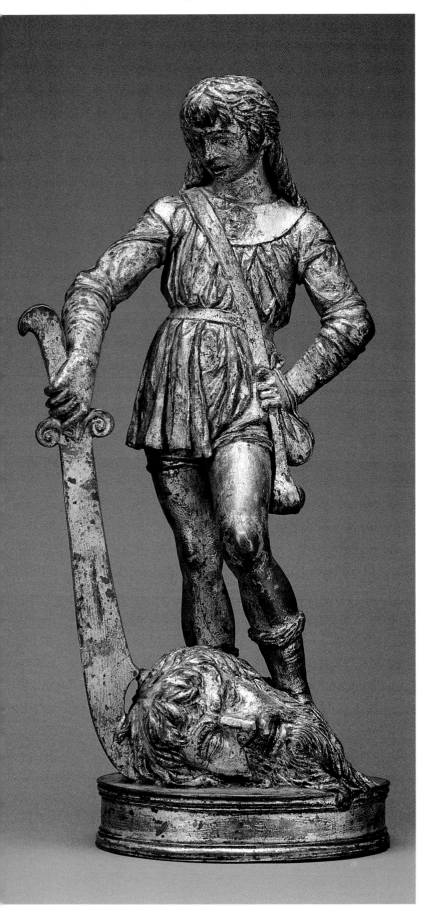

BARTOLOMMEO BELLANO
David with the Head of Goliath

The young hero stands triumphantly over the head of the vanquished Goliath. He wears a tunic belted at the waist, and over his shoulder is slung the satchel in which he placed the stones with which he slew the giant. His pose, known as *contrapposto*, with limbs artfully flexed in interlocking triangles, is reminiscent of Donatello's nude bronze *David* in the Bargello, Florence. The son of a Paduan goldsmith, Bellano is recorded as having worked for Donatello in Florence in 1456, but this statuette has much more in common with the animated narrative reliefs he made in Padua in the 1470s and 80s.

ANTONELLO DA MESSINA
Portrait of a Young Man

The son of a stonecutter in Messina, Sicily, Antonello da Messina was a student of Colantonio at the court of Alfonso in Naples, where he was able to study works by Flemish artists. His portraits, which were invariably shown bust length, in three-quarter view, against a dark ground illuminated from the left, are clearly indebted to Flemish models. Antonello also adopted the northern European technique of oil painting, which enabled him to make a subtle transcription of his sitter's features.

In this portrait of a youth with red hair, which dates from about 1470, the sitter stares candidly at the viewer. Despite considerable damage, this picture displays a sensitivity to the sitter's character that marks the best of Antonello's early work.

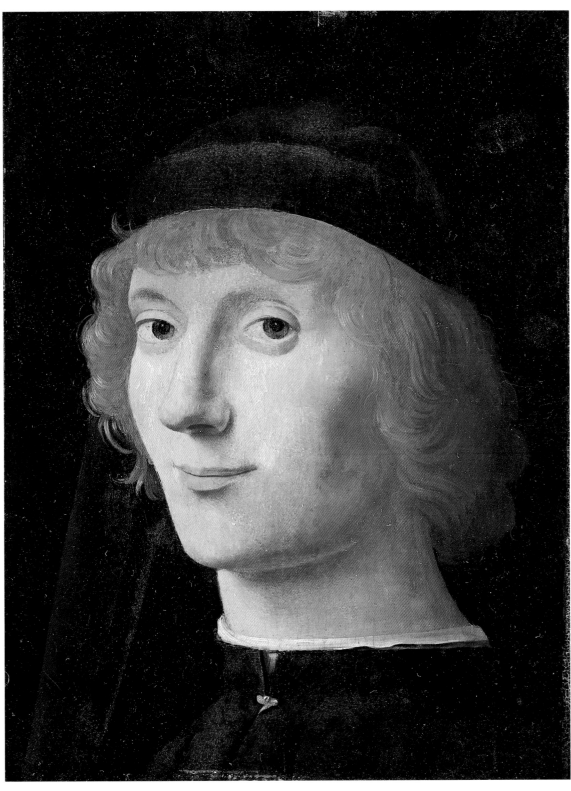

36 *Portrait of a Young Man*, ca. 1470
Antonello da Messina
(Antonello di Giovanni d'Antonio)
Sicily, 1430–79
Oil on wood; 10⅝ x 8⅛ in.
(27 x 20.6 cm.)
Bequest of Benjamin Altman, 1913
(14.40.645)

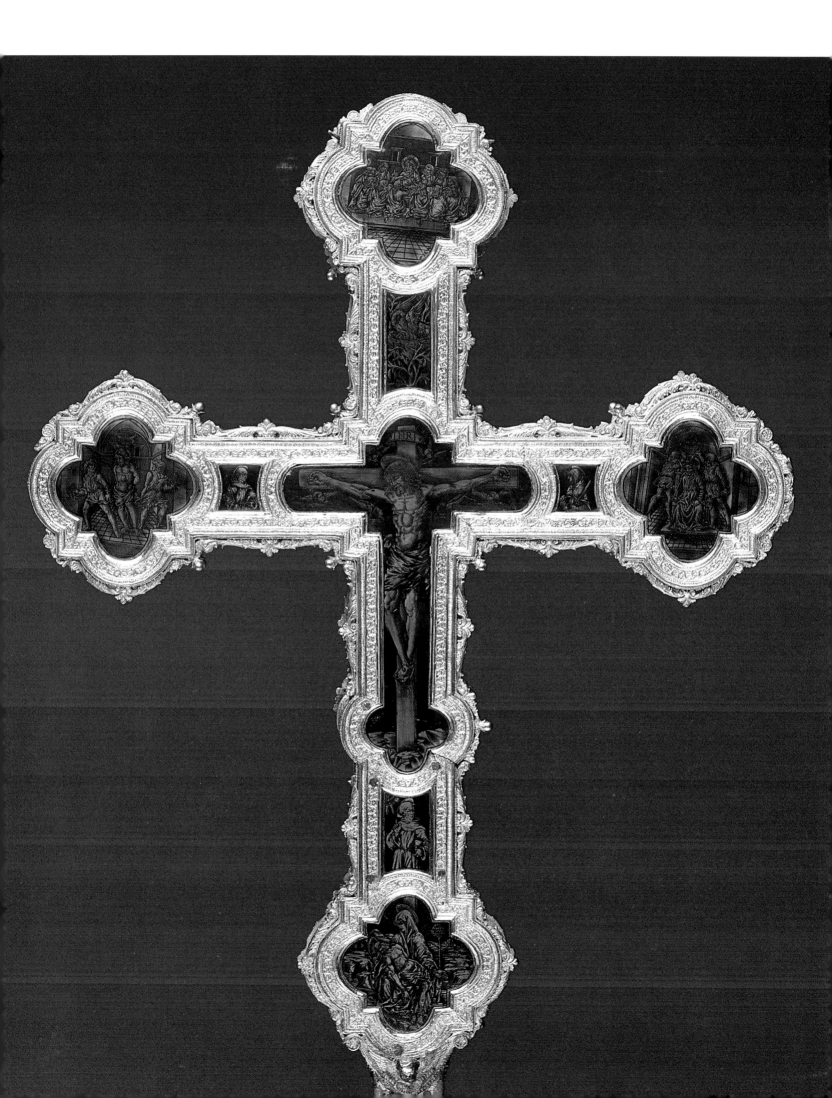

Processional Cross

An inscription on the stem of this cross states that it was made for the convent of Santa Chiara—probably the one in Florence. The fact that both the front and back are fully decorated indicates that it was made for use during processions. The cross, which is an exceptional example of Florentine Renaissance metalwork, incorporates within its silver-gilt frame twenty plaques representing scenes from Christ's Passion and various saints. The central portion of the front of the cross originally bore a three-dimensional figure of the crucified Christ. Above this central area is a reliquary window that once contained a fragment of the True Cross. The side shown is the back, with its eloquent representation of the crucified Christ in the large central plaque.

All the plaques were executed in niello, a technique that reached its technical and aesthetic heights in Florence dur-ing the Renaissance. Niello was produced by engraving on a silver plate and filling in the engraved lines with a black enamellike substance, a mixture of powdered silver, copper, lead, and sulfur, to which borax was often added. The niello was applied in its powdery form and secured by the application of heat. The surface was then burnished, and the design's black outlines stood out against the silver background.

In Florence, niello work was carried on as a collaborative effort, involving both designer and engraver. This cross is the work of artisans of the generation of Antonio Pollaiuolo and Maso Finiguerra. Niello work never regained the expressiveness achieved during this period: Cellini wrote that when he was a young man learning to make nielli, "a few old men still living did nothing but talk of the great masters who had wrought it, and above all of Finiguerra."

37 Processional Cross
Florence, 1460–80
Silver gilt, nielloed silver;
21¾ x 12¾ in. (55.2 x 32.4 cm.)
Gift of J. Pierpont Morgan,
1917 (17.190.499)

Below: detail

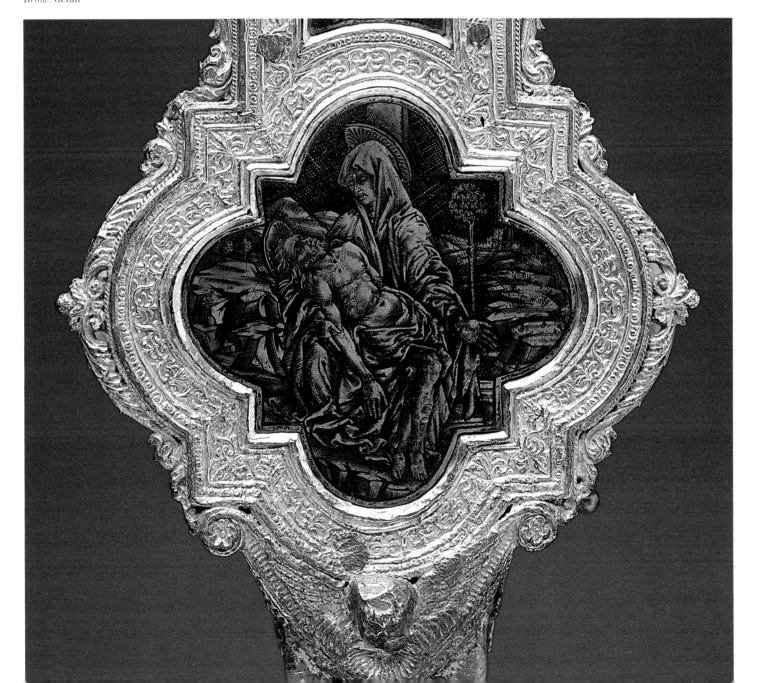

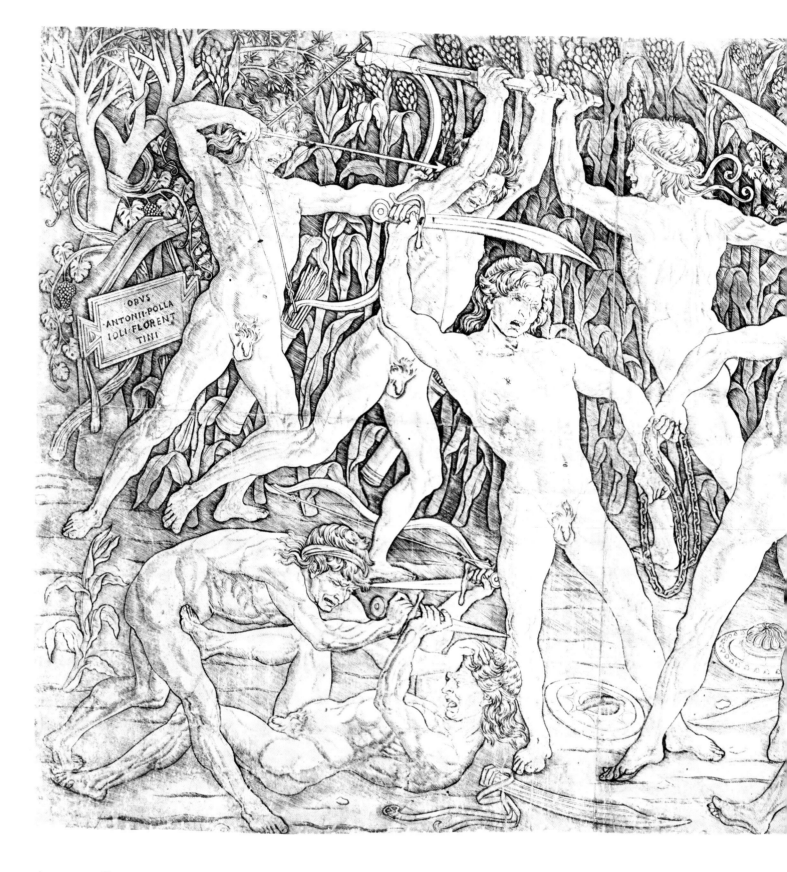

Antonio Pollaiuolo
Battle of the Naked Men

Antonio's obsession with anatomy is expressed to the point of caricature in his print of the *Battle of the Naked Men*, which is thought to represent Titus Manlius Torquatus battling a Gaul for his torque, the gold collar that marked him as a chieftain. The print is a thorough study in the structure of the human anatomy; each of the figures is one of a mirrored pair, approximating the reverse of any given position. Antonio was so conscientious that he showed the muscles and tendons of the body as if they were all flexed at once. Leonardo ridiculed him for producing "sacks of nuts," and Vasari says he was the first artist to flay cadavers in order to paint and model the bones and muscles.

The arrangement of the figures in a series of overlapping registers against a dense thicket of grape vines and sorghum suggests the reliefs of Roman sarcophagi, which may have been a source of inspiration.

38 *Battle of the Naked Men*, late 1460s
Antonio Pollaiuolo
Florence, 1429–98
Engraving; 15⅝ x 23¼ in.
(39.7 x 59.1 cm.) Purchase,
Joseph Pulitzer Bequest, 1917 (17.50.99)

OVERLEAF:

MASTER OF THE BARBERINI PANELS *(Pages 60–61)*
The Birth of the Virgin

Within the ground-floor room of an elegant Renaissance palace—the central arch of which is open to permit an interior view—is shown the birth of the Virgin. The child's mother, Saint Anne, reclines on a bed, waited on by a number of servants, while other maids or nurses bathe the newborn infant in an adjacent area. Outside, in front of the palace, well-wishers gather and greet one another while below the portico, to the side, a hunter returns with a rabbit.

To a degree that is almost without parallel in fifteenth-century painting, the author of this picture has envisaged the religious event in terms of daily life. Were it not for the fact that the baby has a halo, there would, indeed, be grounds for doubting the subject of the painting. However, a companion panel in the Boston Museum of Fine Arts, showing the Presentation of the Virgin in the Temple, makes the subject of the Metropolitan's picture almost certain.

Until 1934, both the Metropolitan and the Boston panels were in the Barberini collection in Rome, where they were described in seventeenth-century inventories as the work of Fra Carnevale. A Marchigian painter-priest, Carnevale was trained in the workshop of Fra Filippo Lippi in Florence but worked primarily at the court of Urbino. Fra Carnevale's most important documented commission was for an altarpiece to decorate the church of Santa Maria della Bella in Urbino, which he painted in 1467. Though there is good reason to believe that the Metropolitan and Boston paintings formed part of that work, the identity of both author and altarpiece has been questioned. The author of the two pictures is therefore known as the Master of the Barberini Panels, after the collection from which they come.

There can be little doubt that the principal influence on these pictures is that of the great Renaissance theorist and architect Leon Battista Alberti. Alberti was a visitor at the court of Urbino, and his treatise on architecture was influential in the conception of the ducal palace there. The author of the Metropolitan's panel has borrowed a number of architectural details from the ducal palace, and from Alberti's treatise he has conceived the notion of decorating the exterior of his building with reliefs *all'antica*—in the classical manner—showing the drunken Bacchus, the infant Bacchus and Silenus, and a Nereid on a Triton's back.

The *Battle of the Naked Men* is important and revolutionary for a number of reasons. The only print ever to be signed by a great Florentine artist, it represents a key transition in the technique of engraving from pen or silverpoint drawing to specific engraving techniques. Furthermore, it is the only known print by Pollaiuolo, it is perhaps the finest anatomical study of the fifteenth century, and it is the first print that can be regarded as a major work of art.

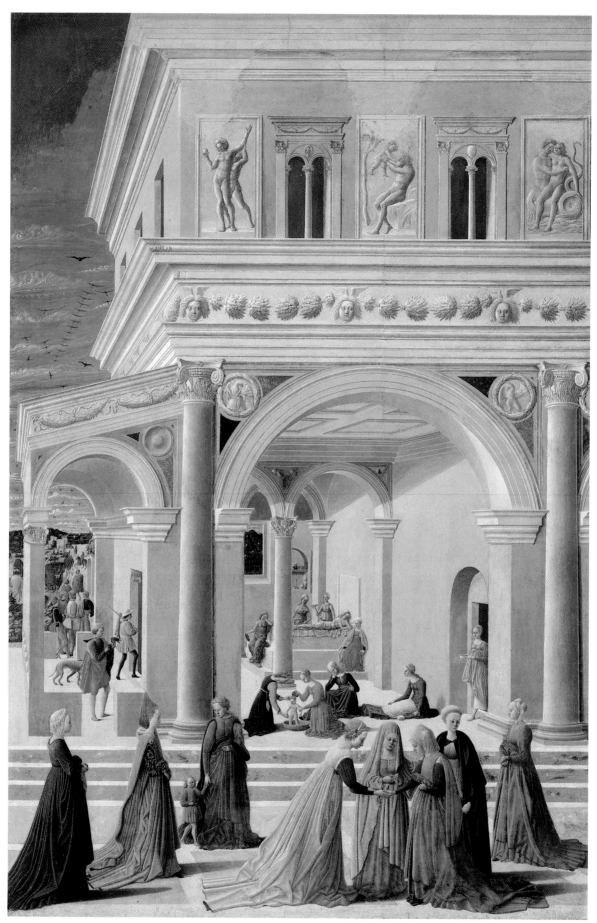

39 *The Birth of the Virgin*
Master of the Barberini Panels
(Giovanni Angelo di Antonio?)
School of the Marches, 1447–75
Tempera and oil on wood;
57 x 37⅞ in. (144.8 x 96.2 cm.)
Rogers and Gwynne Andrews
Funds, 1935 (35.121)

Opposite: detail

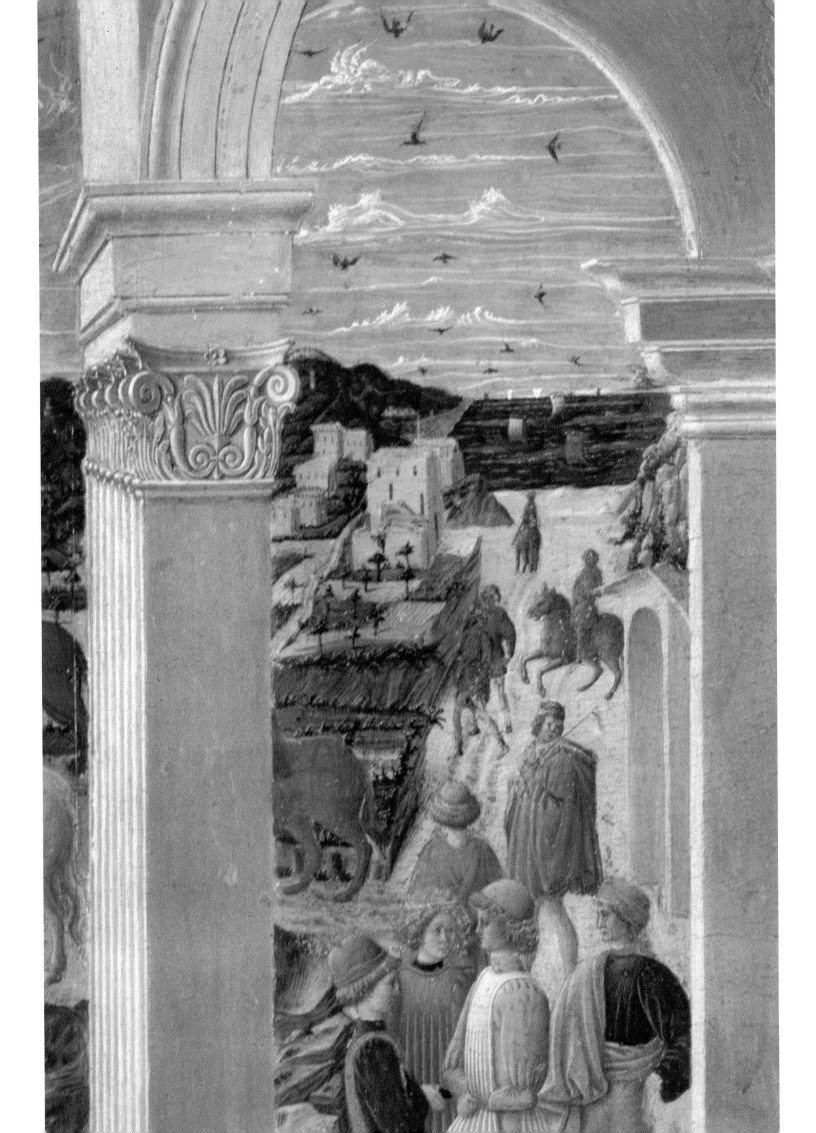

40 A Kneeling Humanist Presented by Two Muses
Francesco di Giorgio
(Francesco Maurizio di Giorgio
di Martino Pollaiuolo)
Siena, 1439–1502
Pen and brown ink with brown wash
and blue gouache on vellum;
7¼ x 7⅝ in. (18.4 x 19.4 cm.)
Robert Lehman Collection, 1975
(1975.1.376)

*41 Study from the Palace of Federigo
da Montefeltro at Gubbio*
Italian, ca. 1476–80
Intarsia of walnut, beech, rosewood,
oak, and fruitwoods on walnut base
Rogers Fund, 1939 (39.153)

FRANCESCO DI GIORGIO

A Kneeling Humanist Presented by Two Muses

Francesco di Giorgio was an artist who, like Alberti before him and Michelangelo after, embodied the title "Renaissance man." Born in Siena in 1439, Francesco was a painter, sculptor, architect, and military engineer. Both his buildings and theoretical treatises were seminal to developments in High Renaissance architecture.

This small drawing is an example of Francesco's talents as a draftsman. It shows a kneeling figure presented by two Muses. The figures are encased in an architectural roundel with a coffered ceiling decorated with rosettes. This composition, unusual for this period, was probably an innovation stimulated by Francesco's contact with the scholars and poets at the court of the legendary Federigo da Montefeltro at Urbino, where he began work in 1477. It has been suggested that the Muses represent the two directions of poetry according to Aristotle's poetics: The one on the left, who wears a garland in her hair, represents high poetry, and the other one, low.

STUDY FROM THE PALACE AT GUBBIO

This detail of a wall is from the *studiolo*, a small room intended for meditation or study, in the palace of Duke Federigo da Montefeltro at Gubbio. The walls of the chamber were decorated with small pieces of wood of various sorts, inlaid in patterns—a technique known as intarsia. Here the designs produce trompe-l'oeil effects. Doors of cabinets appear ajar, seats "project"—their supports throwing shadows—books lie open in the cupboards, and a faceted *mazzochio*—a support for a turbanlike male headdress—lies on the bench.

The duke, a military leader of distinction, was also a dedicated humanist. The objects represented here attest to his wide-ranging interests: musical and scientific instruments, elements of armor, writing implements, and books, which recall the fact that, during his lifetime, Federigo assembled a library of manuscripts that surpassed those of most European universities. *Imprese*, or emblems, of the duke and his wife, Battista Sforza, are also represented. The probable designer of the Gubbio room was Francesco di Giorgio (see Plate 40); the intarsia panels were executed by Baccio Pontelli (ca. 1450–92) and assistants.

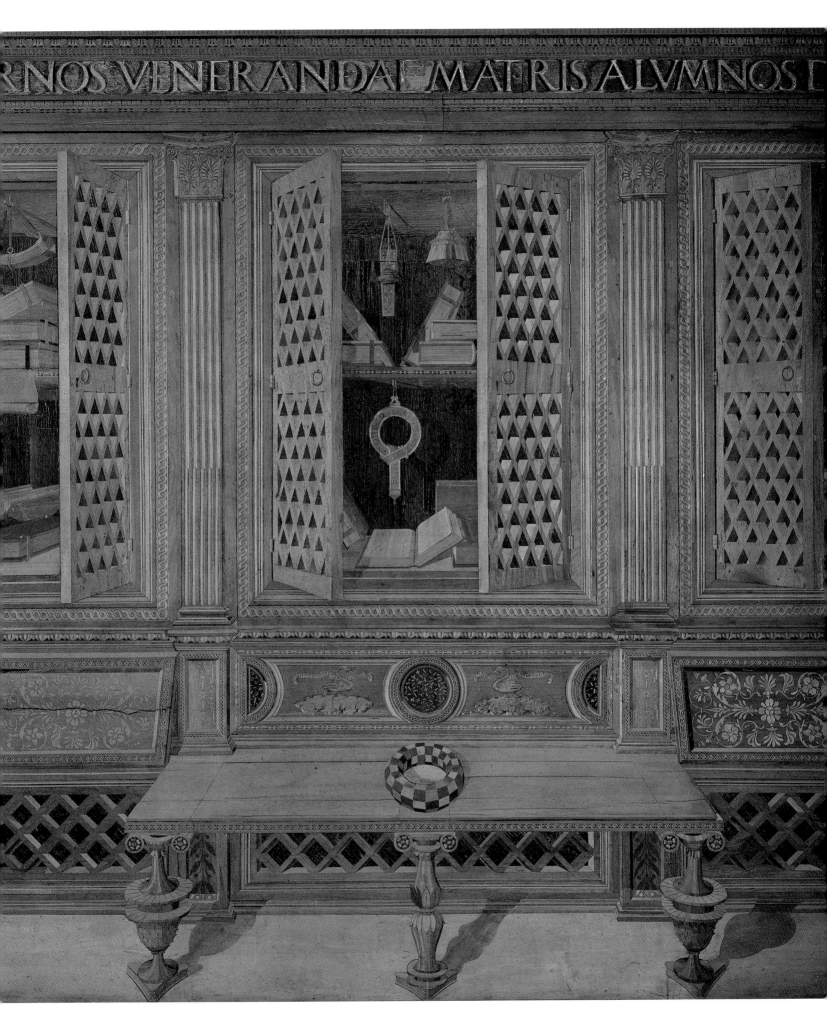

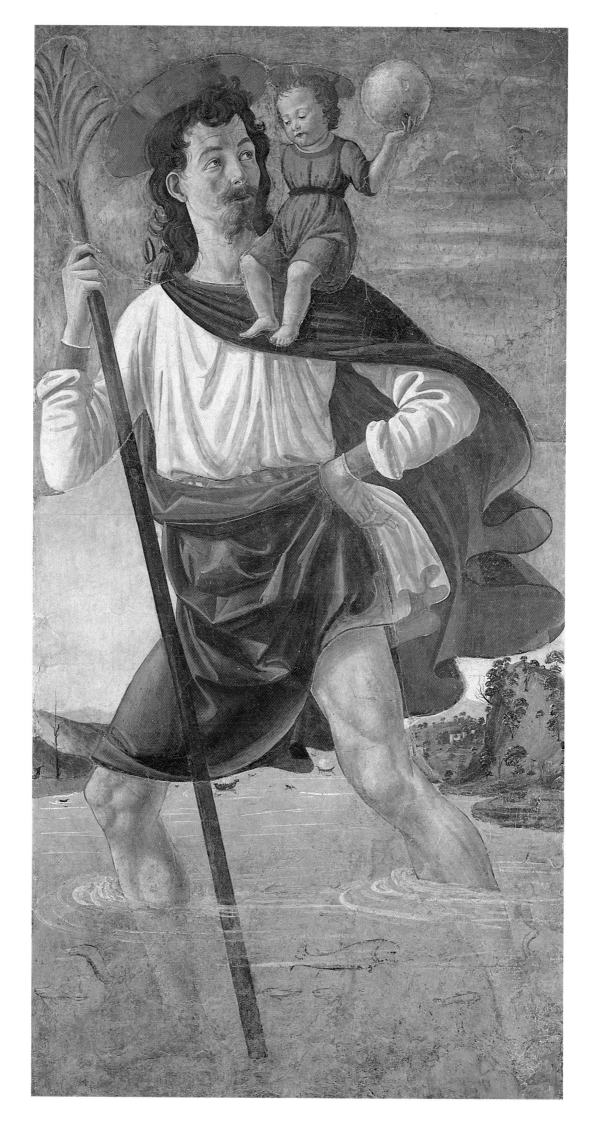

64

DOMENICO GHIRLANDAIO
Saint Christopher and the Infant Christ

Saint Christopher and the Infant Christ has only recently been identified as a work by Domenico Ghirlandaio, having previously been thought to be by Antonio Pollaiuolo. In his life of Pollaiuolo, published in 1568, Vasari mentions a fresco of Saint Christopher on the facade of the San Miniato fra le Torri outside Florence, and the Museum's work has sometimes been associated with this reference. However, the Pollaiuolo fresco was nearly twice as large, and since the practice of decorating the porch of a church or chapel with such a subject was a common one, this fresco may originally have come from some other church in the area.

The word *fresco* (fresh) derives from the condition of a newly plastered wall, onto which pigments mixed with water were applied directly by the artist. As the plaster set, a chemical reaction locked the pigment in and created a remarkably durable image. Details added to the works after the plaster had dried (known as *secco* work) sometimes become brittle over the years and flake away.

Ghirlandaio was one of the most meticulous craftsmen of his day, and his use of a solidly grounded fresco technique accounts in large part for the splendid preservation of this work (except in the lower fifth, where there are signs of damage due, probably, to water infiltration). Even those details and highlights added after the plaster was dry are exceptionally well preserved.

The subject of this early work by Ghirlandaio, which can be dated to the 1470s, refers to the legend wherein Saint Christopher, faithfully accomplishing his Christian duty as a ferryman for the poor and weak, carried the infant Christ, and with him the weight of the world, across the river. This deed earned him the role of patron saint of travelers.

42 *Saint Christopher and the Infant Christ*, ca. 1475
Domenico Ghirlandaio (Domenico di Tommaso
Curradi di Doffo Bigordi)
Florence, ca. 1449–94
Fresco; 112 x 59 in. (284.4 x 149.9 cm.)
Gift of Cornelius Vanderbilt, 1880 (80.3.674)

DOMENICO GHIRLANDAIO
Portrait of a Lady

In the third quarter of the fifteenth century, Domenico Ghirlandaio headed one of the best organized and busiest workshops in Florence, and some of the same people who looked to him to decorate the interior of the family chapel with large narrative frescoes also sat for portraits by him, confident of the results they would obtain.

The sitter in this portrait bears a strong resemblance to a female bystander in the fresco *Saint Francis Raising the Dead Child*, painted by Ghirlandaio for the Sassetti family in the church of Santa Trinità, Florence. Since Ghirlandaio frequently included his benefactors and their families in his religious scenes, this leads to the supposition that she was a member of the Sassetti family, possibly a daughter of Francesco, a business adviser to the Medicis.

43 *Portrait of a Lady*, 1483–85
Domenico Ghirlandaio (Domenico di
Tommaso Curradi di Doffo Bigordi)
Florence, ca. 1449–94
Tempera on wood; 22½ x 17⅜ in.
(57.1 x 44.1 cm.)
The Friedsam Collection. Bequest of
Michael Friedsam, 1931 (32.100.71)

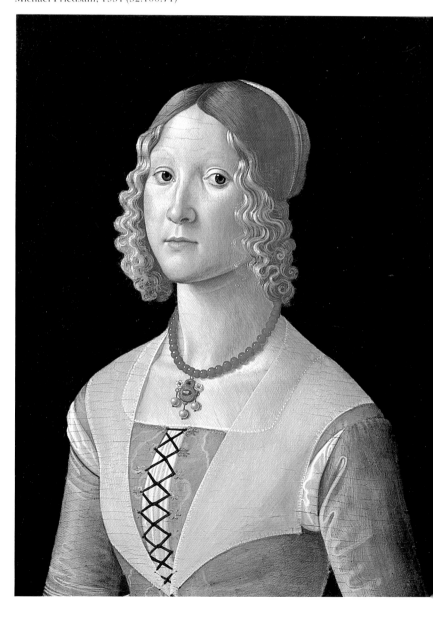

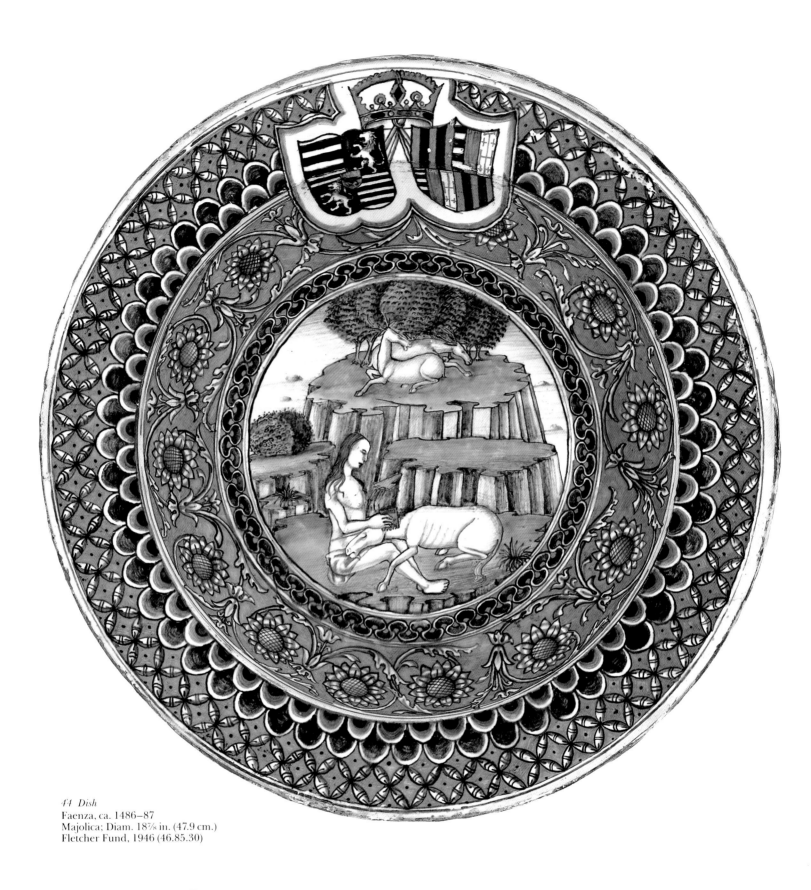

44 Dish
Faenza, ca. 1486–87
Majolica; Diam. 18⅞ in. (47.9 cm.)
Fletcher Fund, 1946 (46.85.30)

ITALIAN MAJOLICA DISH

At the top of this dish are the arms of Matthias Corvinus, king of Hungary from 1458 to 1490, and his wife, Beatrice of Aragon. It formed part of a service of Italian majolica sent to Beatrice by her sister Eleonora, duchess of Ferrara. The dish, which was painted by an anonymous master in Faenza in 1486 or 1487, represents the height of technical and aesthetic achievements in majolica at that time. The blues, browns, greens, and aubergine typical of majolica are har-

moniously combined in four decorative bands surrounding the central scene, a lady combing the mane of a unicorn.

This dish is evidence of the receptivity of the Hungarian court under King Matthias to the ideas of the Italian Renaissance. Matthias encouraged art, science, and literature, and in his lifetime helped bring the Kingdom of Hungary close to the forefront of European cultural and intellectual development.

Spanish Apothecary Jar

This Spanish *albarello*, or apothecary jar, is an example of lusterware, a type of pottery that simulated the sheen of precious metals by means of a special glazing technique. Lusterware was originally imported to Spain from the Muslim East, where it was developed as early as the eighth century. Eventually, it was produced in Spain, where the potters of Valencia—where this *albarello* was made—became especially well known (one was even mentioned in the fourteenth-century inventories of the duc de Berry).

Albarellos were used to store spices, herbs, and medicine. Although some of them had ceramic tops, most were sealed with tightly fitting parchment or muslin. The cylindrical, slightly concave shape of this vessel—with its slanting collar and narrower neck, and its slanting base—is typical of Valencian *albarellos*. Decorated with a delicate design of bryony leaves and acacia blossoms, it is a particularly fine example of the type.

45 *Albarello*
Valencia, 15th c.
Earthenware, tin-enameled;
H. 11⅛ in. (28.3 cm.)
The Cloisters Collection,
1956 (56.171.91)

OVERLEAF:

Birth of the Virgin *(Pages 68–69)*

Ecclesiastical embroidery was a particularly important art form during the Middle Ages and the Renaissance. Well-known artists were sometimes commissioned to design embroideries for vestments and altar frontals; these designs were then worked by anonymous artisans. The primary subject matter of these embroideries was frequently narrative, depicting scenes from the lives of major religious figures such as Christ, the Virgin, and Saint John the Baptist.

The setting for this *Birth of the Virgin* is a realistically rendered interior replete with details of daily life in fifteenth-century Italy. The perspective and the emphasis on architectural elements relate this composition to paintings of the period. Although the designer is not known, the figure style is close to that of Francesco del Cossa, a fifteenth-century Ferrarese painter.

The embroidery techniques used to create this panel include finely worked *or nué*—in which metallic threads are laid down and worked over in silk, allowing gleaming specks to show through as highlights—and split stitch, which is especially visible in the women's hair and clothing.

46 Birth of the Virgin
Italy, last quarter of 15th c.
Silk and metallic threads on canvas;
12¾ x 19½ in. (32.4 x 49.5 cm.)
Gift of Irwin Untermyer, 1964
(64.101.1381)

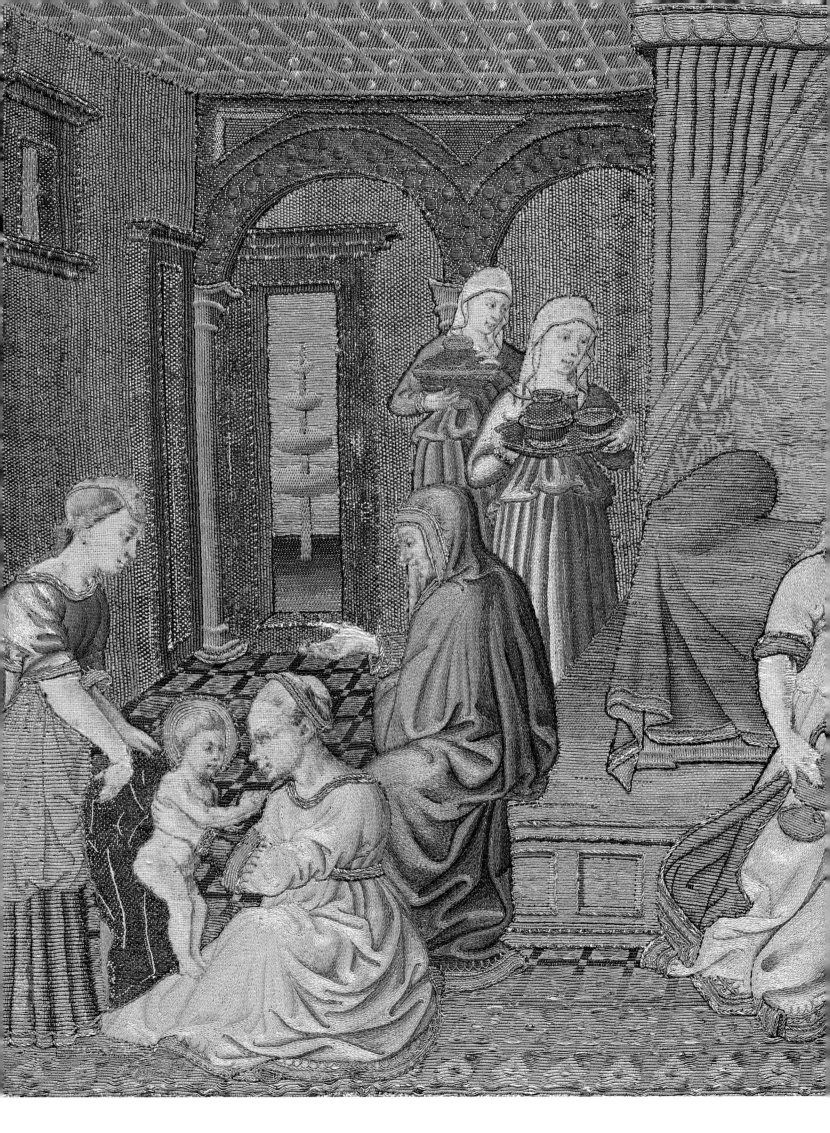

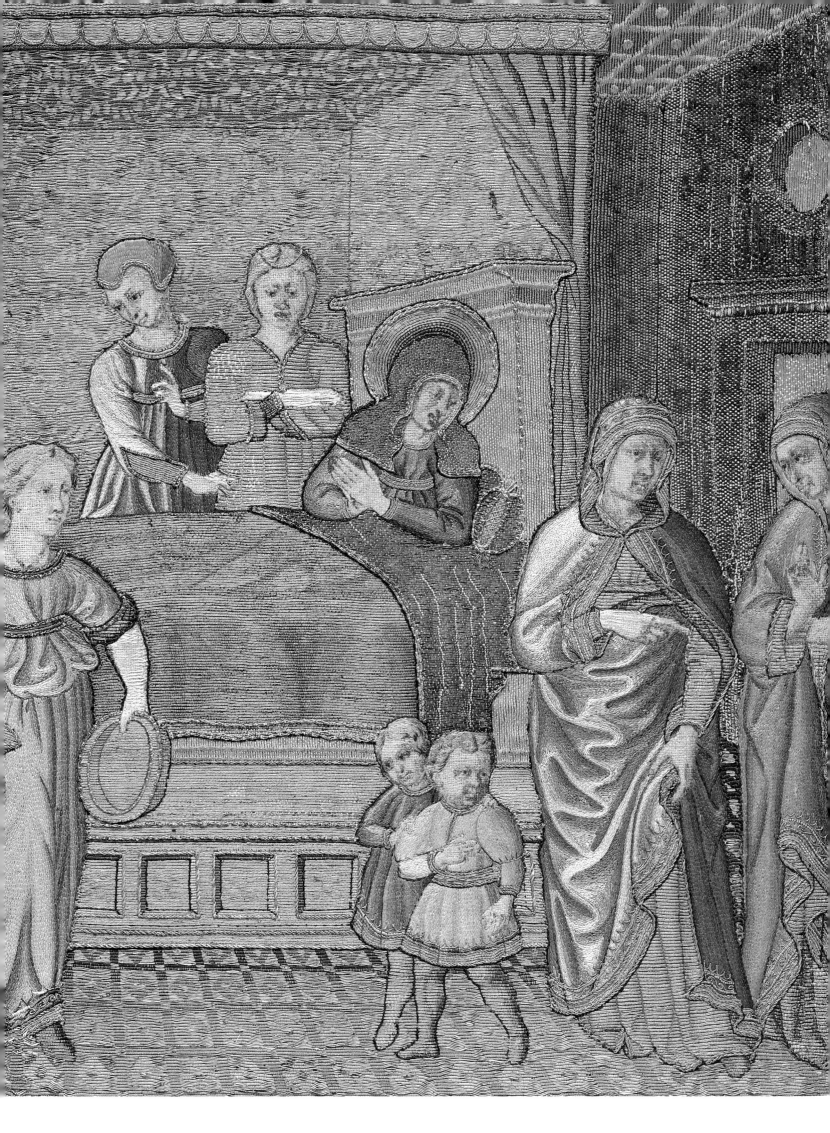

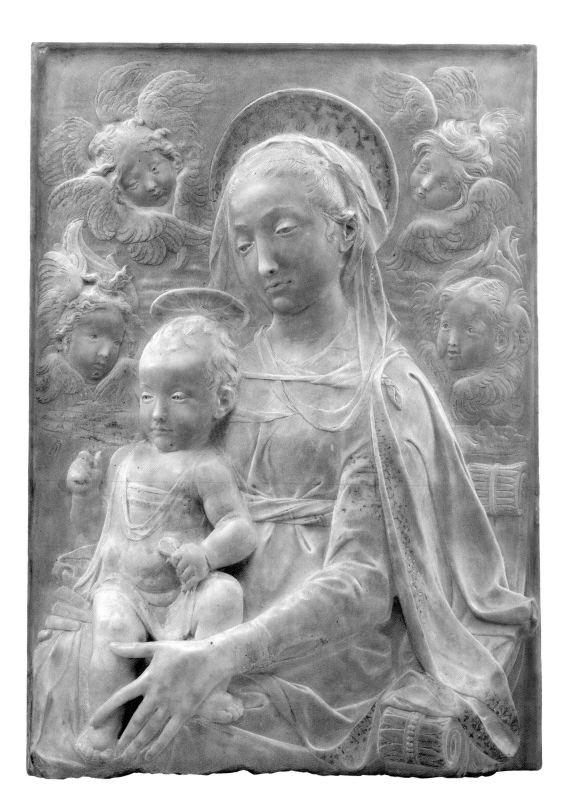

47 *Madonna and Child with Angels,*
ca. 1455–60
Antonio Rossellino
Florence, 1427–79
Marble with gilt details;
28¾ x 20¼ in. (73 x 51.4 cm.)
Bequest of Benjamin Altman, 1913
(14.40.675)

Antonio Rossellino
Madonna and Child with Angels

Antonio Rossellino was among the most gifted sculptors in the generation following Donatello and Luca della Robbia. His reliefs of the Madonna and Child are justly celebrated. This example, carved from mottled brown marble in about 1455–60, is particularly successful. The Virgin sits on an elaborate throne, whose scrolled armrests project in high relief. Both she and the Child in her arms seem strangely subdued, as if they both were transfixed by the preternatural vision of Christ's future Passion—a reflection that renders the protective, caressing gesture of her left hand all the more poignant.

The surface is richly contoured and decorated. Antonio's concern for finish extends to the background, which is enlivened by the heads and feathery wings of seraphim. With the ornamental attention typical of paintings of the period, the fringe of the Virgin's mantle, the halos, and strands of the hair of both Virgin and Child are delicately accented with touches of gilding.

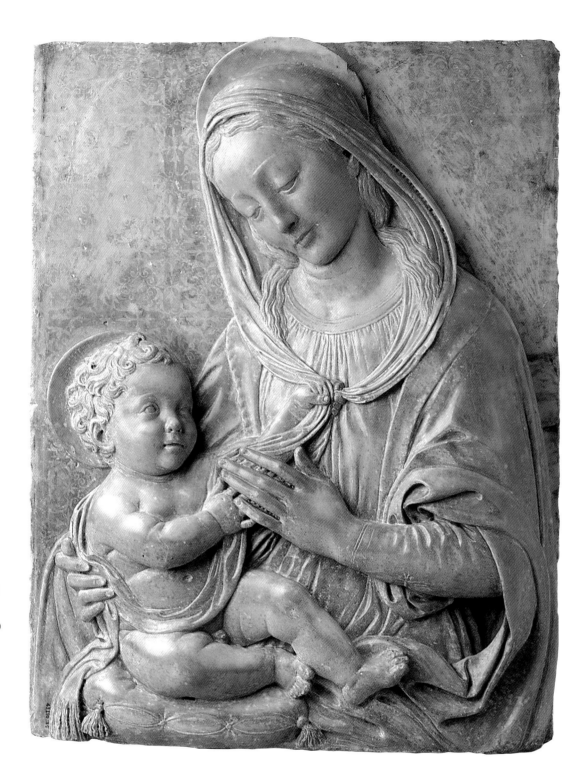

48 *Madonna and Child*, ca. 1494–95
Benedetto da Maiano
Florence, 1442–97
Marble; 31 x 22 in. (78.7 x 55.9 cm.)
Bequest of George Blumenthal,
1941 (41.190.137)

BENEDETTO DA MAIANO

Madonna and Child

Benedetto da Maiano, like Antonio Rossellino, was a distinguished master of marble carving, producing portrait busts and tomb decorations as well as independent Madonna reliefs. This is the most forward-looking of his Madonnas and is dated as late as 1494–95. Although the mottled, tawny marble is similar to that used by Rossellino (see Plate 47), it is instructive to compare the very great differences between the two compositions. In Benedetto's relief, the bonds of intimacy between mother and child are strengthened by the curvilinear arrangement of cloth and limbs; but in general, it is fair to say that Benedetto replaces concern for surface decoration with a more sweeping interest in volume—the bodily forms seem large by comparison. They originally stood out all the more by being stationed in front of a patterned background, whose traces are most visible near the child's head. The humanity and the voluminous effects in the art of Benedetto make him an anticipatory figure of vital importance for the development of the High Renaissance.

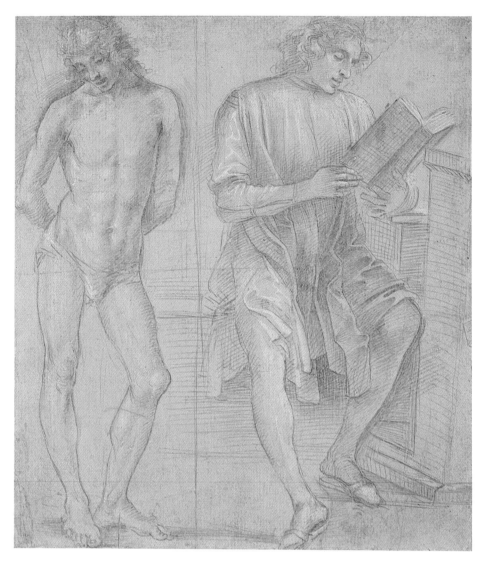

49 *Standing Youth with Hands Behind His Back, and a Seated Youth Reading*
Filippino Lippi
Florence, 1457/58–1504
Metalpoint, heightened with white, on pink prepared paper;
9¹¹⁄₁₆ x 8½ in. (24.5 x 21.6 cm.)
Harris Brisbane Dick Fund, 1936
(36.101.1)

Filippino Lippi
Standing Youth with Hands Behind His Back, and a Seated Youth Reading

This study, in which the figures were drawn from life in the artist's studio, represents one in a series of studio drawings of young models by Filippino Lippi. Although we cannot identify these figures with ones in any specific painting, they probably were done as studies for a larger composition; the pose of the standing youth leads us to believe that he is a study for a figure of Saint Sebastian. Filippino has outlined the figures and indicated their inner modeling with metalpoint. In this technique, which was widely used in the fifteenth and sixteenth centuries, the artist first coated the page with opaque white, to which was often added a pale tint of color—here it is pink. Then the drawing was done with a metal stylus, which produced an indelible line that would not smudge. Because metalpoint produces a permanent mark, the artist must mentally work out the composition carefully before committing line to paper. Filippino added white highlights to give the forms their final plasticity.

Antonio Pollaiuolo
Study for a Projected Equestrian Monument

Antonio Pollaiuolo was among the artists who dominated Florence during the third quarter of the fifteenth century. Trained as a goldsmith, Antonio was also a painter, sculptor, embroidery designer, engraver, and draftsman. He was fascinated by the human body and its motion in space, and was among the first artists to dissect it and attempt to understand its arrangement. It is in the realm of anatomical study that Antonio excelled.

This drawing was executed between 1480 and 1485, and presumably served as a study for an equestrian monument that Ludovico Sforza, duke of Milan, planned to erect in memory of his father, Francesco. This and a related study, now in the Graphische Sammlung in Munich, seem to be those once owned by Vasari and described in his *Lives* as having been found in Antonio's studio after his death.

Characteristic of Antonio's style is the evident fascination with the tensing muscles of horse and rider, the revolutionary manipulation of line to indicate motion, and the concern for the relationship between the figure and the space that surrounds it. Though Leonardo da Vinci offered an alternative design to Ludovico in 1483 and was awarded the commission, his clay model was destroyed during the French occupation of Milan in 1499, and no bronze was cast.

50 *Study for a Projected Equestrian*
Monument to Francesco Sforza, 1480–85
Antonio Pollaiuolo
Florence, 1429–98
Pen and brown ink with light brown wash
on paper; 11¾₆ x 9⅝ in. (28.5 x 24.4 cm.)
Robert Lehman Collection, 1975
(1975.1.410)

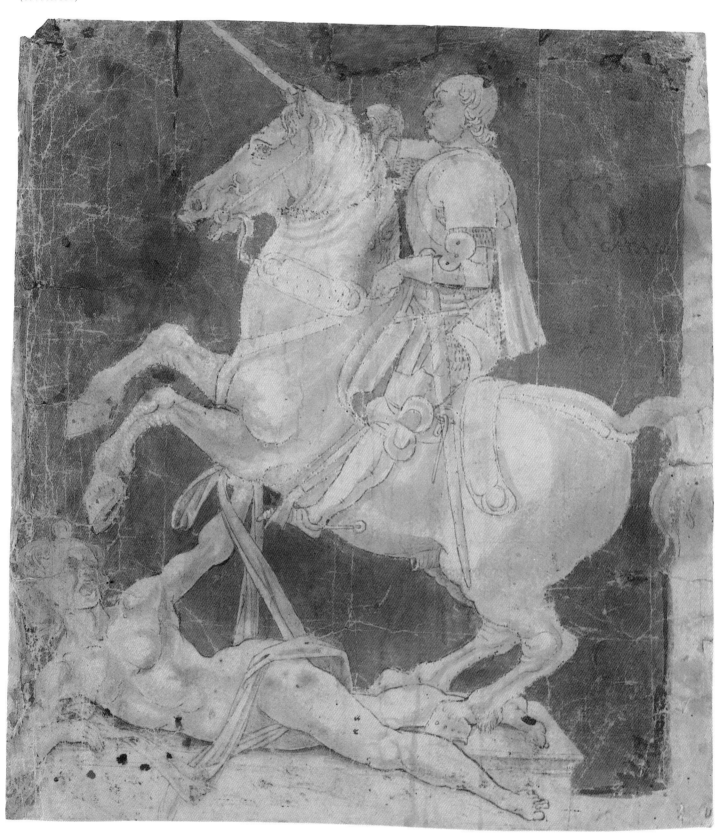

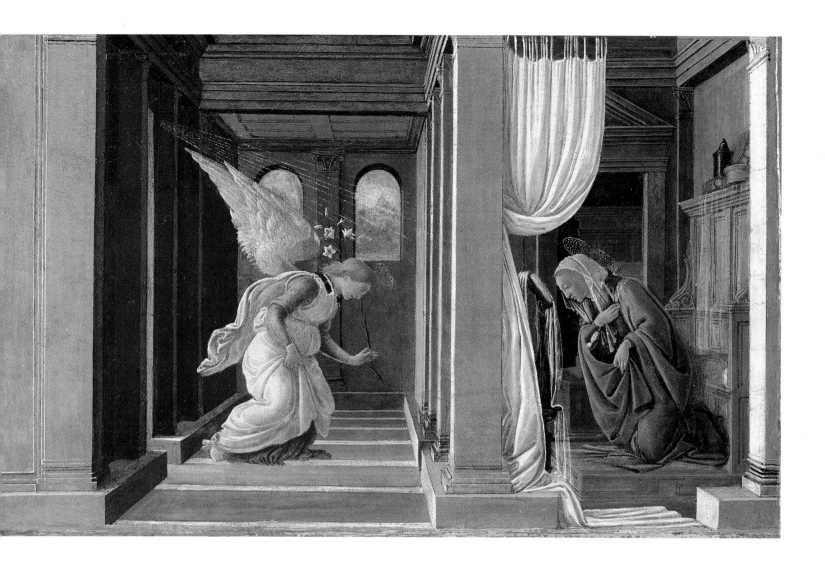

BOTTICELLI
The Annunciation

The style and subject matter adopted by Botticelli, while personal and identifiable, are also typical of the changes that took place in Florentine culture in general, and painting in particular, during the latter half of the fifteenth century. These changes were the result of the influence of the humanists who filled the court of Lorenzo de' Medici, broadening the themes of artistic exploration that had, throughout the Middle Ages, been strictly governed by the Church. Early Renaissance realism became mixed with interpretation and illustration as artists developed an interest in portraying feelings and depicting the poetry of the classics and myths of ancient times. Even when the subject purported to be religious, the emphasis shifted, and the balance of interest was more evenly divided between the main figures and their surroundings.

The classical architectural setting of *The Annunciation* is that of a patrician Florentine household. The Renaissance delight in perspective is evident in the view down the corridor to the trees outside. The pillars that seem to separate the figures of the Virgin and the archangel Gabriel in fact draw them together, and the two human forms balance one another almost as mirror images, inclining toward the central columns. The clarity of the colors and cleanness of line are characteristic of the work of Botticelli's mature years.

BOTTICELLI
The Last Communion of Saint Jerome

In the last decade of the fifteenth century, the reforming preacher Savonarola had Florence firmly in the grip of his eloquence. This picture—one of Botticelli's most perfect small-scale works—is first mentioned in the 1503 will of one of Savonarola's ardent supporters, the Florentine wool merchant Francesco del Pugliese. In the will, where the work is described as "the Passing of Saint Jerome, by the hand of the said Sandro [Botticelli]," Pugliese left the picture to Savonarola's convent of San Marco in Florence. Botticelli himself is known to have sympathized with Savonarola's reforming ideals, but whether he was a supporter as early as 1495, the probable date of the picture, is not known.

Saint Jerome is shown in his wattle cell, the front wall of which has been removed. Around him are the monks of the order he founded. One has donned a red chasuble and administers the communion, while the two youngest are dressed as acolytes and hold large candlesticks with lit candles. Behind the group of figures, Botticelli has pictured the saint's bed, draped with a sheepskin coverlet and foreshortened, so that it resembles an altar. Above, on the right of the headboard, hangs his cardinal's hat, and in the background there are a crucifix, three palms (symbols of victory over death), and two juniper branches (possibly intended as symbols of chastity).

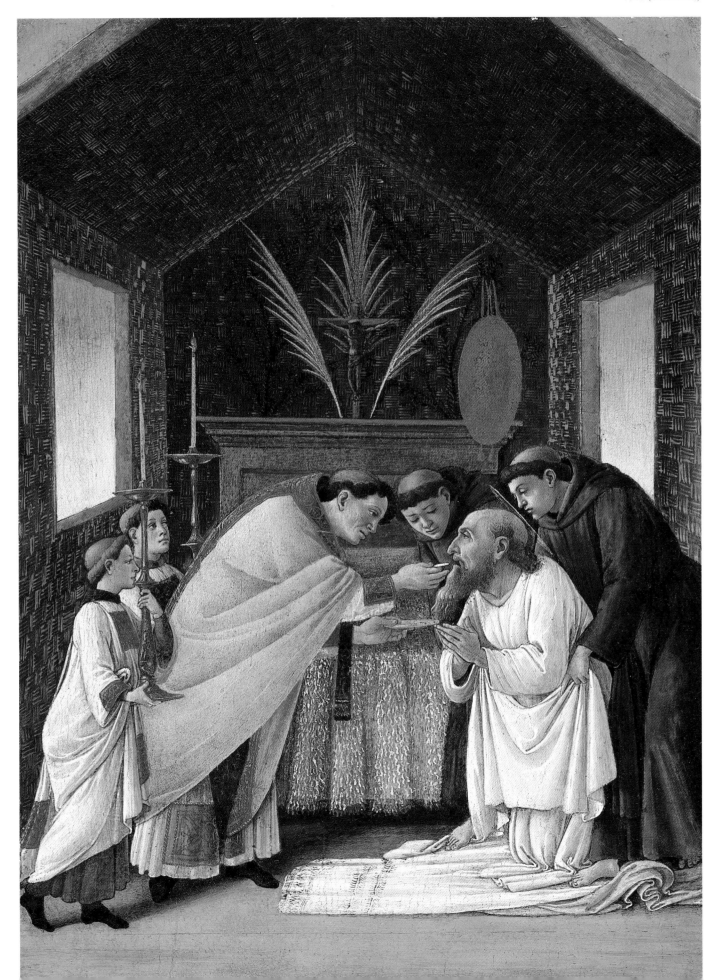

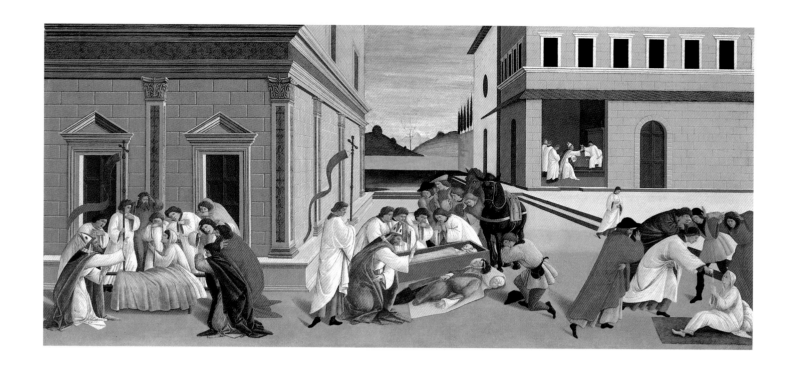

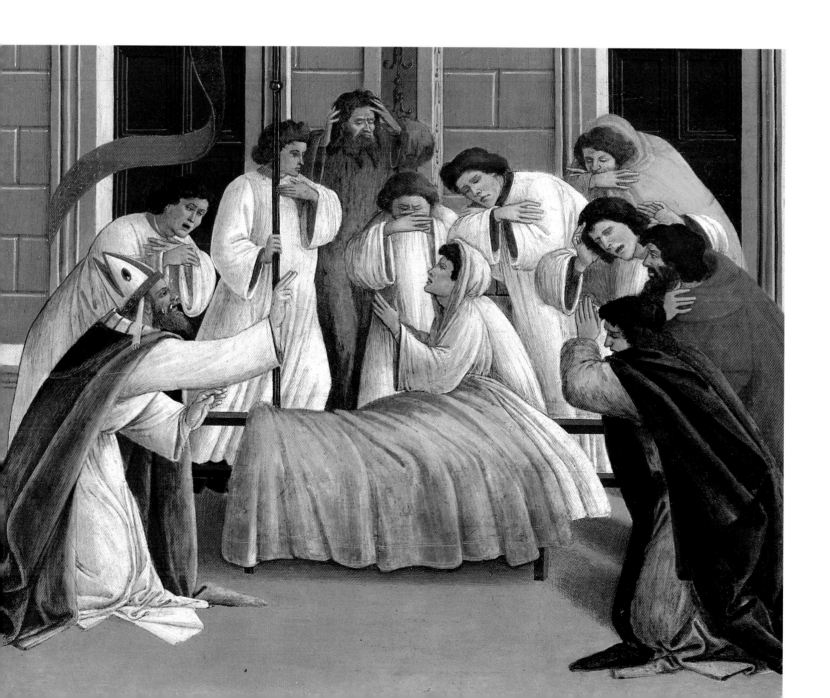

BOTTICELLI

Three Miracles of Saint Zenobius

Late in his career, around the first decade of the sixteenth century, Botticelli painted four panels with scenes from the life of Saint Zenobius. They may have been intended to be framed and hung above the wainscoting in a room of a confraternity. Two of the panels are now in the National Gallery, London; another is in the Gemäldegalerie, Dresden; and the fourth, seen here, is in The Metropolitan Museum.

Zenobius was the bishop of Florence in the fifth century, and is also one of the patron saints of the city. A biography of him, composed by Clemente Mazza in 1475, was published in Florence in 1487, and it is this source that Botticelli utilized in conceiving his series. In the Museum's panel, three scenes are shown. On the left, the saint is seen restoring to life a young boy whose funeral procession he had encoun-

tered. In the center, Zenobius meets a group of porters mourning the death of a companion. He had been killed while transporting the relics of four saints, and Zenobius brings him back to life by calling their names. On the right, Saint Eugenius hurries across a square with a glass of water and salt blessed by the saint and restores a relative to life. In the same section, Zenobius is shown in the background, blessing the water.

Like most late works by Botticelli, these scenes are less seductively drawn and executed than his earlier paintings. He has achieved a sense of urgency by utilizing a conventional technique in an unorthodox way: reducing the buildings to simple cubic forms and treating the landscape in a schematic fashion, void of any enveloping atmosphere.

53 *Three Miracles of Saint Zenobius*, ca. 1500
Botticelli (Alessandro Filipepi)
Florence, 1444/45–1510
Tempera on wood;
26½ x 59¼ in. (67.3 x 150.5 cm.)
John Stewart Kennedy Fund, 1911 (11.98)

Opposite below and this page: details

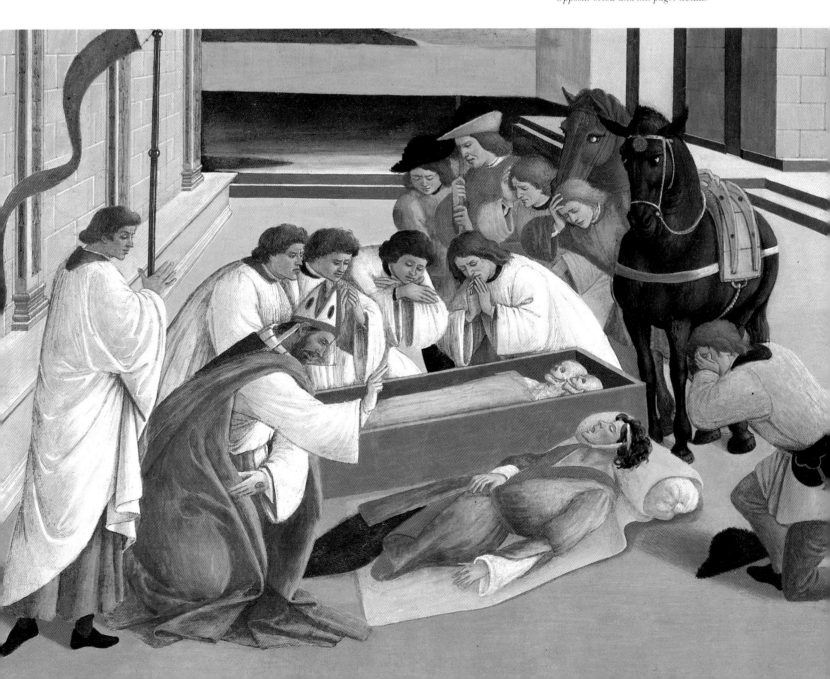

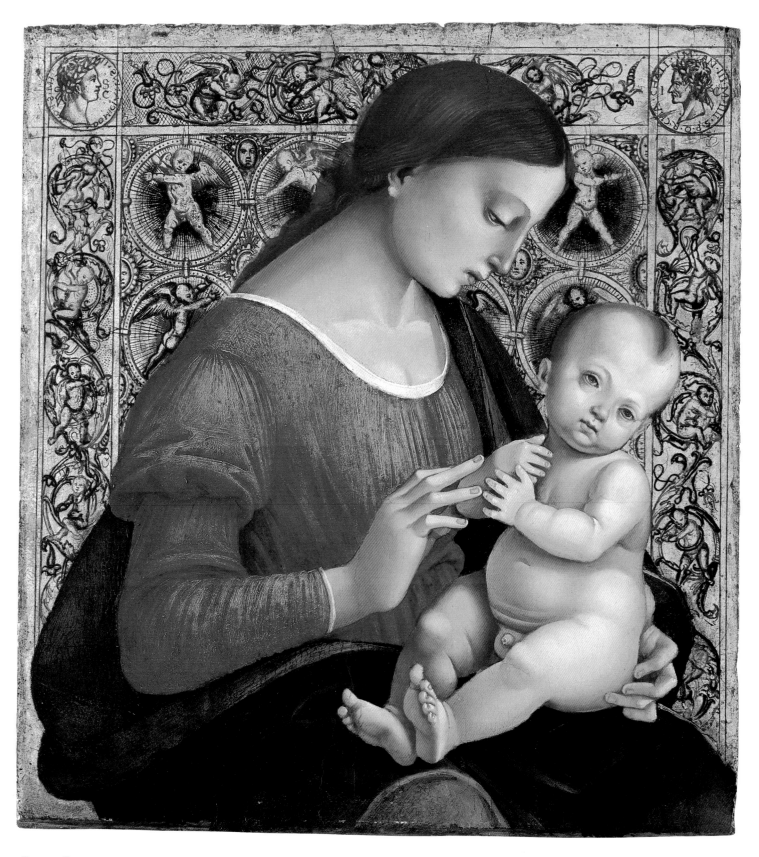

Luca Signorelli
Madonna and Child

A master of the nude, Luca Signorelli was also one of the most forceful draftsmen of the fifteenth century. Between 1499 and 1504, he was engaged in his most important work, the frescoes in the chapel of San Brizio in the cathedral at Orvieto, where his talent in both areas was given the fullest scope. The *Madonna and Child* seen here appears to date from the same period, around 1505, although it is a subject with which Signorelli had been working for a number of

years. The background of classical grotesque decoration and putti in athletic poses is similar to that of the frescoes at Orvieto. In the upper corners of the work Signorelli has placed portrait heads, copied from Roman coins, of two Roman emperors—Domitian, on the left, and Julius Caesar, on the right. This elaborate *all'antica* background serves as a brilliant foil for the simply defined forms of the Madonna and Child.

54 Madonna and Child, ca. 1505
Luca Signorelli
(Luca d'Egidio di Luca di Ventura)
Umbria, act. by 1470–d. 1523
Tempera and oil on wood;
20¼ x 18¾ in. (51.4 x 47.6 cm.)
The Jules Bache Collection, 1949
(49.7.13)

Below: detail

57 *Lovers*
Aeneas Silvius Piccolomini (Pope Pius II)
Florence (published by Piero Pacini), ca. 1495
Woodcut (in *Hystoria di due amanti*)
Harris Brisbane Dick Fund, 1925 (25.30.17)

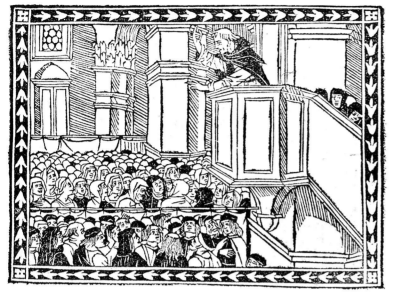

55 *Savonarola Preaching in the Duomo*, 1496
Florence (published by Piero Pacini)
Woodcut (in *Compendio di Revelazione*);
2¹⁵⁄₁₆ x 4 in. (7.4 x 10.2 cm.)
Harris Brisbane Dick Fund, 1925 (25.30.129)

56 *Savonarola Writing*, 1496
Florence (Lorenzo Morgiani for Piero Pacini, publisher)
Woodcut (in *Della Semplicita della Vita Christiana*);
3⅛ x 3⅞ in. (7.9 x 9.8 cm.)
Harris Brisbane Dick Fund, 1925 (25.30.149)

FLORENTINE WOODBLOCK PRINTS

The first Italian books were printed by Germans in the monastery of Subiaco, in the middle of the fifteenth century, and Italy, dominated by Venice, soon became a leader in book publishing. Interestingly, Florentines did not use woodcuts to illustrate books until 1490, sixty years after they had been introduced there for playing cards. And unlike the Venetians and Germans, the great Florentine artists did not make woodblock illustrations. These were produced by anonymous woodcutters in their guild shops.

The prints illustrated in Plates 55 and 56 were made for Girolamo Savonarola, the Dominican friar from Ferrara who practically ruled Florence from 1490 to 1498. Eventually, a conspiracy of clerical and lay enemies led to Savonarola's trial on charges of heresy. He was hanged and then burned, but his message remained vital for many years to come.

A brilliant preacher, Savonarola fueled his sermons with a determination to cleanse society and rid it of its frivolity. He attracted a huge following and used as his chief weapon an understanding of propaganda. At a time when illustrated books and pamphlets were becoming more widespread, he used them to great advantage, as seen in these illustrations from his *Compendio di Revelazione* and *Della Semplicita della Vita Christiana*.

The woodblock print reproduced in Plate 57 is a page from a mildly erotic tale by Aeneas Silvius Piccolomini, who later became Pope Pius II. Piccolomini was a man of letters, and wrote his *Hystoria di due amanti (Story of Two Lovers)* before taking Holy Orders in 1446. This page is from an edition printed in 1495, thirty-five years after Piccolomini became pope; his story continued to be a best seller. With its gaiety and eroticism, the *Hystoria di due amanti* was naturally included in Savonarola's "bonfires of vanities," and only three copies remain.

⸿ PROEMIO DI SER ALEXANDRO BRACCIO AL

preſtantiſſimo & excellentiſſimo giouane Lorēzo di Pier frã
ceſco de Medici ſopra la traductione duna hyſtoria di due a=
manti compoſta dalla felice memoria di Papa Pio .ii.

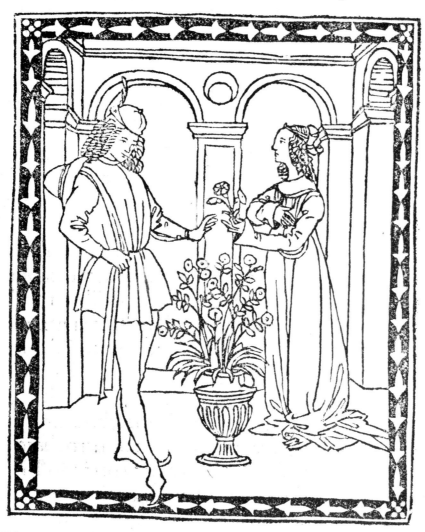

Enche molti ſieno li exempli Lorēzo mio excel
lentiſſimo : pequali facilmente in altri ho poru
to comprehendere quanto ſieno ualide & gran
di leforze damore & molte carte habbi riuolte:
doue lincendii ſuoi ſitractano & fannoſi mani=
feſti:nientedimāco alchuna coſa non ha potuto
piu ueramente monſtrarmi laſua potentia:che lo experimento
che ho facto in me ſteſſo:concioſia coſa che nella mia florida eta

FRANCESCO PESELLINO
Saint Philip, Apostle

Saint Philip was one of the first apostles to be called to Christ. He is not a common subject in art, and when he is represented, he is usually depicted as Pesellino has shown him—a bearded, middle-aged man holding his attribute, the cross. Here the seated apostle holds a book as well. It is said that with his cross Saint Philip banished a serpent from the Temple of Mars in Hierapolis, where it was being worshiped, and that in their fury the priests of the temple captured and crucified him.

Saint Philip is elaborately modeled in brush and brown wash, heightened with white. The angular and complex drapery folds suggest the influence of northern art, and the broad, heavy hands and feet add a touch of human realism to the apostle.

ANDREA BREGNO
Saint Andrew

This relief with the apostle Saint Andrew holding his identifying attribute, the cross, was executed by Andrea Bregno, the most prolific sculptor in Rome during the second half of the fifteenth century. Bregno was esteemed not only for the measured classicism of his figural style, but also for the purity of his ornamental carving, exemplified here by the shell-niche and flanking pilasters.

An attribution to Andrea Bregno was initially made on stylistic grounds. Later, the statue's original setting—an altar made for the old basilica of Saint Peter's in Rome—was determined. Although the altar was demolished in 1606, a drawing of it in its original state occurs in the Grimaldi Codex, assembled by Jacopo Grimaldi, who chronicled the contents of old Saint Peter's as they appeared prior to the great campaign of rebuilding early in the seventeenth century. Grimaldi's drawing reveals that the altar, commissioned in 1491 by a French prelate named Guillaume de Perrier, included reliefs with figures of Saints Andrew, Peter, and Paul, all standing in niches. It stood just inside the door of the old basilica. In 1612, a few years after the demolition of the altar, a papal chamberlain obtained the two other marble reliefs, those with Saints Peter and Paul, and placed them in the church of San Pietro Ispano in the town of Bauco, known today as Boville Ernica. The comparison of the Metropolitan's relief with these and with Grimaldi's drawing leaves no doubt whatsoever that Saint Andrew, along with the reliefs in Boville Ernica, formed part of the Perrier Altar.

59 *Saint Andrew*, 1491
Andrea Bregno
Rome, 1421–1506
Marble; 47⅛ x 31¾ in.
(119.7 x 80.6 cm.),
including pilasters Gift of
J. Pierpont Morgan,
1917 (17.190.1736)

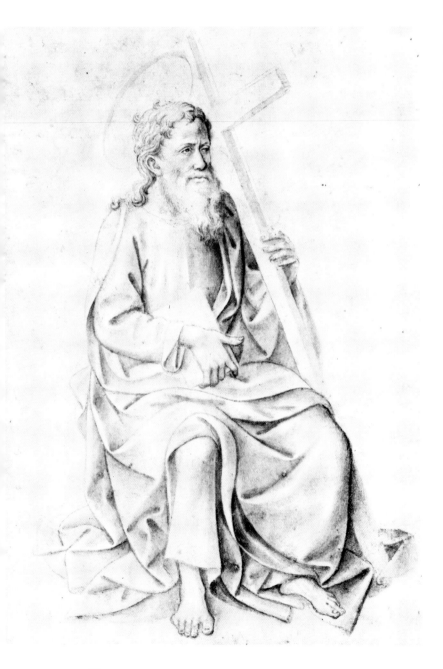

58 *Saint Philip, Apostle, Seated,
Holding Cross and Book*, before 1457
Francesco Pesellino
(Francesco di Stefano)
Florence, 1422–d. 1457
Brush and brown wash, heightened
with white gouache, over black chalk,
10¾ x 7½ in. (27.3 x 19 cm.)
Rogers Fund, 1965 (65.112.1)

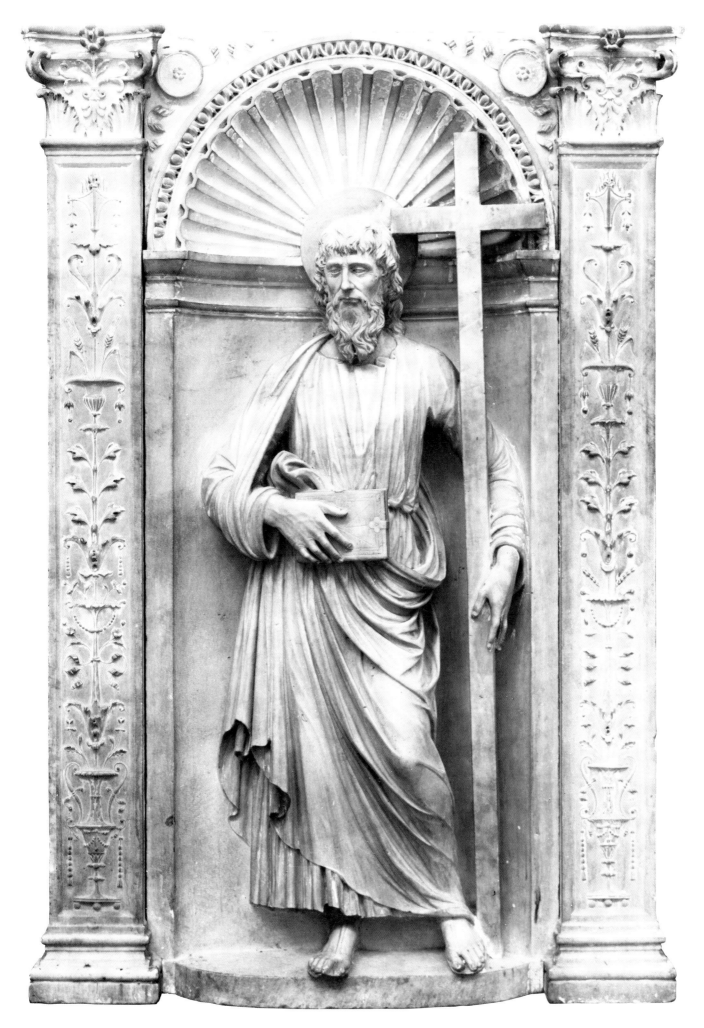

83

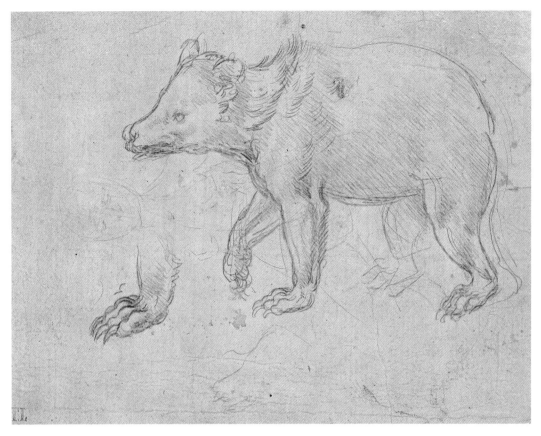

60 *Study of a Bear Walking*
Leonardo da Vinci
Italy, 1452–1519
Silverpoint on pinkish buff
prepared paper; 4¹⁄₁₆ x 5¼ in.
(10.3 x 13.4 cm.)
Robert Lehman Collection,
1975 (1975.1.369)

61 *Studies for a Nativity*
Leonardo da Vinci
Italy, 1452–1519
Pen and brown ink, over
preliminary sketches in metal-
point, on pink prepared paper;
7⅝ x 6⅜ in. (19.3 x 16.2 cm.)
Rogers Fund, 1917 (17.142.1)

LEONARDO DA VINCI

It was through his drawings that Leonardo explored an idea, a pose, a composition, or an invention. Hundreds of notebooks filled with his studies and comments survive to explain an artist, consummately empirical in his approach, who trusted in nature to reveal herself, and in the ability of the human eye to observe and understand an object or a process.

His curiosity led him to sketch and puzzle out such diverse subjects as the way running water adheres to rocks, the grace of growing plants, human anatomy, and the particular distribution of weight in a body that has been hung by the neck. The number and variety of the fields in which he excelled is well known; in addition to designing moats, theater sets, equestrian statues, flying machines, and war devices, he painted the *Mona Lisa*.

On the left is an anatomical study of a brown bear. Leonardo concentrated on the structure of a particular paw —isolated on the left—which illustrates his stated plan for an anatomical treatise: "I will discourse of the hands of each animal to show in what way they vary; as in the bear, which has ligatures of the sinews of the toes joined above the instep." The bear appears to have been sketched from life; its

species is recognizable as *Ursus arctus*, a type of brown bear found in quantity during the fifteenth century in the Alps north of Milan. The species is notable for the distinctive ruff of hair that grows through the matted fur around the neck and shoulders during the summer months.

During the Middle Ages and the Renaissance, the bear was a symbol of evil, specifically of unchastity and lust. This connotation may explain the presence of the nude woman with spread legs whose faint outline is visible beneath the bear. Her downcast eyes and prominent abdomen, coupled with the presence of the bear, suggest pregnancy or childbirth and may be an allusion to the mythical nymph Callisto, who was transformed into a bear after being seduced by Zeus and bearing him a child, Arcas.

On the right, a series of sketches shows Leonardo's ideas for the composition of figures in scenes of the Nativity. With various alterations of head and hand, the Virgin kneels above the infant Christ, arms stretched out in gestures of devotion and benediction. In these studies, one can recognize the gestating composition of Leonardo's painting *Madonna of the Rocks*, now in the Louvre.

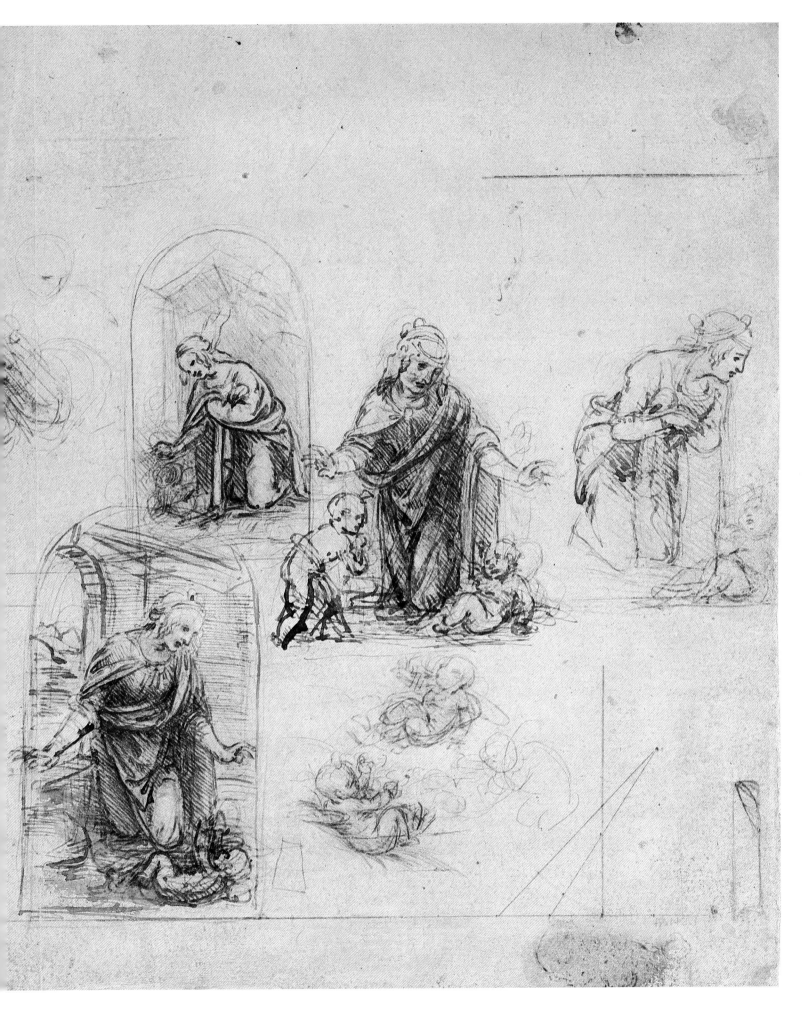

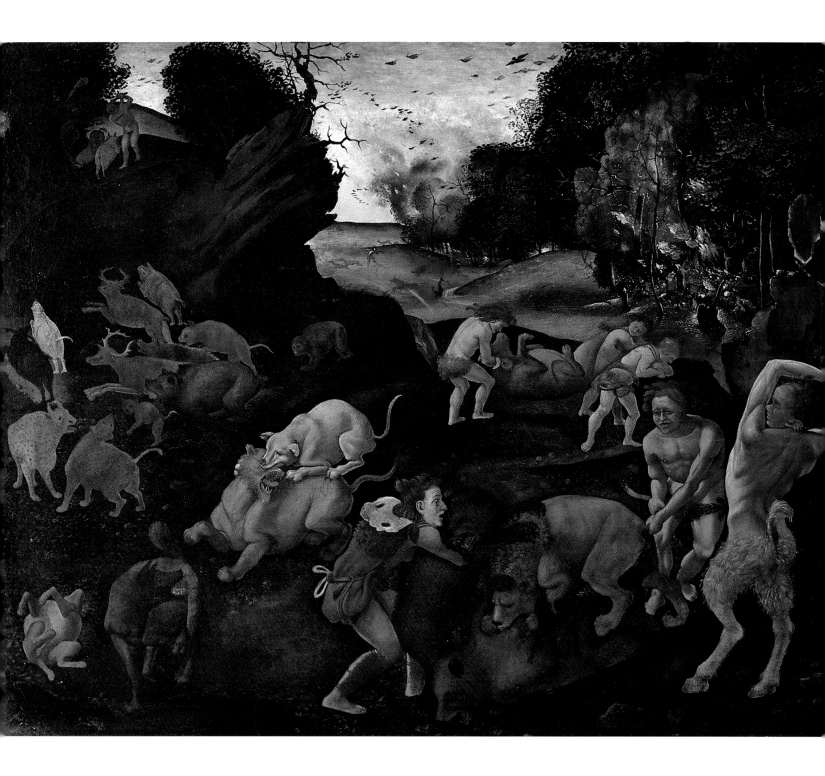

PIERO DI COSIMO
A Hunting Scene

During the Renaissance there was a fascination with the accounts of primitive life by such ancient authors as Lucretius and Vitruvius. *De Rerum Natura*, by the Epicurean philosopher Lucretius, seems to have been the principal source for this panel painting by Piero di Cosimo showing primitive men hunting in a forest. The panel is part of a cycle, possibly commissioned by the Florentine wool merchant Francesco del Pugliese. The two companion panels, a badly damaged one that is also in the collection of the Museum, and another in the Ashmolean Museum, Oxford, show men returning from a hunt, boarding fantastic boats made of twigs and reeds, and animals fleeing a forest fire.

Piero di Cosimo was one of the most eccentric painters of the Renaissance. Vasari has left a vivid account of his unconventional behavior—his abhorrence of the sounds associated with city life and his love of a wild, untamed nature:

> He did not like his rooms to be swept, he preferred to eat when hungry, and he did not want his garden hoed or the fruit trees pruned, preferring the branches of his vines to trail on the ground.... Also he enjoyed seeing everything in an undomesticated state, as his own nature.

In *A Hunting Scene*, we see Cosimo's untamed garden in the form of a dark, primeval forest, where the dangers and

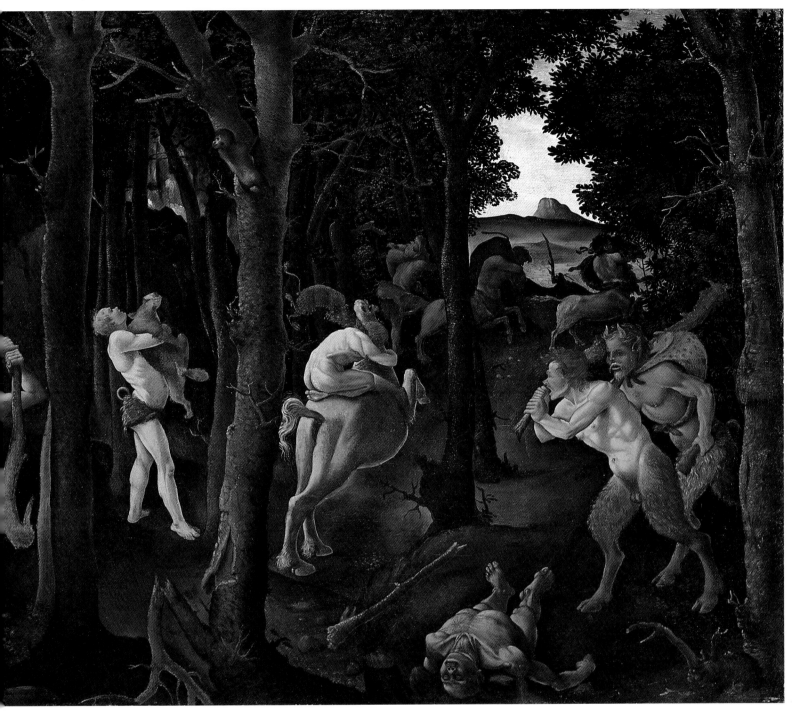

62 A Hunting Scene, ca. 1505–07
Piero di Cosimo (Piero di Lorenzo)
Florence, 1462–1521(?)
Tempera and oil on wood;
27¾ x 66¾ in. (70.5 x 169.5 cm.)
Gift of Robert Gordon, 1875 (75.7.2)

Pages 88–89: detail

chaos of a primitive hunt are re-created with men and myth-
ical satyrs joining in the fray. Two satyrs, at the right, bran-
dish crude clubs, while others, like the Herculean figure seen
on the back of a galloping horse, crush their prey bare-
handed. In the distance, a forest fire blazes; animals run
from it, panic stricken, only to find themselves at the mercy
of hunters who lie in wait in the passage of a hill. The
foreshortened corpse, which seems almost to project out of
the right side of the picture, is a grisly reminder of the
dangers of the hunt. Framed above the wainscoting of a
room in a private palace, the cycle must have had an aston-
ishing effect.

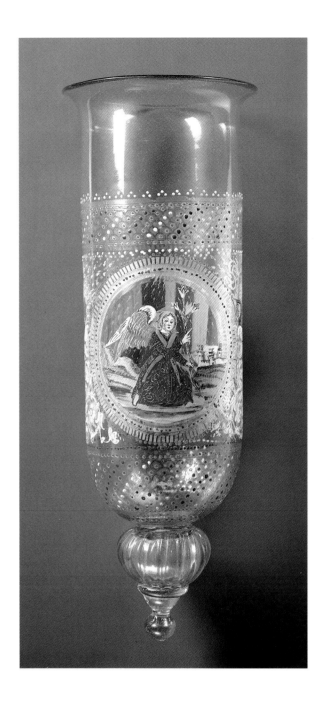

63 *Sanctuary Lamp*
Venice, early 16th c.
Glass, enameled and gilt;
H. 14¼ in. (36.2 cm.)
Rogers Fund, 1914 (14.83)

The emperor had to agree to Virgil's remedy—Febilla was exposed in the marketplace until the women of Rome had rekindled their fires with tapers lighted from a live coal magically placed in her body.

While the general shape of the sanctuary lamp in Plate 63 is very old, dating from as far back as Roman times, this particular variant was especially popular in late-fifteenth- and early sixteenth-century Venice. Such lamps were usually suspended by three chains and included a smoke shade above. The example illustrated here dates from the early years of the sixteenth century. It is made of clear glass with enamel and gilt decoration, and depicts the Annunciation to the Virgin. In a medallion on one side of the lamp, the Virgin kneels at her lectern as the dove of the Holy Spirit descends. In a medallion on the other side, the angel Gabriel, with the traditional lily, stands on a green field with a medieval building in the background. Between these two scenes are busts of Saints Peter and Paul. The rim of the lamp is filled with a delicate decoration made by etching the gold leaf with a point and adding dots of colored enamel to the elements of the pattern thus produced.

Venetian Glassware

By the fifteenth century, Venetian glassware, of an unparalleled elegance and refinement, was eagerly sought throughout Europe. So highly valued was the industry that the government accorded it extraordinary treatment, including special privileges as well as the threat of severe punishment to anyone who spread the secret of glassmaking.

The enameled and gilt goblet in Plate 64 is likely from the workshop of Angelo Barovieri (act. 1424–d. 1461), one of the most important glass manufacturers of his time. (His factory still exists.) He came from a family of glassmakers and played an important role in raising the artistic and technical levels of glassmaking to new heights.

The decoration on this goblet is one of the earliest surviving examples of minute-scale enameling and gilding on glass. The composition, which was probably taken from a contemporary Venetian illuminated manuscript, depicts a popular Italian story: The poet Virgil fell in love with Febilla, daughter of the emperor of Rome. Enraged by her rejection, he magically caused all the fires in Rome to go out.

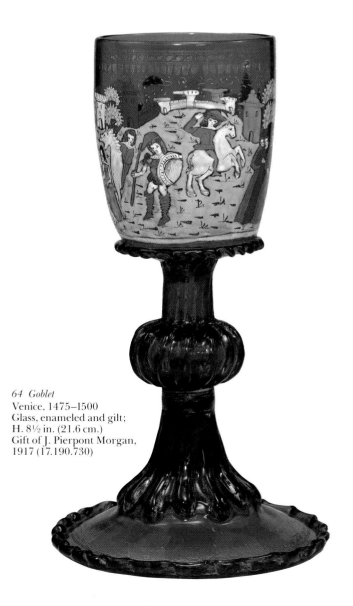

64 *Goblet*
Venice, 1475–1500
Glass, enameled and gilt;
H. 8½ in. (21.6 cm.)
Gift of J. Pierpont Morgan,
1917 (17.190.730)

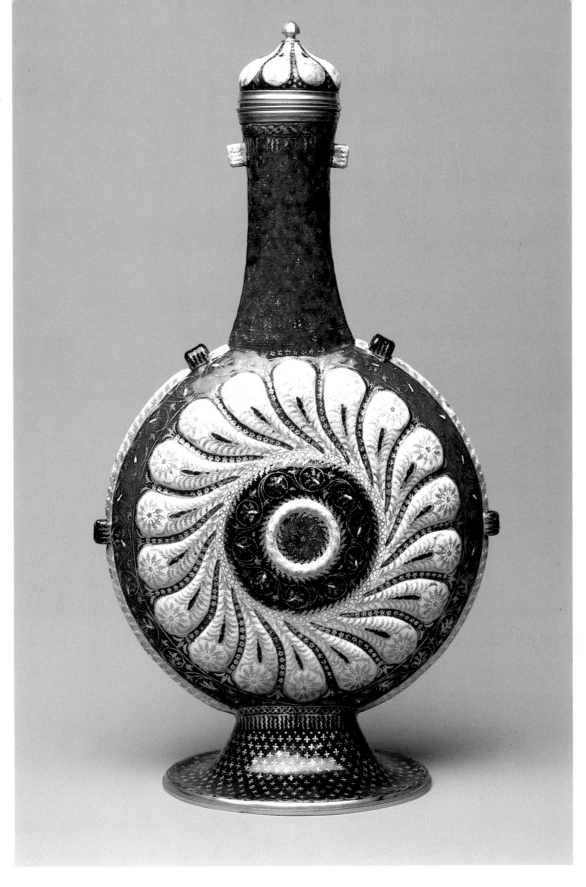

PILGRIM FLASK

As the name implies, pilgrim flasks were originally used to carry water on journeys. This one, however, although it contains the loops through which a rope would be tied for carrying, is clearly an elegant example of the type rather than a bottle intended for traveling. The red is of a russet hue; the other colors—blue, gold, white, and green—are arranged to create an effect of great richness. The ground of the flat circular body and long, elegant neck is blue, while that of the base is green. Both sides of the body are decorated with a circle of swirling white gadroons, each marked with a green teardrop shape. The crown-shaped lid is also ornamented with gadrooning; here the teardrop shapes are alternately blue and white. Finally, careful observation reveals that the abundant gilded decoration contains a delicately tooled design. Rich in color and complex in decoration, this pilgrim flask has all the opulence associated with Venetian art.

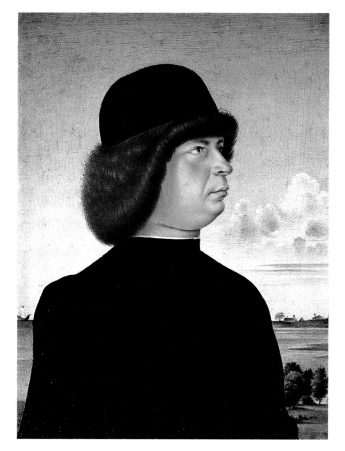

66 Alvise Contarini
Jacometto Veneziano
Venice, act. 1472–97
Panel; 4⅛ x 3 in.
(10.5 x 7.7 cm.)
Robert Lehman Collection,
1975 (1975.1.86)

JACOMETTO VENEZIANO

In 1543, the Venetian collector Marcantonio Michiel noted that in the house of Michele Contarini, "There is a small portrait of Messer Alvise Contarini . . . who died some time ago, and, opposite, in the same painting there is a portrait of a nun of San Secondo, and on the cover of these is a hart in a landscape. . . . A most perfect work from the hand of Jacometto." These are almost certainly the two portraits now in the Lehman Collection of The Metropolitan Museum of Art, which indeed show a man facing a woman with the headdress of the Benedictine nuns of San Secondo, an order whose laxity is evident in the revealing neckline of her habit. On the reverse of the male portrait Jacometto has painted

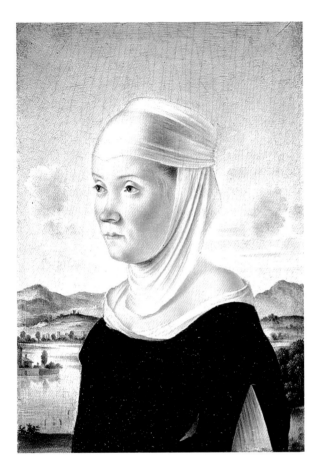

a seated hart wearing a red collar attached by a chain to a gold rondel.

Jacometto was considered the most outstanding miniaturist in Venice in the second half of the fifteenth century, and these two portraits bear out that claim. They are painted with a perfection and attention to detail that would, in and of itself, justify their attribution to a brilliant miniaturist. What is perhaps even more remarkable is Jacometto's sensitivity to the light that plays across the sitters' features and enlivens the distant landscape of the lagoons around Venice. For this aspect of his art, Jacometto was indebted to Antonello da Messina, who arrived in Venice in 1475.

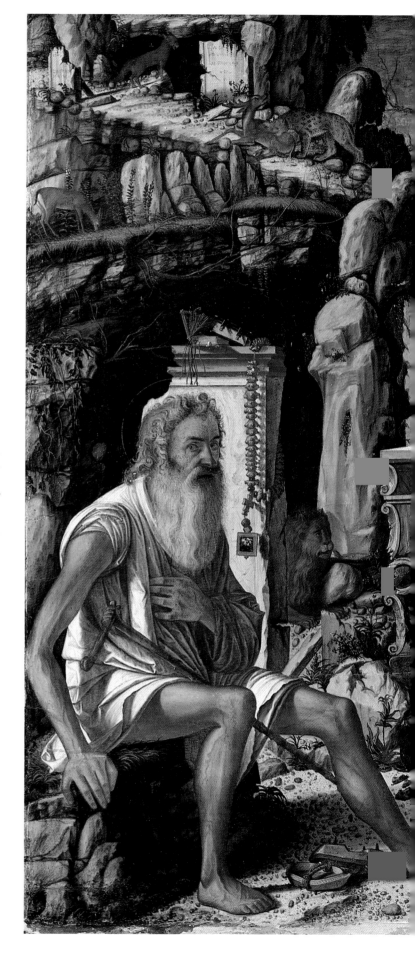

VITTORE CARPACCIO

The Meditation on the Passion

Today, Carpaccio is famous principally for the extensive cycles that he painted for Venetian confraternities. However, he is also the author of a number of individual religious works for private collectors in which the same descriptive approach and wealth of detail that characterize the large cycles were brought to bear. One of the most beautiful of these is The Metropolitan Museum's painting, which shows the Meditation on the Passion of Christ. Its subject was first interpreted by Frederick Hartt in 1935.

The key to the odd arrangement of figures in this painting —the dead Christ seated on a broken throne, with Saint Jerome on his right and Job on his left—is contained in an inscription chiseled into the stone block on which Job is seated. Job had asked that his words "be graven with an instrument on a flint stone," and so they are. They read, "I know that my redeemer liveth," and include the number 19, referring to the chapter in the Book of Job from which this statement was taken. According to Saint Jerome, who wrote an extensive commentary on the Book of Job, this passage refers to the Resurrection. Hence these two figures —Job, whose sufferings in the Old Testament prefigured those of Christ, and Saint Jerome, who so interpreted them —sit in meditation upon the body of the dead Christ.

Carpaccio has elaborated on this theme in the abundance of still-life details, such as the bones next to Job, the crown of thorns propped against the throne of Christ, and the small bird that flies upward from Christ (a symbol of the Resurrection). Even the landscape is conceived so as to underscore the theme. Desolate on the left, where a leopard catches a stag, it is lush and open on the right, where a stag successfully escapes a leopard. There can be no doubt that, in this, Carpaccio has meant to contrast the bleakness of death with the promise of the Resurrection.

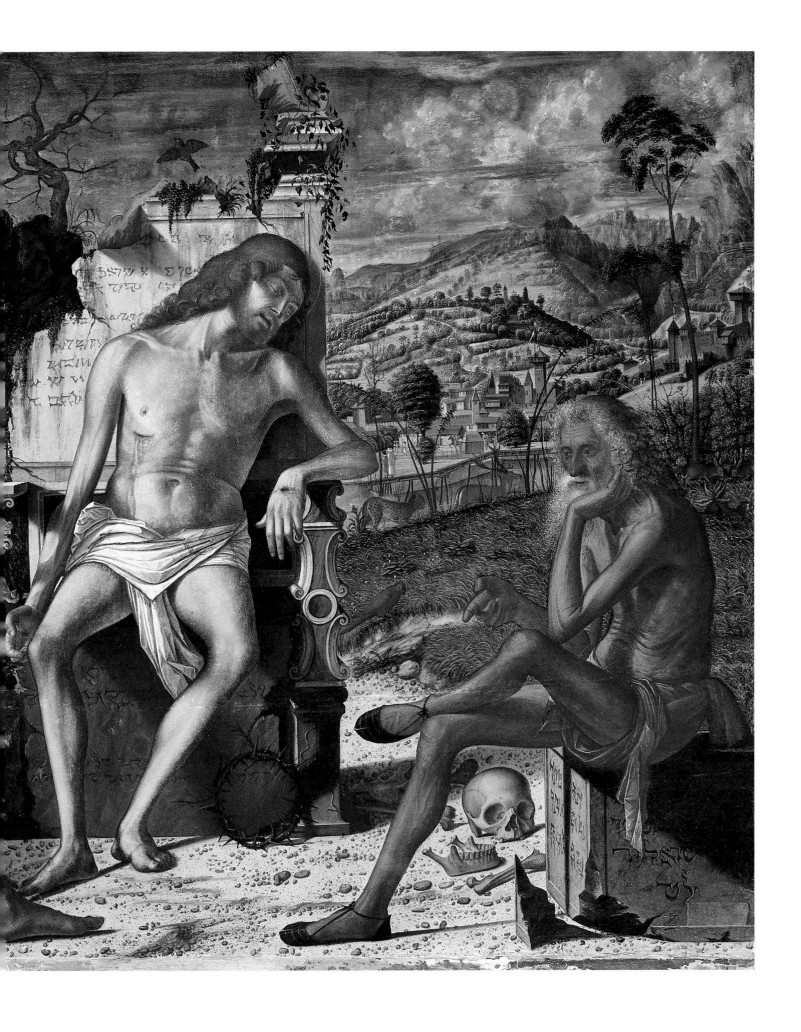

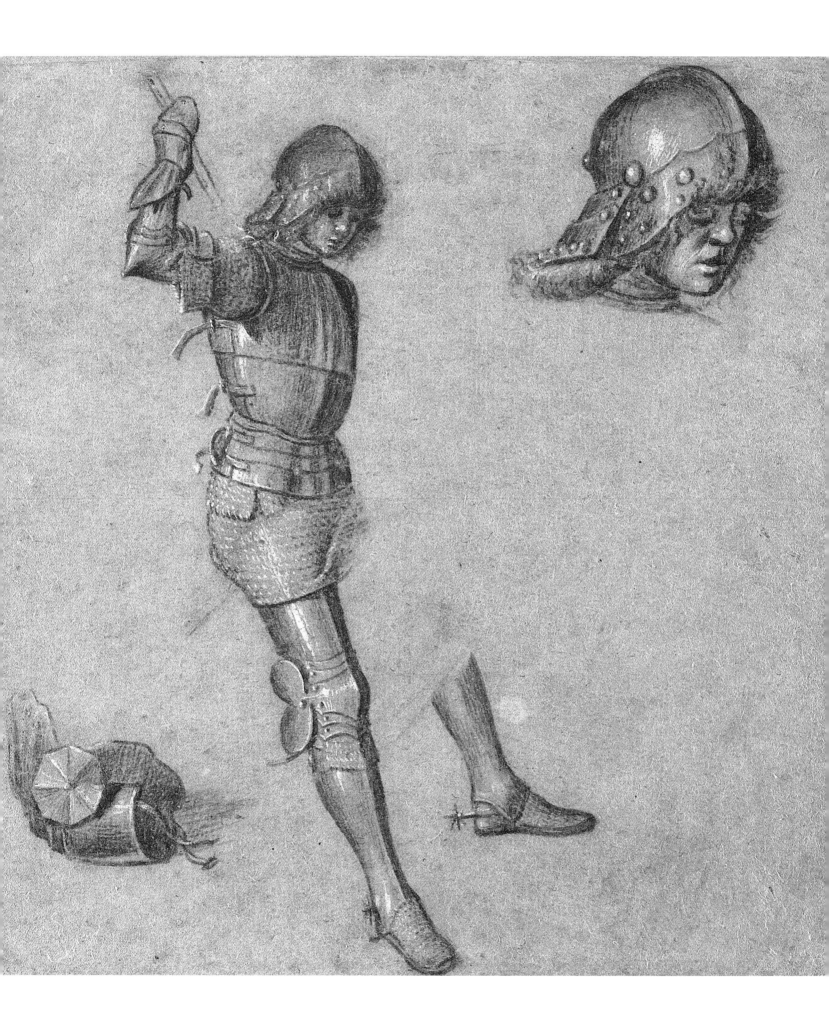

VITTORE CARPACCIO
Studies of a Seated Youth in Armor

This drawing by Vittore Carpaccio shows a youth, wearing a suit of armor, with legs apart, so that he appears to be straddling a horse. He holds a spear high in his right hand, which has led to the theory that this studio drawing may have been a preliminary study for a painting of a youthful Saint George slaying the dragon. Typically Venetian is Carpaccio's use of the point of the brush, rather than metalpoint or pen and ink, to delineate form and to study the details of the suit of armor.

The armor the youth wears is an eclectic appropriation of the Gothic and Renaissance styles used during this period. Instead of the stiff, sheet-metal trunk hose that formed the armored skirt of most sixteenth-century suits, Carpaccio has borrowed a more pliable and anatomically revealing skirt of chain mail from an earlier epoch of armor design. The artist has also taken liberties with the helmet, which lacks its essential visor, to allow the model's youthful curls to escape and play about the edges.

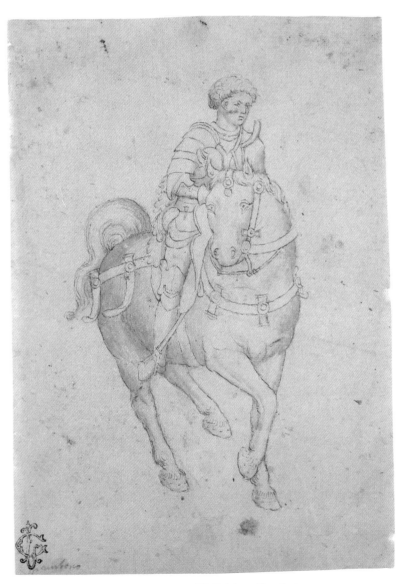

MICHELE GIAMBONO
Knight on Horseback

Painter and mosaicist Michele Giambono was one of the last exponents of the Venetian phase of the International Gothic style. In contrast to the work of some of his predecessors, Giambono's paintings are forceful, with a strong emphasis on large sculptural figures, elaborate decoration, textiles, and lavish embroidery. The drawing reproduced here is related to one of Giambono's most important paintings, a panel representing Saint Chrysogonus, now in the church of San Trovaso in Venice. Although there are strong correspondences between the painting and the drawing, the knight in the drawing is somewhat younger, and the movement of both horse and rider seems to be much freer. Giambono's horse is derived from the famous bronze horses of San Marco. While the stance, the body, and the details of the anatomy are analogous to one of the San Marco horses, there are distinct differences because of the need to adjust the chariot horse to the requirements of a mount that must harmonize with its rider.

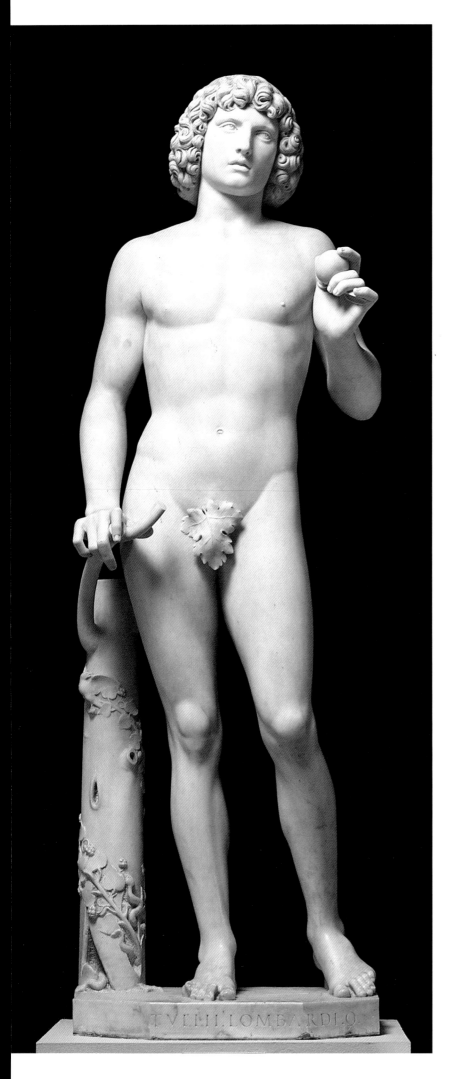

TULLIO LOMBARDO
Adam

Tullio Lombardo came from a prestigious family of sculptor-architects in Venice. His tomb for the Doge Andrea Vendramin (d. 1478), in the church of Santi Giovanni e Paolo, is the most lavish funerary monument in Renaissance Venice, and originally contained this life-size figure of Adam, on whose base the sculptor has signed his name.

Tullio's *Adam* is clearly classicized, as is the architectural framework—derived from the Roman triumphal arch—in which he was formerly situated. *Adam* is based on a combination of antique figures of Antinous and Bacchus, interpreted with an almost Attic simplicity. Further refinements are his meaningful glance and eloquent hands, and the tree trunk adorned with ivy and serpent. This figure, remarkable for the purity of its marble and smoothness of its carving, was the first monumental classical nude to be carved since antiquity.

71 Adam, 1490–95
Tullio Lombardo
Venice, ca. 1455–d. 1532
Marble; H. 75 in. (190.5 cm.)
Fletcher Fund, 1936 (36.163)

Opposite: detail

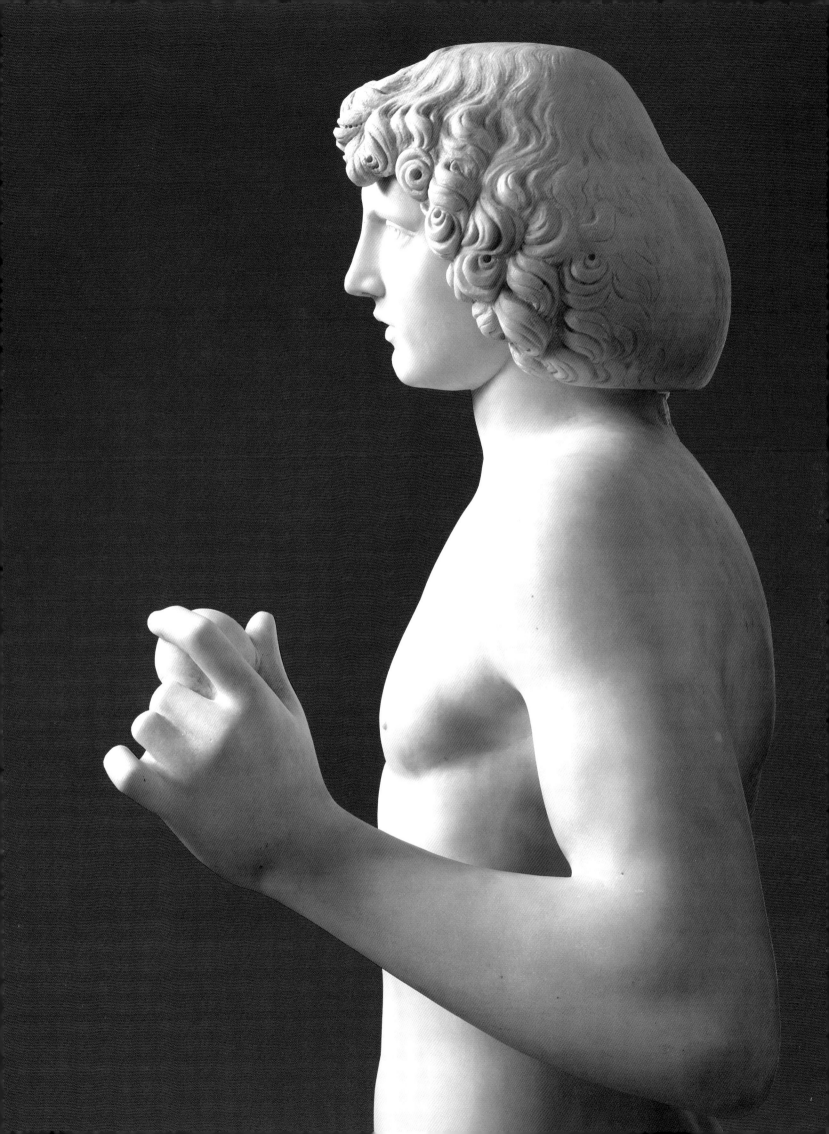

72 *Adam and Eve with the Infants
Cain and Abel*, early 16th c.
Cristofano Robetta
(Cristofano di Michele)
Florence, 1462–1522
Engraving on paper;
9¹⁵/₁₆ x 6⅞ in. (25.2 x 17.5 cm.)
The Elisha Whittelsey Collection,
The Elisha Whittelsey Fund, 1945
(45.80)

73 *Allegory of Carnal Love*
Cristofano Robetta
(Cristofano di Michele)
Florence, 1462–1522
Engraving on paper;
11¾ x 11 in. (29.8 x 27.9 cm.)
Anonymous Gift, 1929 (29.44.20)

CRISTOFANO ROBETTA

Cristofano di Michele, known generally as Il Robetta, was the son of a hosier. He grew up in Florence in the second half of the fifteenth century and learned many of the skills necessary for engraving while working as a goldsmith. Robetta drew heavily on Filippino Lippi and Perugino for his figures. But for his background landscapes, and frequently his architecture, he turned to the German engravers Albrecht Dürer and Martin Schongauer.

Adam and Eve with the Infants Cain and Abel is an excellent example of this amalgam of sources. The figures are Italian: Eve, with her round form and sweetness of face, resembles the Virgin in works by Filippino Lippi, and the child on the rock is paralleled in a painting by Lorenzo di Credi. The background is closely borrowed from Dürer—in fact, the cloud formation and the bench behind the Virgin are directly from his *Virgin and Child with the Monkey*, made around 1498, and the little peaked, half-timbered house on the left is purely northern in style.

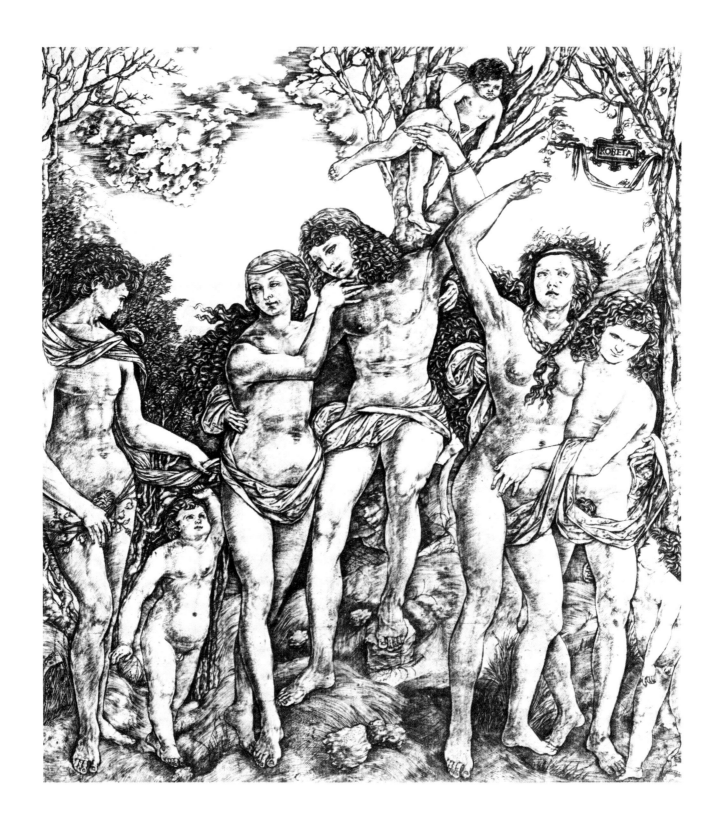

The subject matter, the first family, was a popular one at the time. Indeed, it was considered to be a parallel to the family group of the Virgin, Saint Joseph, and the infant Christ. There is sorrow in the picture, which evidently depicts the first family after their fall from grace. Adam is downcast, and the hoe he is carrying suggests the hard life ahead of them.

The *Allegory of Carnal Love* is a friezelike composition whose message is not entirely clear. On the right, the woman seems to represent physical love, and the putto pointing to a skull is probably a reminder of the transitory nature of lust. A similar but less obvious message is offered by the group on the left. The man appears to be the captive of love, but there is another, somewhat androgynous figure on the left, whose role is mysterious, although he appears to be controlling the actions of the couple, who are wound up in his sash. Once again, the figures are Italianate, but the setting is derived from northern prints.

ANDREA RICCIO
Satyr

Andrea Riccio, like Antico, was trained as a goldsmith. But he put this practice to a different sculptural purpose, that of activating the surfaces of the statuettes for which he is justly famous. They are a by-product of his work as a sculptor on a larger scale. In his great bronze Paschal Candlestick in the church of Saint Anthony in Padua, a striking blend of the sacred and the profane, satyrs are seated on the corners. Because of the taut control of design in this *Satyr*, with its firmly modeled contours and vigorous chasing, a date near the beginning of the Paschal Candlestick (1507) is probable. Later, Riccio's style became sketchier, almost disembodied in its visionary way. In addition, he discovered an increasingly large market for his statuettes. No two are identical, but gradually they became relatively repetitious.

74 *Satyr*, ca. 1507
Andrea Riccio
Padua, 1470–1532
Bronze; H. 14⅛ in. (35.7 cm.)
Purchase, Gifts of Irwin Untermyer,
Ogden Mills and George Blumenthal,
Bequest of Julia H. Manges and
Frederick C. Hewitt Fund, by exchange;
and Rogers and Pfeiffer Funds,
1982 (1982.45)

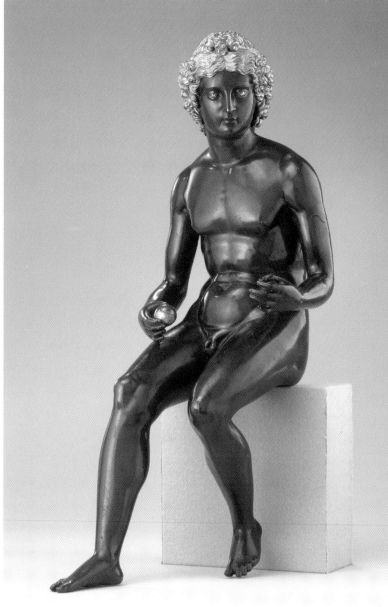

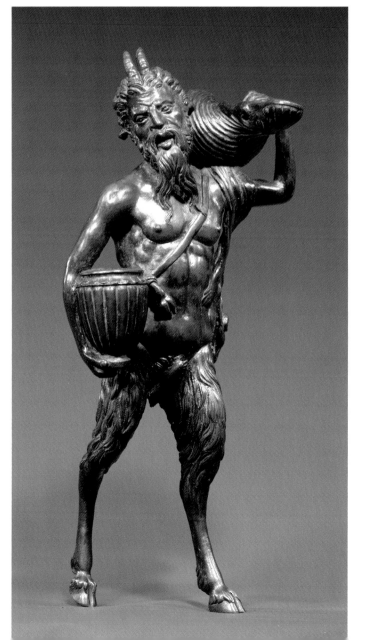

ANTICO
Paris

The artist who made this statuette was nicknamed Antico because of the devotion to ancient canons of composition manifest in his work. Not only did he keep the flame of Greco-Roman antiquity alive in his small-scale bronze reductions of classical sculptures, but he also worked as a restorer. One of the horses of the Dioscuri on the Quirinal in Rome has been found to bear his signature.

Much of Antico's work was produced at the brilliant court of Isabella d'Este at Mantua. The well-knit features of his bronzes have much in common with those in paintings by his contemporary, Andrea Mantegna. Although much of Antico's energy went into reproduction, there is no known original for the *Paris*. It is Antico's largest surviving statuette. The smooth flesh and exquisite detail—gilding of hair and apple, silvering of eyes—attest to the high quality of his best creations.

The subject of the statuette derives from a classical myth wherein Paris, son of Priam, king of Troy, was called upon to judge a beauty contest among the three goddesses, Venus, Juno, and Minerva, an event that led directly to the Trojan War.

Antonello Gagini
Spinario

Making copies after the works of antiquity was one of the chief means available to Renaissance sculptors for communicating classical proportions. This was especially true of the way in which artists approached the nude in the days before drawing from living models was an established practice. One of the most admired ancient nude figures was the *Spinario* in Rome, a Hellenistic bronze now in the Palazzo dei Conservatori. It was first recorded in the twelfth century as outside the Lateran Palace, and was apparently among the ancient bronzes taken to the Capitoline by Sixtus IV after 1471. The genre subject of the boy removing a thorn from his foot, which gives the *Spinario* its name, vied in popularity with the Marcus Aurelius statue, also on the Capitoline. Replicas have abounded well into modern times.

Antonello Gagini, the leading sculptor of the Renaissance in Sicily, worked briefly in Rome, where he could not have failed to know the original *Spinario*. His sculptures are almost exclusively of marble, and this is a rare instance of bronze casting in Sicily. A *spinario* by Gagini is mentioned as surmounting a fountain at the top of a stairway in Palazzo Alcontres, Messina. Gagini's version is far from being a slavish copy. He chose to give the boy cropped curls instead of the longer haircut of the ancient bronze, and the forms of the body are more rounded in general. The *Spinario* was more frequently copied in bronze statuettes much smaller in scale—for example, those by Antico and Severo da Ravenna. The Museum's collection alone contains several reductions from Severo's workshop.

75 *Paris*, ca. 1500
Antico
(Pier Jacopo Alari Bonacolsi)
Mantua, ca. 1460–d. 1528
Bronze, partly gilt and silvered;
H. 14⅝ in. (37.2 cm.)
Edith Perry Chapman Fund,
1955 (55.93)

76 *Spinario*, ca. 1506–09
Antonello Gagini
Sicily, 1478–1536
Bronze; H. 34¼ in. (87 cm.)
Gift of George and Florence
Blumenthal, 1932 (32.121)

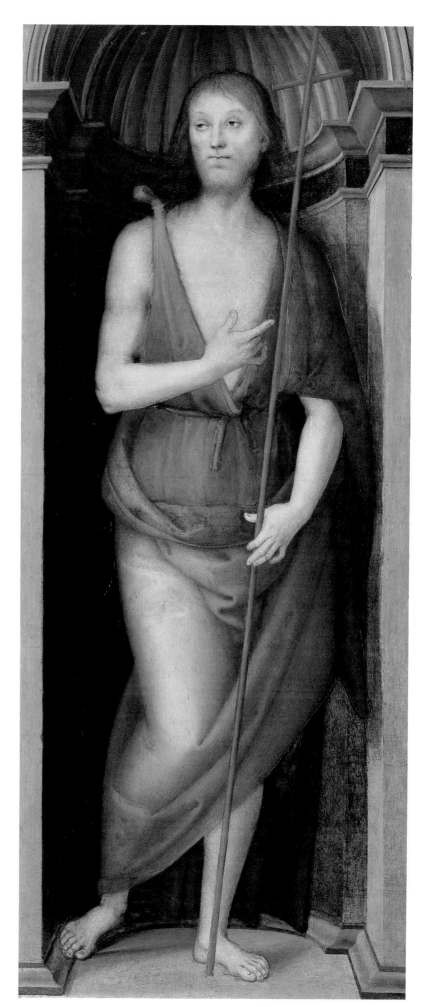

77 Saints John the Baptist and Lucy
Perugino
(Pietro di Cristoforo Vannucci)
Umbria, act. by 1469–d. 1523
Oil(?) on wood; each panel
63 x 26⅜ in. (160 x 67 cm.)
Gift of The Jack and Belle Linsky
Foundation, Inc., 1981 (1981.293.1,2)

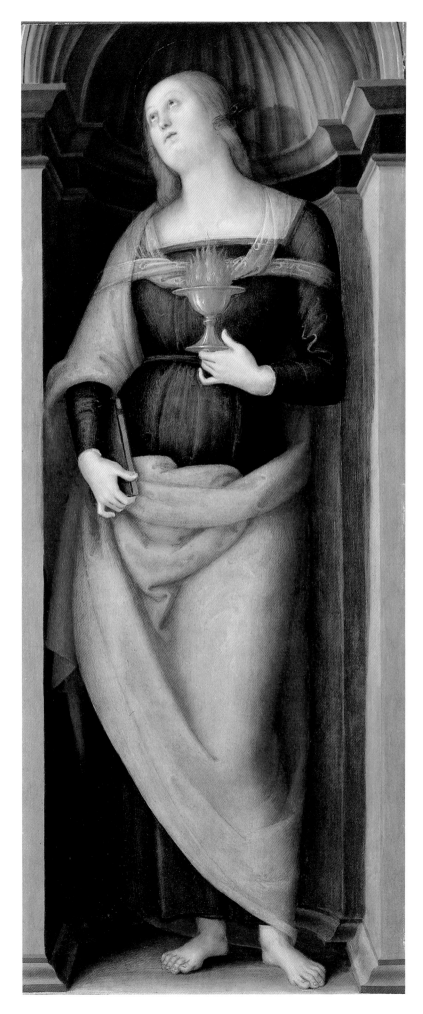

PERUGINO
Saints John the Baptist and Lucy

In 1505, the Umbrian painter Perugino was commissioned to complete the high altarpiece for the Servite church of Santissima Annunziata in Florence. The massive, free-standing altarpiece had the shape of a triumphal arch. Facing the choir was a large scene of the Assumption of the Virgin, while facing the nave was a Deposition of Christ. These were flanked by figures of saints in fictive niches. The Saint John the Baptist and Saint Lucy reproduced here seem to have flanked the Deposition. Saint John is shown holding as his attribute, the reed cross, and Saint Lucy holds a burning oil lamp, an attribute that perhaps derives from her Latin name, which means "light."

In a fashion typical of Perugino, the two saints are conceived as mirror images. Each has one foot centered on the pavement with one arm extended in front of the torso and the other aligned with the curving lines of the drapery. The subdued coloring and the attention to the effects of light and shadow are somewhat exceptional in Perugino's work of this date and probably mark a response to the High Renaissance work of Fra Bartolommeo.

RAPHAEL
The Colonna Altarpiece

Reproduced here are the main panel with lunette and a predella panel from the *Colonna Altarpiece*, a relatively early work by Raphael, painted about 1504–05 for the convent of Sant'Antonio da Padova at Perugia. The altarpiece remained in the church until 1663, when the scenes from the predella—those below the main panel—were sold to Christina, the former queen of Sweden. The main panel and lunette were sold fifteen years later. According to Vasari, the nuns requested that the Christ Child be fully dressed, and they must also have been responsible for some of the conservative features of the composition, which reflects the work of Perugino and Pinturicchio. Nevertheless, Raphael has infused into the rather stiffly composed group a breadth and dignity—especially in the male saints—that perhaps derive from his knowledge of the work of Fra Bartolommeo in Florence. Particularly beautiful are the logic and clarity with

which the figures of God the Father and two angels have been placed in the curved lunette. The saints in the main panel, flanking the Madonna and Child with the infant Saint John the Baptist, are Peter, Catherine, Cecilia(?), and Paul.

The predella constituted perhaps the most beautiful and forward-looking portion of the altarpiece. Shown were three narrative scenes: the Agony in the Garden (reproduced here), the Procession to Calvary, and the Pietà flanked by small figures of Saint Francis and Saint Anthony of Padua. In *The Agony in the Garden*, the figures are shown in eloquently differentiated poses and are grouped so as to articulate the space Raphael depicted. The angel who holds a chalice before the praying figure of Christ represents a change in Raphael's original intention of showing only an isolated chalice. It may be that the nuns again objected to this less familiar iconographic detail.

78 The Agony in the Garden, 1505
Raphael
(Raffaello Sanzio *or* Santi)
Umbria, 1483–1520
Tempera and oil on wood;
9½ x 11¾ in. (24.1 x 29.8 cm.)
Funds from Various Donors, 1932
(32.130.1)

79 Madonna and Child Enthroned,
with Saints, 1504–05
Raphael
(Raffaello Sanzio *or* Santi)
Umbria, 1483–1520
Tempera, oil, and gold on wood;
main panel 66⅞ x 67⅞ in.
(169.9 x 172.4 cm.) Gift of
J. Pierpont Morgan, 1916 (16.30ab)

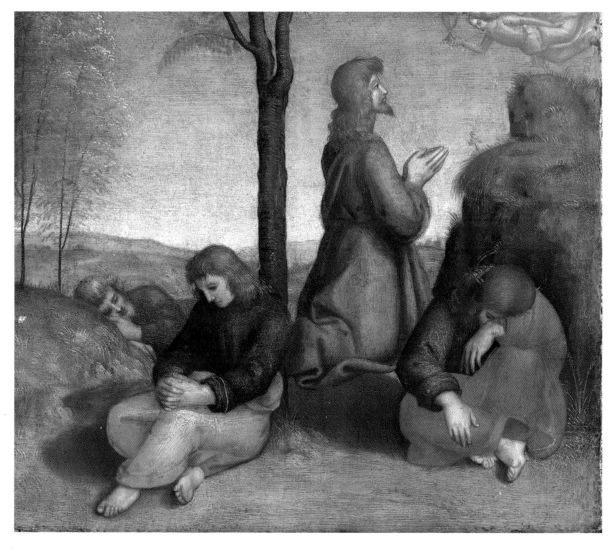

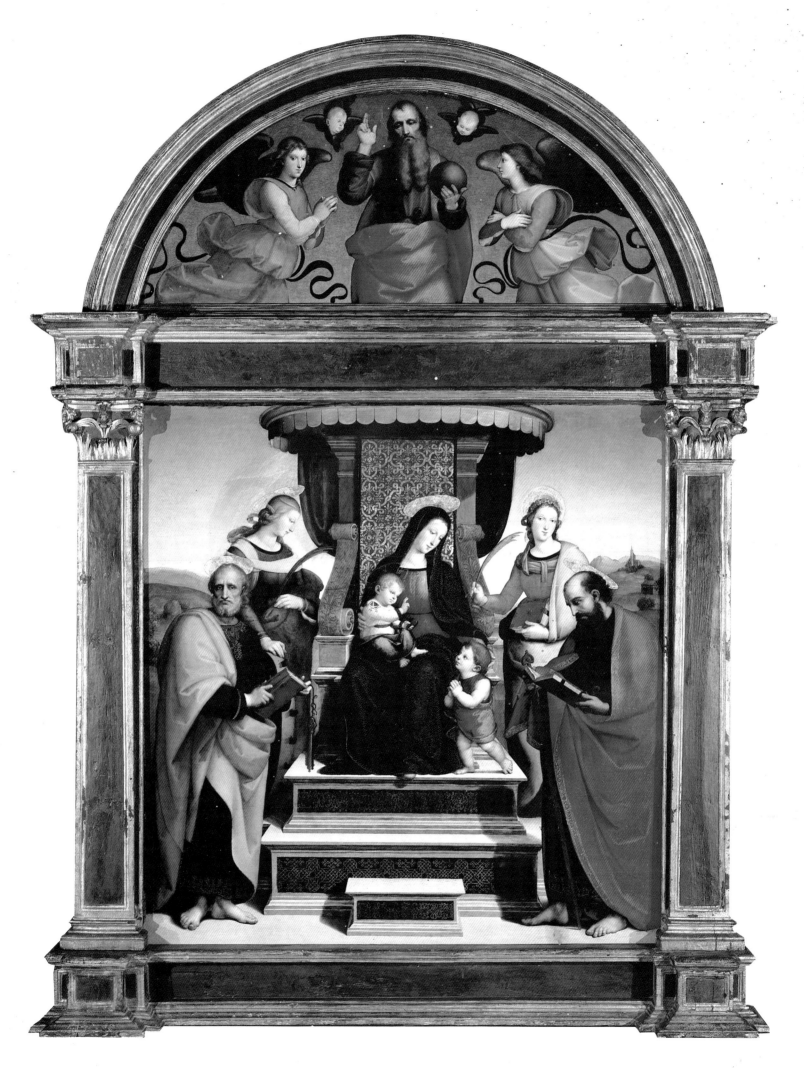

107

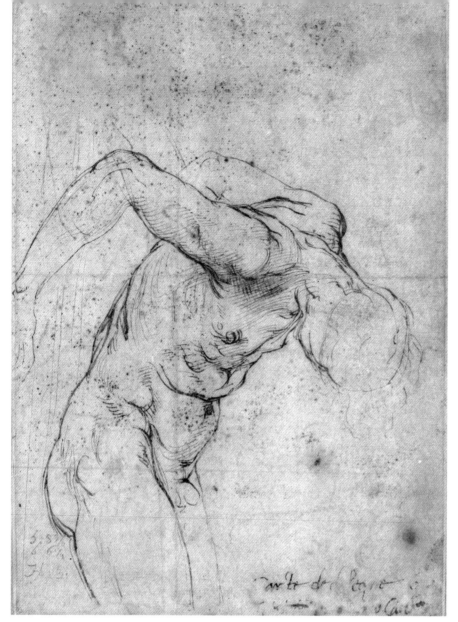

80 Nude Male Figure, 1505–06
Raphael
(Raffaello Sanzio *or* Santi)
Umbria, 1483–1520
Pen and brown ink;
8¹³⁄₁₆ x 6¼ in. (22.4 x 15.9 cm.)
Rogers Fund, 1964 (64.47)

81 Studies for the Libyan Sibyl, ca. 1510
Michelangelo Buonarroti
Italy, 1475–1564
Red chalk; 11⅜ x 8⁷⁄₁₆ in.
(28.9 x 21.4 cm.) Purchase,
Joseph Pulitzer Bequest, 1924
(24.197.2)

RAPHAEL
Nude Male Figure

This nude male figure was drawn by the young Raphael from a model in his studio. Executed with pen and brown ink, it was drawn with a forceful pen line and testifies to the artist's intense anatomical observation. The figure is depicted with his head hanging limply forward and his arms raised behind his back, held by cords that are just barely indicated. He may well be a study for the figure of one of the crucified thieves: During his Florentine period, Raphael worked on solutions for a representation of the Descent from the Cross, and he may have intended to include the crucified thieves in the scene.

On the other side of this sheet is a red chalk drawing of a Madonna and Child with the infant Saint John, a study for the *Madonna in the Meadow* now in the Kunsthistorisches Museum in Vienna. That drawing of the Madonna, which was not executed from life, is concerned with the lighting and construction of the overall composition, rather than with the precise detail that concerned the artist in his drawing of the nude.

MICHELANGELO BUONARROTI
Studies for the Libyan Sibyl

Along with Leonardo and Raphael, Michelangelo typifies the concept of the Renaissance artist. Sculptor, painter, architect, draftsman, and poet, he redefined the parameters of each field through the filter of his own individual genius. His *David* in the Accademia in Florence and his *Pietà* in Saint Peter's Basilica in Rome are among the best-known and -loved works in the history of art.

Michelangelo made these drawing studies from a nude male model for the figure of the Libyan Sibyl in the ceiling frescoes of the Sistine Chapel, commissioned in 1508 and unveiled in 1512. Here, he studies the contours of the Sibyl's twisting back as she turns to close what would become in the fresco a large book on the ledge behind her. Michelangelo has concentrated on particular passages of his drawing by sketching them in the margins: the profiled head, the musculature of the torso, the foreshortened wrist and hand, and the distribution of weight over bent toes.

Though executed on the flat surface of a page, Michelangelo's figure has been drawn with the force and volume of a piece of sculpture. Through the motion of a body, the artist expresses the human spirit.

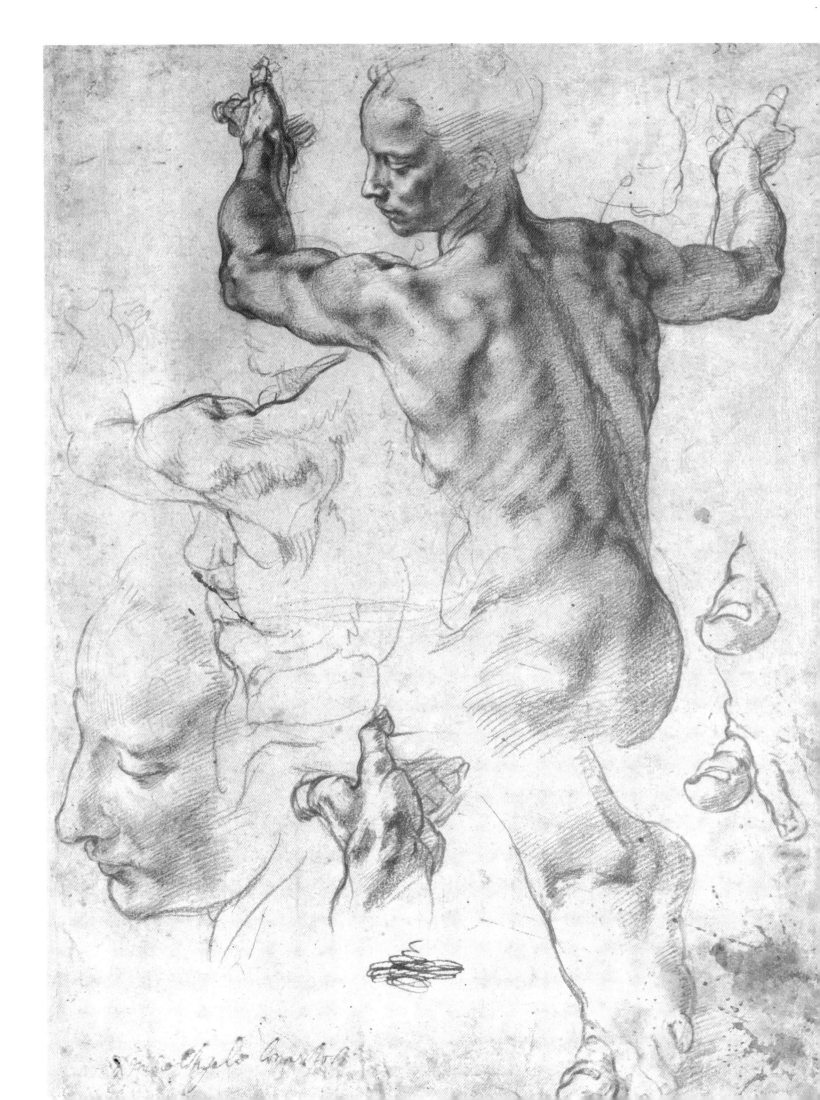

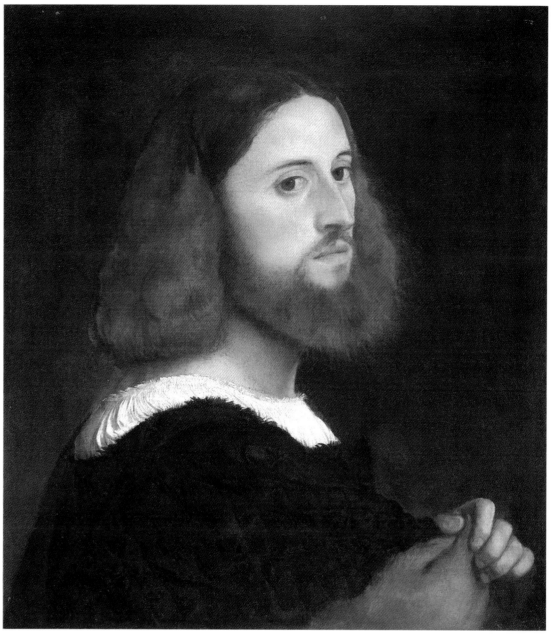

82 *Portrait of a Man*, ca. 1515
Titian (Tiziano Vecellio)
Venice, ca. 1488–d. 1576
Oil on canvas; 19¾ x 17¾ in.
(50.2 x 45.1 cm.) Bequest of
Benjamin Altman, 1913 (14.40.640)

83 *Fra Gregorio Belo
of Vicenza*, 1547
Lorenzo Lotto
Venice, ca. 1480–1556
Oil on canvas;
34¾ x 28 in. (88.3 x 71.1 cm.)
Rogers Fund, 1965 (65.117)

TITIAN
Portrait of a Man

This picture has been ascribed both to Giorgione and to
Titian. Recent cleaning confirms, however, that it is a beau-
tiful, though damaged, portrait by Titian, dating from per-
haps 1515. Comparison with other contemporary portraits
has suggested that originally the sitter was shown behind a
parapet with his right hand fully visible, but this cannot be
demonstrated.

While the picture is certainly by Titian, it is among his
most poetic, Giorgionesque works, with a subdued range of
color and a particularly beautiful description of light.

LORENZO LOTTO
Fra Gregorio Belo of Vicenza

Fra Gregorio is shown in the habit of the Hieronymite or-
der, holding an edition of the homilies of Gregory the Great
in one hand and striking his breast penitentially with the
other. In the background is shown Golgotha, with the cruci-
fied Christ surrounded by his mother, Mary Magdalen, and
Saint John. The juxtaposition of the Crucifixion with the
figure of Fra Gregorio leaves little doubt that Lotto wished
to emphasize the psychological unity between the background
scene and the action of the monk—the Crucifixion is a vi-
sual re-creation of the object of Fra Gregorio's devotions.
Only in an extended sense can this poignant and intensely
personal work be called a portrait. It was obviously the prod-
uct of Lotto's sympathy for the character of the monk.

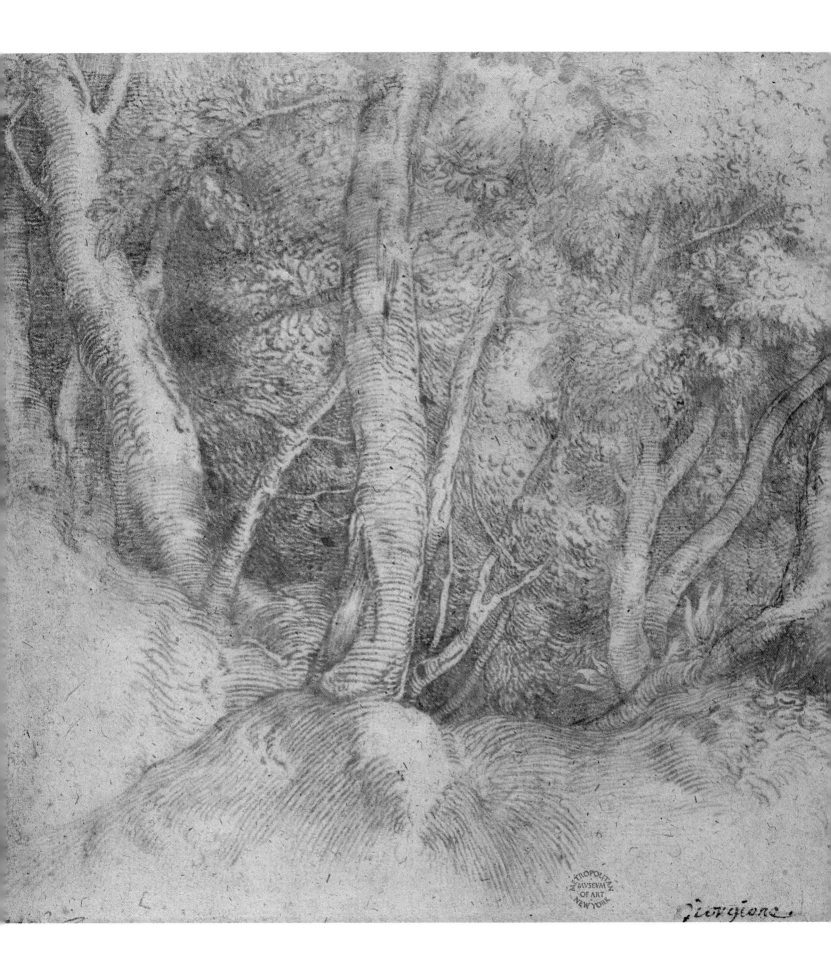

Giorgione

112

TITIAN
Group of Trees

This rare example of Titian's landscape drawing shows that, in addition to being a virtuoso painter, he was a consummate draftsman. This is a work of great energy and authority. Every mark plays a significant role in the composition, creating depth, volume, and texture, making real every one of the sensitively rendered forms.

The two halves of this composition were used in an early woodcut of the Sacrifice of Abraham. The trees in the left half of the drawing appear in reverse at the upper center of the print, and the trees and stump in the right half appear in reverse near the lower right margin of the woodcut. A blurring of the pen lines in the drawing suggests that two ink counterproofs were pulled from the sheet.

The inscription at the bottom of the page testifies to an early attribution to the artist Giorgione. Since early in this century, however, the drawing has been ascribed to Titian.

84 Group of Trees
Titian (Tiziano Vecellio)
Venice, ca. 1488–d. 1576
Pen and brown ink on beige paper;
8⁹⁄₁₆ x 12⁹⁄₁₆ in. (21.7 x 31.9 cm.)
Rogers Fund, 1908 (08.227.38)

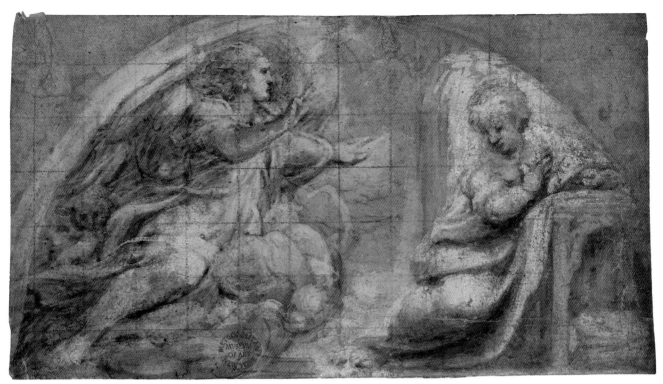

85 The Annunciation, 1522–24
Correggio (Antonio Allegri)
School of Parma, act. by 1514–d. 1534
Pen and black ink, gray wash,
extensively heightened with white, on
red-washed paper; squared in red chalk;
3¾ x 6¾ in. (9.5 x 17.2 cm.)
Frederick C. Hewitt Fund, 1919 (19.76.9)

CORREGGIO

Correggio is probably most famous for his illusionistic frescoes in churches in Parma, where he worked for most of his career. The small drawing of the Annunciation reproduced in Plate 85 was used in preparation for his fresco in the lunette of the church of the Annunciation at Capo di Ponte in Parma.

Despite the drawing's small size, the figures have the appearance of great weight and volume, and Correggio has fashioned a scene marked with all the emotion and drama we associate with his mature paintings. The angel Gabriel rushes in on billowy clouds, his drapery and hair sweeping behind him and his arms poised in a dramatic gesture. The Virgin Mary, with the gentle, delicate face associated with Correggio's female figures, recoils with her hand held at her chest. Both figures are vigorously modeled with thick white gouache highlights.

A work of Correggio's early maturity, the altarpiece in Plate 86 was painted for a local patron, Melchiore Fassi, and was installed in Santa Maria della Misericordia, in the town of Correggio. The four saints are identified by the attributes they carry: Peter holds the keys to heaven; Saint Martha, patroness of housewives and sister of Mary Magdalen and Lazarus, holds the aspergillum with which she tamed the dragon shown at her feet; Mary Magdalen holds the ointment bottle she used to anoint Christ's feet; and Leonard, patron saint of prisoners, holds the broken fetters of prisoners released through his intercession.

*86 Saints Peter, Martha, Mary Magdalen,
and Leonard*, ca. 1517
Correggio (Antonio Allegri)
School of Parma, act. by 1514–d. 1534
Oil on canvas; 87¼ x 63¾ in.
(221.6 x 161.9 cm.)
John Stewart Kennedy Fund, 1912
(12.211)

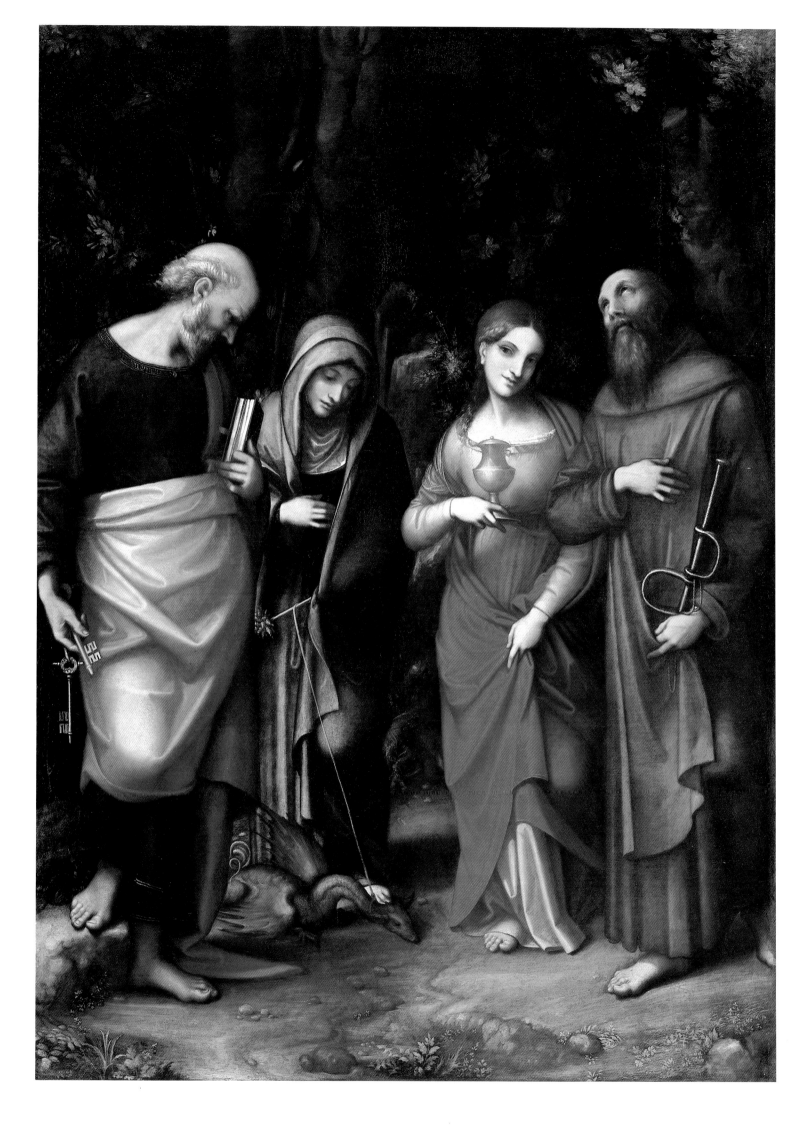

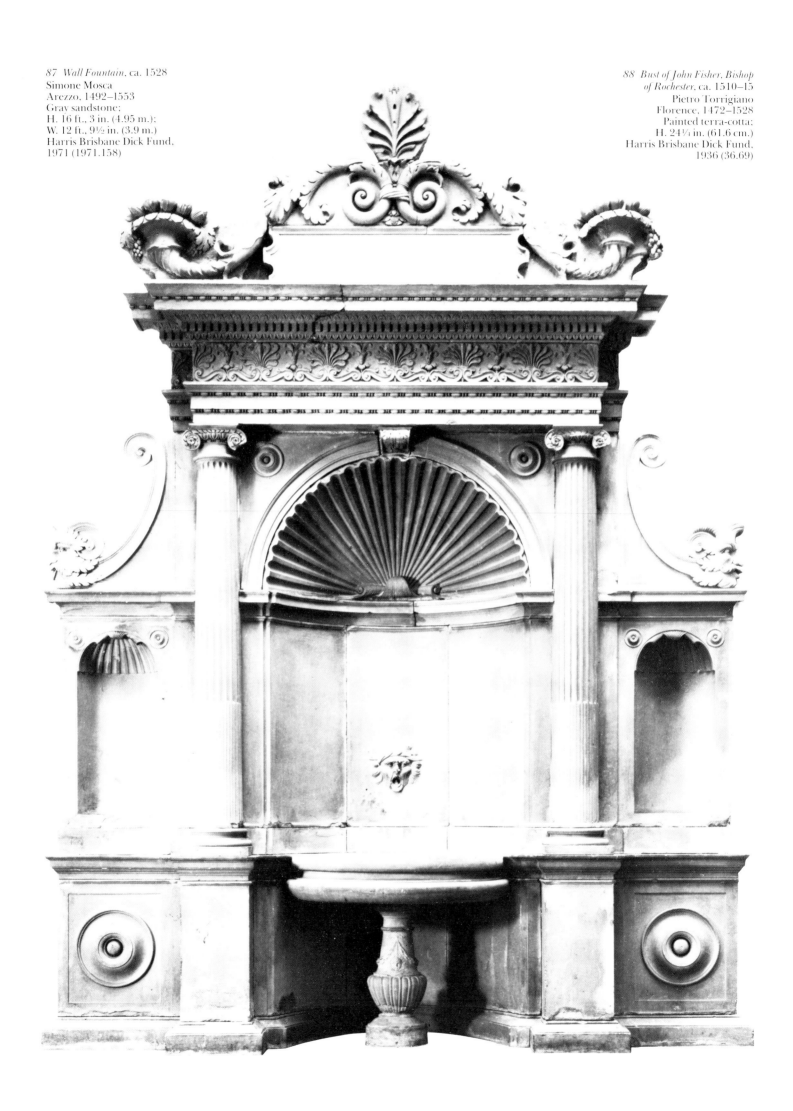

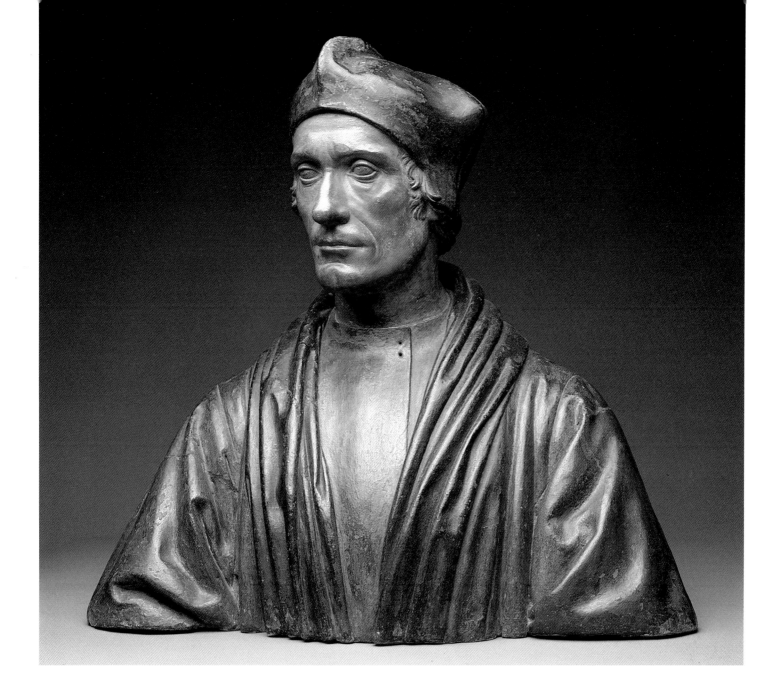

Simone Mosca
Wall Fountain

Simone Mosca, a leading master of High Renaissance orna-
ment, made this wall fountain as well as a fireplace for the
Palazzo Fossombroni in his hometown of Arezzo in about
1528. Mosca's fellow Aretine, Giorgio Vasari, mentions both
works in his famous *Lives*. The fireplace is in the Museo Civico
in Arezzo.

The wall fountain displays the clarity and grandeur
achieved by artists in Rome and Florence during the High
Renaissance. Mosca was trained in Rome by the great archi-
tect Antonio da Sangallo. The architectural nature of the
fountain is easily seen, its horizontal and vertical elements
held in perfect equilibrium. The rectilinear and curvilinear
shapes are balanced well: For example, the strong thrust of
the triumphal arch in the center is offset by the volutes on
either side, and by the graceful acanthus leaves ending in
cornucopias above. At once stately and elegant, Mosca's wall
fountain testifies to the intimate bonds between sculpture
and architecture that existed throughout the Italian High
Renaissance.

Pietro Torrigiano
Bust of John Fisher, Bishop of Rochester

The subject of this portrait bust was the chancellor of Cam-
bridge University and bishop of Rochester. In 1529, he op-
posed Henry VIII's divorce, but it was for his refusal to
take the Oath of Supremacy—by which Henry VIII placed
himself at the head of the church—that he was beheaded,
in 1534. With his friend Sir Thomas More, he was canon-
ized four centuries later. The bust is one of three recorded
for the first time in the eighteenth century as having been
taken from a room above the Holbein Gate at Whitehall
Palace. The others represent Henry VII (Victoria and Al-
bert Museum, London) and Henry VIII (The Metropolitan
Museum of Art).

Torrigiano, a Florentine, was allowed in his youth to study
the Medici collections of sculpture. He is perhaps most fa-
mous as the man who broke the nose of his fellow student,
Michelangelo, but his importance lies in his help in dissemi-
nating Renaissance tenets outside Italy, especially in Tudor
England. His masterpiece is the bronze tomb of Henry VII
in Westminster Abbey.

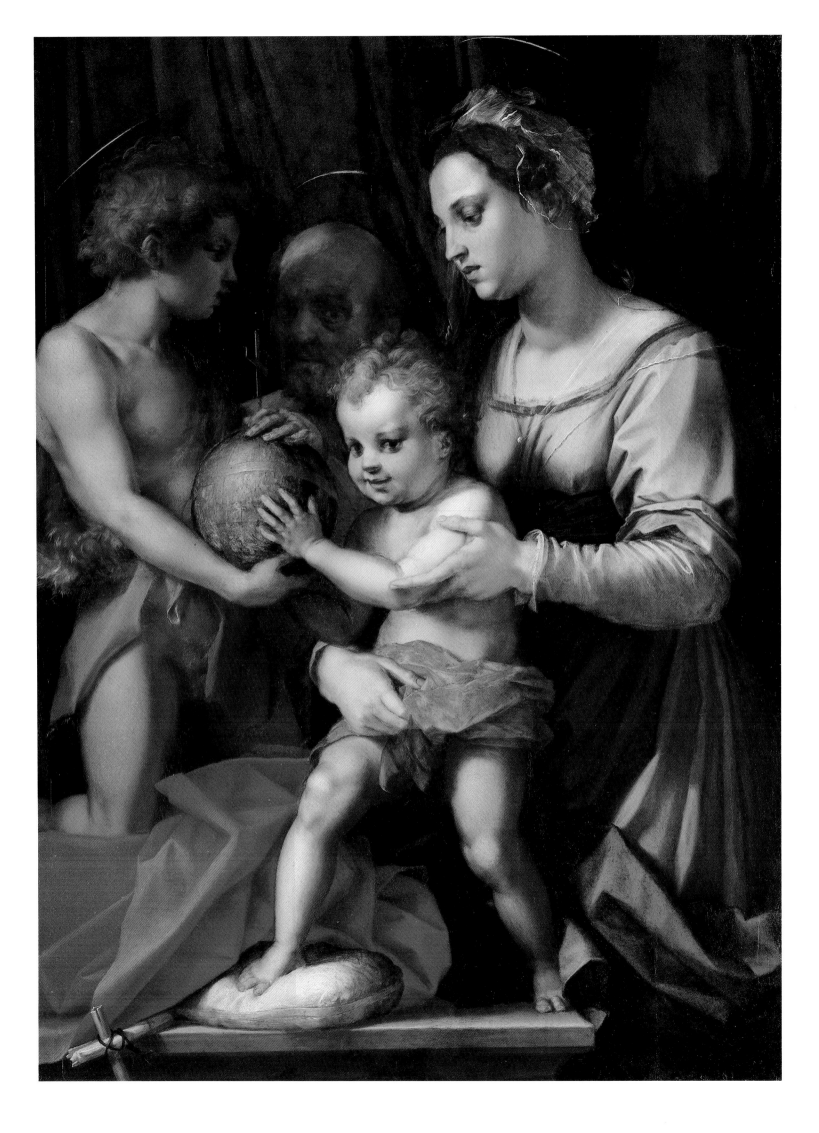

ANDREA DEL SARTO
The Holy Family with the Infant Saint John

In this painting of the Holy Family, the Virgin is supported by the Christ Child, who is grasping a globe held by Saint John the Baptist. The motif, an uncommon one, has been interpreted as a reference to a doctrine promulgated by Savonarola, that Florence should transfer its allegiance from its patron saint, John the Baptist, to Christ himself. According to the Renaissance art historian Giorgio Vasari, who described the composition, the work was made for the Florentine nobleman Giovanni Borgherini. Painted in about 1530, it is one of del Sarto's most beautiful treatments of the theme of the Holy Family, notable not only for the wonderfully conceived design, but also for the marvelous range of colors.

The son of a tailor, Andrea del Sarto was born in the Florence of Lorenzo the Magnificent and throve in the artistically energetic climate. As a young man, he was apprenticed to a goldsmith, an excellent training that instilled a care for detail. He became a leading exponent of Renaissance painting, taking over the artistic leadership of Florence when Raphael and Michelangelo left for Rome.

89 The Holy Family with the Infant Saint John, ca. 1530
Andrea del Sarto
(Andrea d'Agnolo)
Florence, 1486–1530
Oil on wood; 53½ x 39⅝ in.
(135.9 x 100.6 cm.)
Maria DeWitt Jesup Fund,
1922 (22.75)

OVERLEAF:

PATIO FROM VÉLEZ BLANCO *(Pages 120–121)*

The builder of the castle from which the marbles decorating this patio were removed was Don Pedro Fajardo y Chacón. He was born in about 1478, soon after Ferdinand of Aragon and Isabella of Castile accomplished the unification of Christian Spain, and he grew up in court circles. In exchange for ceding the port of Cartagena to the crown, Don Pedro was given a group of Moorish towns in the Vélez Valley between Murcia and Granada in southeastern Spain. He took formal possession in 1505; in the next year, construction began on his castle, erected on the foundation of an old Moorish fortress. It is possible that he may have been influenced by the splendid Italianate castle of La Calahorra that was being built by his wife's family, the Mendozas. The Vélez Blanco castle itself was built according to Spanish design by an architect trained in the traditions of Late Gothic architecture. But much of the embellishment is strongly reminiscent of the Renaissance style of northern Italy and was in all probability carried out by northern Italian stone carvers. The sculptural motifs of the patio recall those to be found in the *palazzi* of Venice and the surrounding towns of the Veneto. The elaborately carved flora and fauna on the capitals and around the doors and windows, the naturalism and three-dimensional quality of the ornamentation on the spandrels and in the main doorway, and the clean-cut, masterfully controlled design are all related to those found in buildings of the Renaissance in Italy.

The patio was removed from the castle in 1904, when most of the contents were sold. Transported to Paris, it was bought in 1913 by George Blumenthal for his Park Avenue house in New York. In 1945, the Blumenthal house was demolished. The component parts of the patio were brought to the Museum and rebuilt in 1963. A portion of the Museum's collection of Renaissance sculpture is now displayed in the courtyard.

90 Patio from Vélez Blanco
Spain, 1506–15
Marble
Bequest of George Blumenthal,
1941 (41.190.482)

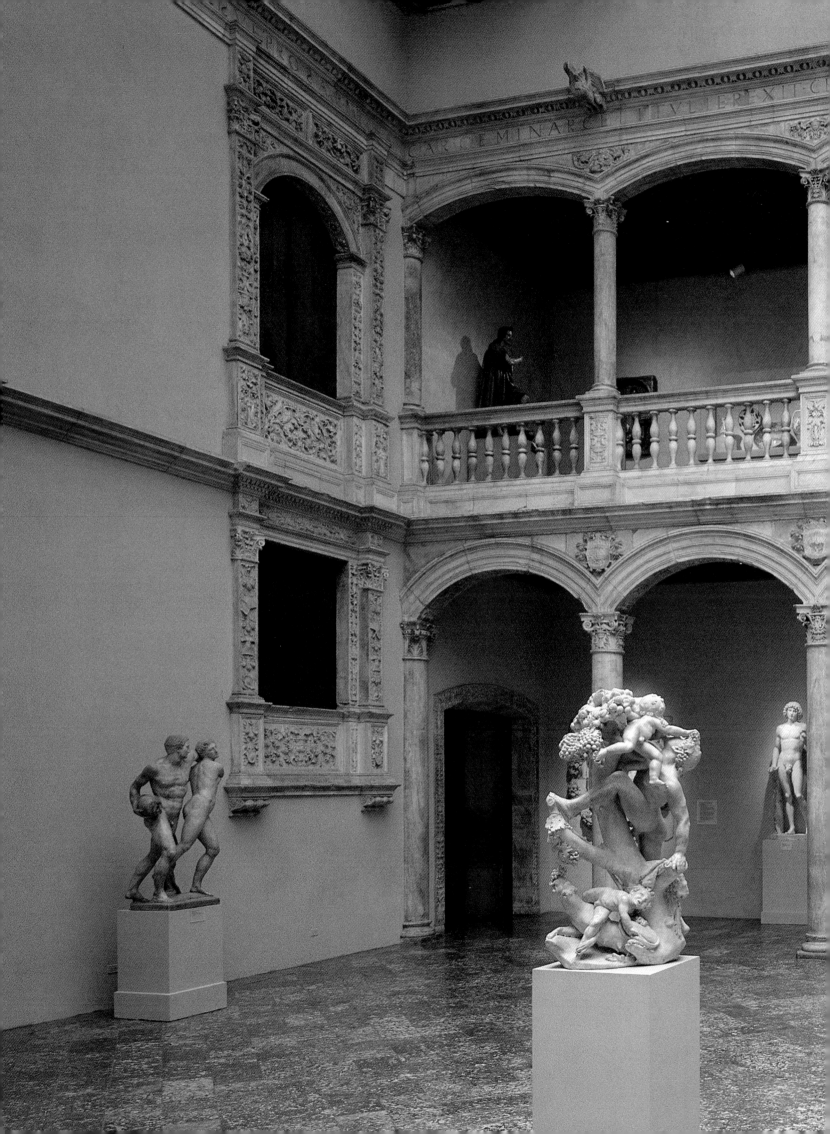

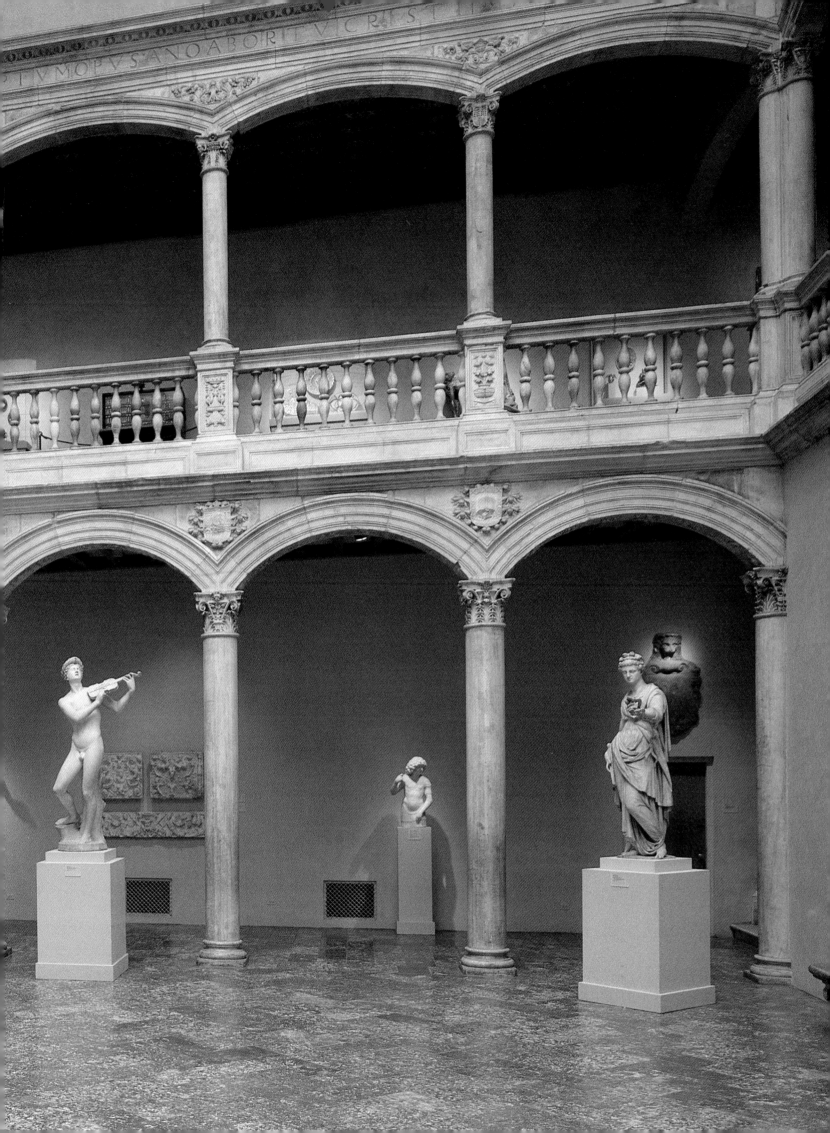

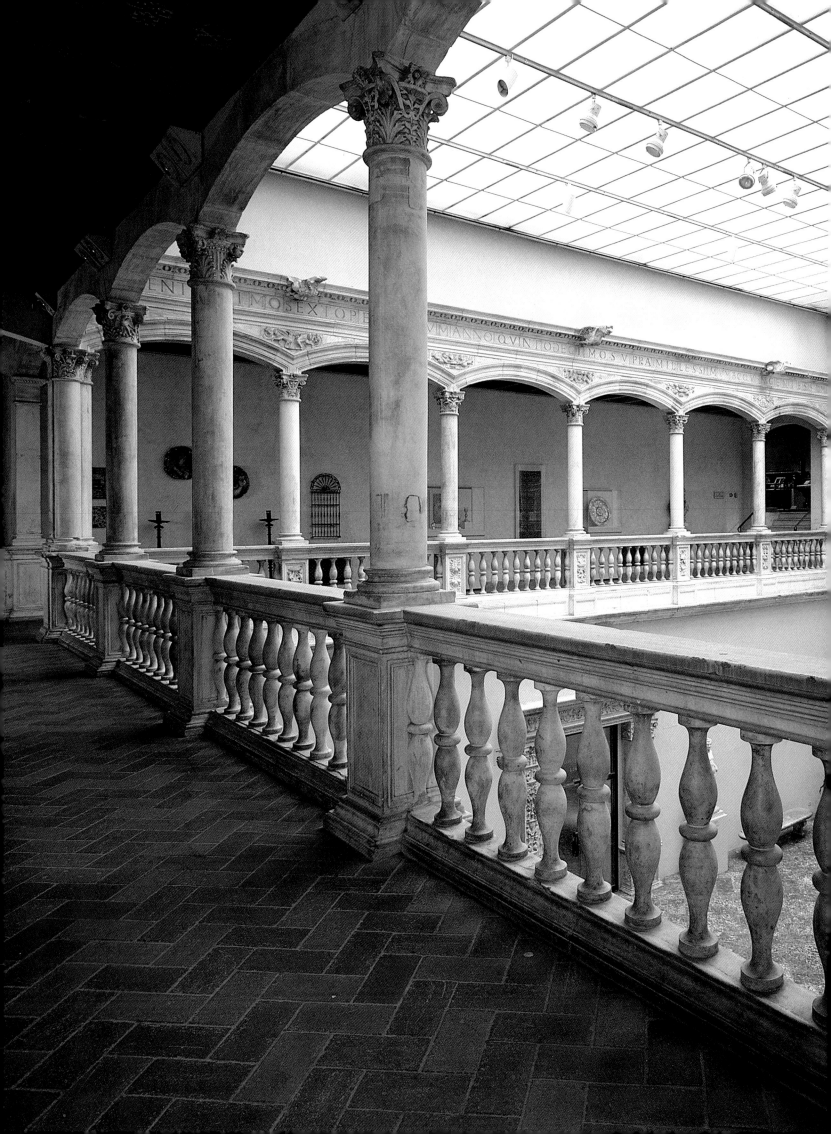

91 Decorative Reliefs
Spain, mid-16th c.
Alabaster;
each 25½ x 29½ in.
(64.8 x 74.9 cm.) Gift of
J. Pierpont Morgan,
1916 (16.32.42,43)

Decorative Reliefs from Spain

These alabaster reliefs once formed part of the architectural decoration on the outside of a building, believed to have been in the neighborhood of Saragossa. The right-hand panel is centered on a female portrait medallion, the left on a male mask. Each panel is bordered on its outer edge by a miniature. Fanciful in subject matter, the reliefs comprise a variety of arabesques and serpentine curves as well as anthropomorphic forms—tendrils grow out of a headless torso and vines end in human faces. The carving of the panels ranges from shallow to high relief, and the play of light over the variegated surfaces must have added greatly to their animation.

These reliefs illustrate the way in which the grotesque style of decoration spread throughout Europe following excavations conducted in the Golden House of Nero. The lively intricacy of wall decoration as practiced by the ancient Romans was intently scrutinized by one generation of artists after another.

Opposite: balcony from Vélez Blanco, see text on page 119

92 *Ornamental Design*, ca. 1540
Enea Vico
Parma, 1523–67
Engraving; 4¼ x 9¼ in.
(10.8 x 23.5 cm.)
Harris Brisbane Dick Fund,
1953 (53.600.58)

93 *Ornamental Design*, ca. 1540
Enea Vico
Parma, 1523–67
Engraving; 4 x 10½ in.
(10.2 x 26.7 cm.)
Harris Brisbane Dick Fund,
1924 (24.10.14)

ENEA VICO
Ornamental Designs

The vocabulary of ornamental motifs remains largely unchanged from ancient times. Forms, gleaned mostly from nature, were adapted for designs in Egypt, Mesopotamia, and Greece, and in successive centuries it has been the province of the illustrator to embroider upon a variety of established examples.

The vines and acanthus leaves pictured above entered the vocabulary with the Alexandrian Greeks. Here they are fashioned according to the whim and inspiration of the Renaissance artist Enea Vico. He made these engravings for a set of plates, probably in Rome in the 1540s. In one, the basic acanthus *rinceau*—or curling vine—is developed into an openwork cornucopia of leaves and fruit; in the other, Vico has placed a ram among the tendrils and has lined the creature's back with scales of acanthus.

BRONZINO
Portrait of a Young Man

The quintessentially aristocratic sitter in this portrait was at one time identified as a duke of Urbino, where Bronzino worked from 1530 to 1532, prior to his extensive employment by Cosimo I de' Medici in Florence. The young man is, however, certainly Florentine, a fact attested to by the sophisticated forms of the architecture and the extravagantly playful details of the Mannerist furniture (note the bizarre faces on the table and the chair arm, for example). X-rays of this painting reveal a number of significant changes. Originally, the features of the sitter were somewhat different: The mouth was higher, the head was narrower, and the hands were placed differently (the right hand held an open book). Even the background underwent a thorough revision: Originally, the dominant motif was a diagonally receding wall, and the complex geometry of the present setting, which acts as such an effective foil for the lively silhouette of the figure, was absent. One of Bronzino's finest portraits, the picture seems to have been painted in the late 1530s, when his powers were at their peak.

94 *Portrait of a Young Man*
Bronzino
(Agnolo di Cosimo di Mariano)
Florence, 1503–72
Oil on wood; 37⅝ x 29½ in.
(95.5 x 74.9 cm.) Bequest of
Mrs. H. O. Havemeyer, 1929,
H. O. Havemeyer Collection
(29.100.16)

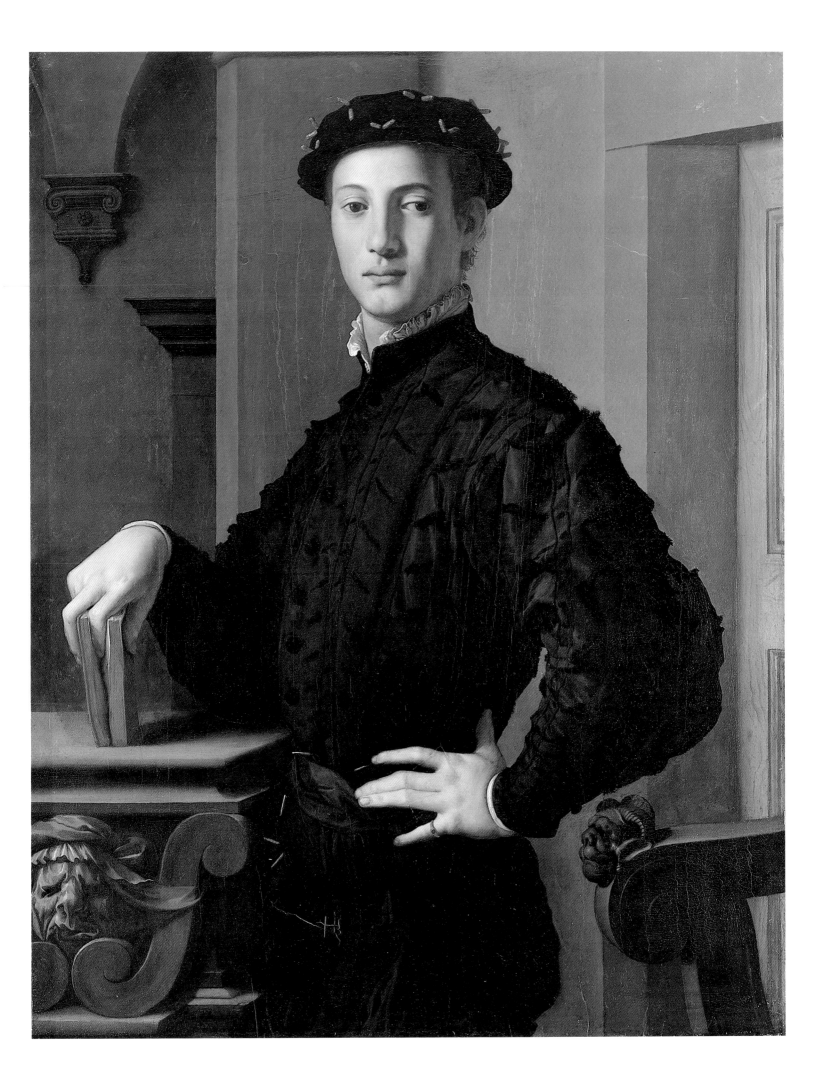

Majolica Dish

This finely articulated majolica dish was part of a service made in the workshop of Orazio Fontana in Urbino, around 1565, and thought to have been designed for Inigo d'Avalos, archbishop of Turin. Majolica was extremely popular throughout central and northern Italy, and the Fontana factory was one of the most distinguished producing this type of ware.

The Fontana factory, the best-known majolica factory in Urbino, was founded around 1520 by Guido Pellipario, who took the name Fontana. Later, it was carried on by his son, Orazio. Although later known for its *bianco di faenza* works, plainer versions of majolica, in its early days the factory produced mainly *istoriato* wares, so called because they were decorated with scenes from myths and ancient tales. The Metropolitan Museum's dish is an excellent example of the *istoriato* style.

The dish tells the story of Amadis of Gaul, a Spanish romance that was popular from the second half of the fifteenth century on, but which had its origins several hundred years earlier in France. It relates the trials of Amadis, son of the king of Gaul, and a daughter of the king of Lesser Britain. Abandoned in an ark on the river by his royal mother, Amadis nonetheless grew up as the flower of chivalry. He fell in love with the princess Oriana, who was promised by her father to the emperor of Rome. After many battles and tribulations, Amadis ended up winning his beloved's hand. The story was so popular that it inspired several sequels involving the children of Amadis and Oriana.

95 *Dish*
Urbino, ca. 1565
Majolica;
W. 26¼ in. (66.7 cm.)
Bequest of George Blumenthal,
1941 (41.190.109)

Above: detail

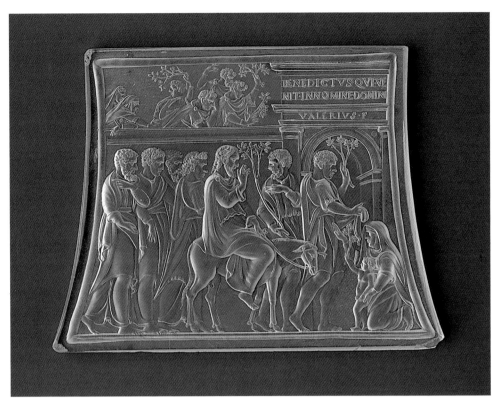

97 *The Institution of the Eucharist*,
1547–48
Fra Damiano da Bergamo
(Damiano di Antoniolo de Zambelli)
Bologna, ca. 1490–d. 1549
Walnut, inlaid with various woods;
60¾ x 40⅞ in. (154.3 x 103.7 cm.)
Gift of the children of
Mrs. Harry Payne Whitney, 1942
(42.57.4.108)

96 *The Entry into Jerusalem*, after 1532
Valerio Belli
Vicenza, 1468–1546
Rock crystal;
2⅜ x 3⅛ in. (6 x 7.9 cm.)
Bequest of George Blumenthal, 1941
(41.190.203)

VALERIO BELLI
The Entry into Jerusalem

The carving of rock crystal plaques was a quintessential art
form at the peak of the Renaissance. Carved intaglio-style
by a handful of northern Italians, who were both immensely
gifted in terms of elegant and stately composition and very
secure in their painstaking technique, these plaques were
avidly sought by the mightiest prelates and princes. Valerio
Belli of Vicenza was the most gifted crystal carver of his
generation. In classicistic designs such as this one, with its
well-paced group flowing past an arch of triumph, he proved
himself time after time to be a Raphael of sorts within his
own small sphere. The plaque is signed and appears to be a
rethinking of a composition that appears on a coffer for
Pope Clement VII in the Palazzo Pitti, Florence, that was
finished in 1532. The curved sides of the Museum's plaque
suggest that it, too, was made for the side of a small casket.
Fitted with engraved plaques that allow the passage of light
through their walls, such coffers must have seemed nearly
miraculous marriages of linearity and transparency.

FRA DAMIANO DA BERGAMO
The Institution of the Eucharist

The chapel of La Bastie d'Urfé (the seat of the Urfé fam-
ily) was lined with intarsia walnut panels that reflected the
Italianate taste of Claude d'Urfé, the French ambassador to
the Council of Trent. There is a contemporary reference to
"a little chapel with altarpiece for Henry II, King of France,"
ordered in 1548 by the ambassador. The chapel remained
at the Urfé estate near Lyons until 1874, when it was sold,
together with many of the contents of the chateau. It was
eventually bought by Harry Payne Whitney, who incorpo-
rated it in the decoration of his Renaissance-style house in
New York. *The Institution of the Eucharist* was combined
with other panels to create a grand entrance to the dining
room. Since 1968, it has been displayed as the altarpiece in
the Museum's reconstruction of the chapel.

Fra Damiano da Bergamo contributed greatly to the de-
velopment of pictorial marquetry. The excellence of his work
attracted the attention of both Pope Clement VII and Em-
peror Charles V. *The Institution of the Eucharist* was based on
a design by the great architect Jacopo Barozzi da Vignola.

The chapel was dedicated to the Holy Eucharist, so the
moment selected during the Last Supper is significant. Ear-
lier generations of artists had focused on Christ's predic-
tion of his imminent betrayal. The choice of the subject,
emphasized by the inscription *hoc est corpus meum* (this is my
body), is in keeping with Counter-Reformation concentra-
tion on the sacrament.

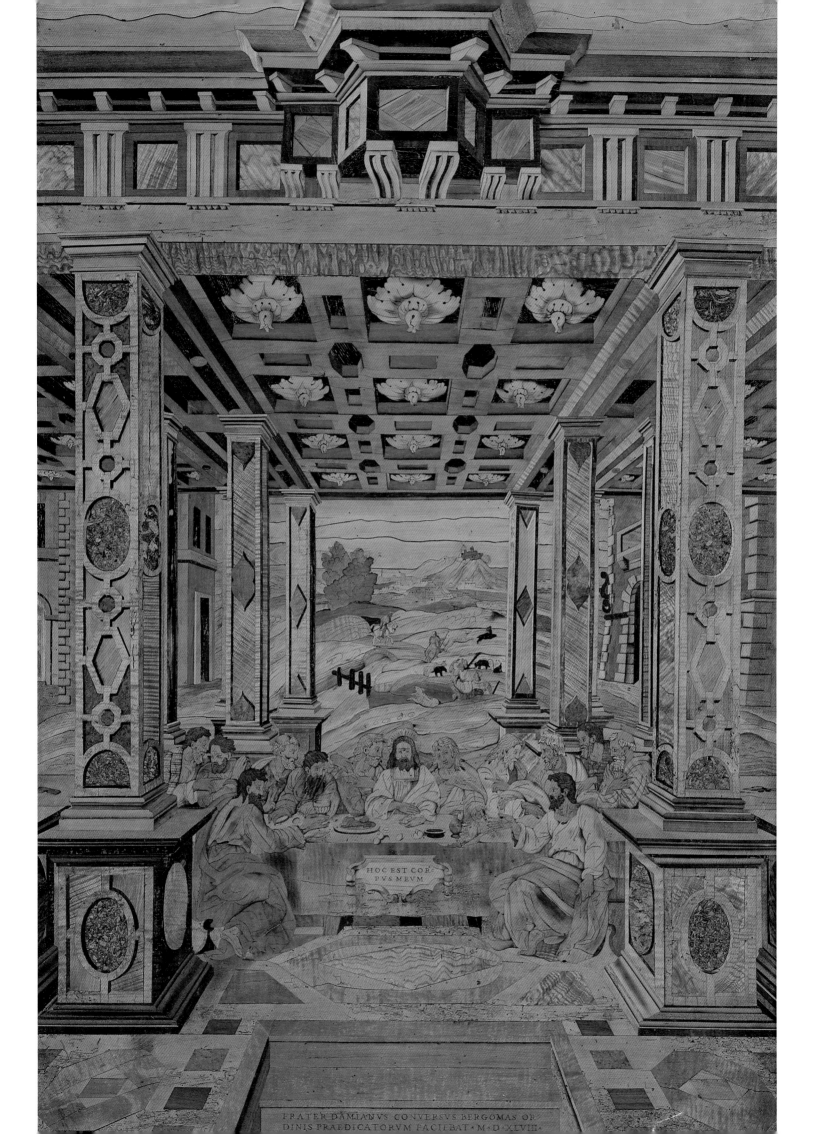

HOC EST COR
PVS MEVM

FRATER DAMIANVS CONVERSVS BERGOMAS OR
DINIS PRAEDICATORVM FACIEBAT · M · D · XLVIII ·

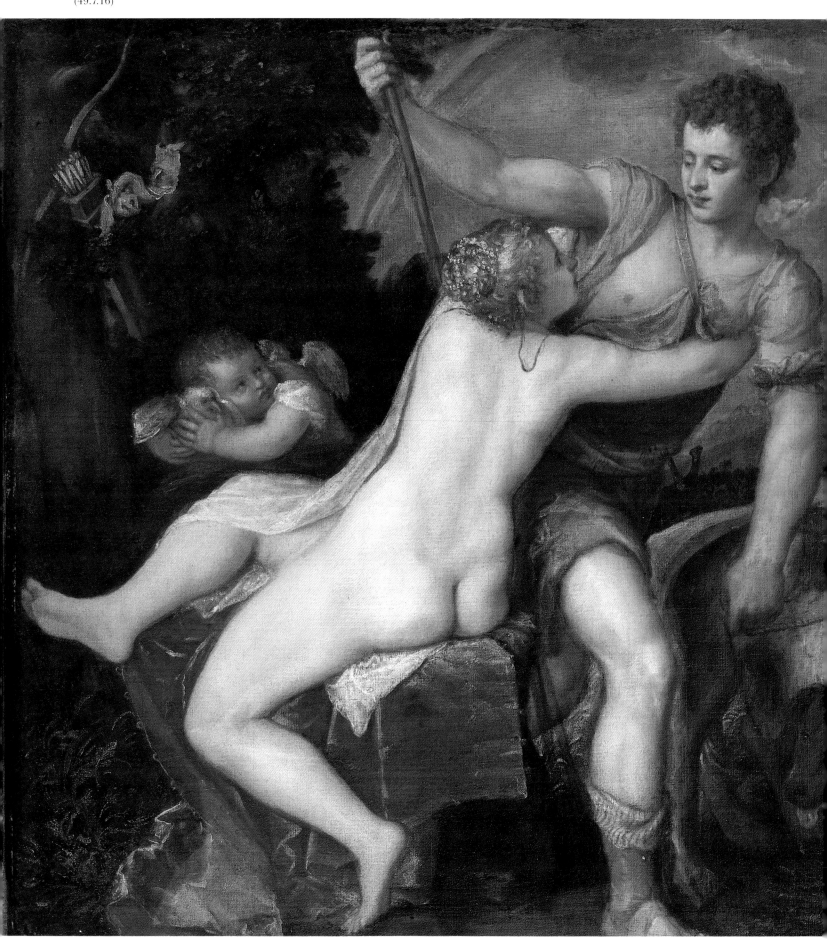

TITIAN
Venus and Adonis

In 1545–46, Titian painted the first of several canvases depicting the story of Venus and Adonis as told in Ovid's *Metamorphoses*. In the picture in The Metropolitan Museum, painted in the 1550s and one of the finest of the group, Titian has taken a good deal of license with Ovid's story. He shows Venus attempting to restrain Adonis from departing for the hunt in which, unbeknownst to either of them, he will be killed by a wild boar. Cupid cowers at this show of manly resolution and protectively clutches a turtle dove, a symbol of love. The two lovers, whose poses derive from an ancient sarcophagus relief, are shown against a dazzling landscape with a rainbow to one side and a shower of golden light to the other.

In one of his letters to Philip II of Spain, for whom he painted a Venus and Adonis, Titian refers to the composition as a *poesia;* it is clear that foremost in the artist's mind was the creation of a visual equivalent to the poetry of Ovid that inspired him. No less important was the depiction of the female nude. Indeed, in the same letter he informs Philip that since in a companion picture he had shown a female nude viewed from the front, here he wished "to vary and show the opposite part of the body, so that it will make the room in which they are to hang, more pleasing to see." By a happy coincidence, the picture of *Venus and the Lute Player* (Plate 99) in the Museum shows Venus in precisely the sort of frontal view that Titian had in mind for the companion picture.

OVERLEAF:

TITIAN (Pages 132–133)
Venus and the Lute Player

Titian painted five pictures showing Venus with a musician playing either an organ or a lute, a theme apparently inspired by the Neoplatonic debate as to whether beauty is apprehended more perfectly through the ear or the eye. This canvas is the latest of the five. It seems that it was left unfinished at Titian's death and that the figure of Venus was completed by another hand. Here Venus reclines on a bed, behind which is suspended a curtain. She lays aside her recorder and turns toward Cupid, who crowns her with flowers. At her feet, a young man in rich costume playing a lute turns to gaze at her, enjoying beauty with both the eye and the ear.

The landscape, painted in the loose, suggestive fashion typical of Titian's late works, is of exceptional beauty. To the left, against a sunset sky, are the foothills of the Alps. In the middle ground, figures dance to the music of a shepherd's pipes, giving an appropriately bucolic slant to this picture of love and music.

99 *Venus and the Lute Player*, 1560s
Titian (Tiziano Vecellio)
Venice, ca. 1488–d. 1576
Oil on canvas; 65 x 82½ in.
(165.1 x 209.6 cm.)
Munsey Fund, 1936 (36.29) *131*

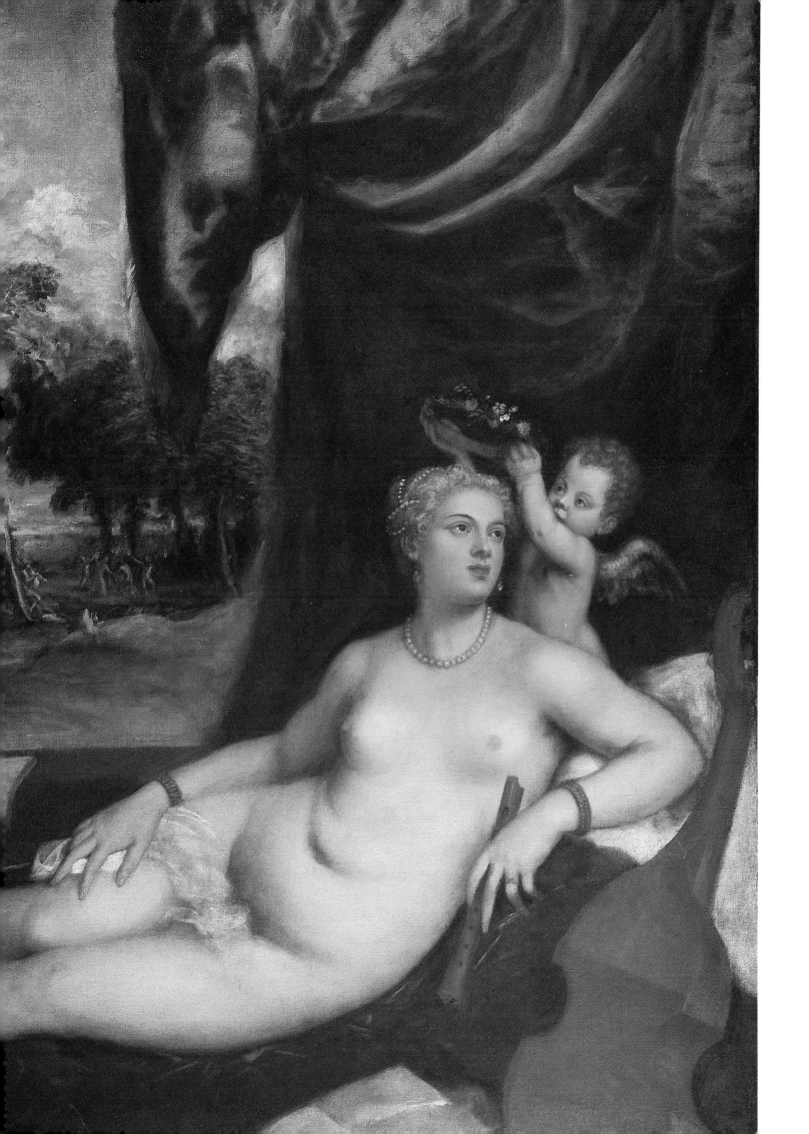

100 *Pentagonal Spinet*
Venice, 1540
Wood, various other materials;
L. 57¼ in. (145.3 cm.);
W. 19 in. (48.3 cm.)
Purchase, Joseph Pulitzer Bequest,
1953 (53.6)

Pentagonal Spinet

Spinets, with a light, crisp tone suitable for the dances and popular tunes of the day, were the favorite keyboard instruments of the nobility in sixteenth-century Italy. An inscription on this particular spinet informs us that it was built for Eleonora d'Este, duchess of Urbino, and also how much was paid for it. Eleonora d'Este, wife of Francesco Maria della Rovere, grew up in Mantua in the cultivated atmosphere that permeated Renaissance Italian courts. Music, both religious and secular, was held in high regard.

Built by an unknown Venetian instrument maker, the spinet is richly decorated with intarsia and carvings. The shape of the instrument is dictated by functional necessity; the fifty brass strings run parallel to the front wall, the long bass strings at the front and the shortest, highest ones at the back. The keyboard, which, unlike those of the related

Flemish virginals of the period, juts out from the front and is held in place by an intricately carved wooden block at each end, spans four and a half octaves. The sound hole is ornamented with several layers of decorated parchment, in the style of a Gothic rose window, and the front wall has nine square panels of alternating patterns, four with mother-of-pearl inlay and five with Gothic tracery stars.

There is an additional inscription, lighthearted in the humanistic vein of the time. It reads (in Italian), "I'm rich in gold and in tone/ If you lack virtue, leave me alone" (a double entendre referring to the player's spiritual as well as technical virtues). This pentagonal spinet is in perfect playing condition, with a crisp, clear tone. It has been used at The Metropolitan Museum of Art for both concerts and recordings.

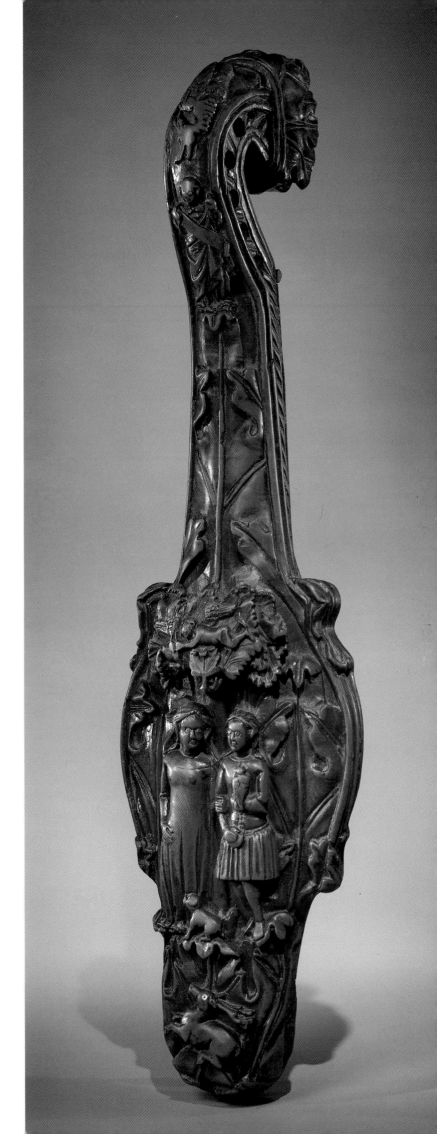

101 Mandora
Northern Italy, early 15th c.
Boxwood, spruce, rosewood;
L. 14½ in. (36.9 cm.)
Gift of Irwin Untermyer, 1964
(64.101.1409)

MANDORA

This stringed instrument, dating from the early fifteenth century in northern Italy, has been so altered over the years that it is hard to tell whether it was originally plucked or bowed. The pattern of wear and the instrument-playing figure that decorates the top of the pegbox lead to the informed guess that it was a mandora—a small, lutelike instrument that was played by plucking its five strings. It was obviously an instrument of some value because it is beautifully decorated with carved figures and patterns. The nuptial symbolism, including hearts, rosettes, and a young couple posed beneath a Cupid, suggests that it was designed as a betrothal gift for a young girl. The mandora was favored for the playing of love songs, and the light sound that would have been produced by an instrument of this size and depth would clearly have been suited to a female voice.

Two Portraits

The painter Moretto da Brescia (Plate 102) determined the character of sixteenth-century painting in Lombardy, the area of the cities of Brescia, Verona, and Bergamo. The distinguishing trait of the Lombardy School was a pervasive naturalism—Vasari described Moretto's works as *molto naturali*—that contrasts with the work of Venetian artists, despite the geographical proximity of Brescia to Venice. The sitter in the Museum's portrait has been identified as a member of the Martinengo family in Brescia, but there is no proof for this. To a degree, Moretto's composition recalls contemporary portraits by Titian, but Moretto has emphasized such still-life details as the oriental carpet and the hourglass, a traditional symbol of the passage of time and the brevity of life, and he has employed a more descriptive style. Painted in the early 1520s, the picture is one of Moretto's finest, most evocative portraits.

The portrait reproduced in Plate 103 is by Moroni, who studied with Moretto and was the major Lombard painter in the generation following that of his teacher. The sitter is identified by the inscription as Bartolommeo Bonghi, a member of one of Bergamo's oldest families, who was a doctor of both canon and civil law as well as a distinguished jurist. In his left hand, Bonghi holds a book—a commentary on Justinian's codification of Roman civil law, the *Pandects;* the author, Camillo Plauzio Pezzoni, dedicated the work to Bonghi in 1553, the year Bonghi served as rector at the University of Pavia, where Pezzoni was a colleague. The portrait may have been painted in that year, to commemorate Bonghi's rectorship.

Through the window in the background is the *palazzo communale* of Bergamo, shown as it appeared prior to work carried out in 1551–52. The inscription is obviously posthumous, since it records Bonghi's death. Analysis of the painting under infrared light reveals that originally the base of the window had a deep sloping ledge, viewed from the same angle as the rest of the objects in the portrait. Of extraordinary sobriety and meticulous detail, the picture beautifully exemplifies Moroni's objective approach to portraiture.

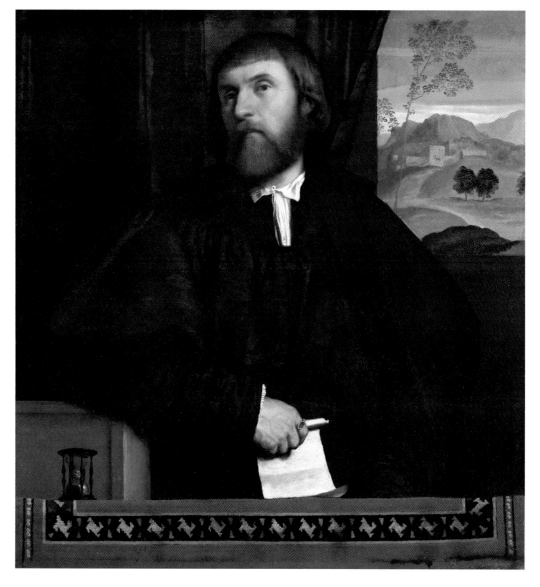

102 Portrait of a Man, ca. 1520–25
Moretto da Brescia
(Alessandro Bonvicino)
Brescia, 1498–1554
Oil on canvas;
34¼ x 32 in. (87 x 81.3 cm.)
Rogers Fund, 1928 (28.79)

103 Bartolommeo Bonghi, 1553(?)
Giovanni Battista Moroni
Brescia, ca. 1530–78
Oil on canvas;
40 x 32¼ in. (101.6 x 81.9 cm.)
Purchase, Joseph Pulitzer
Bequest, 1913 (13.177)

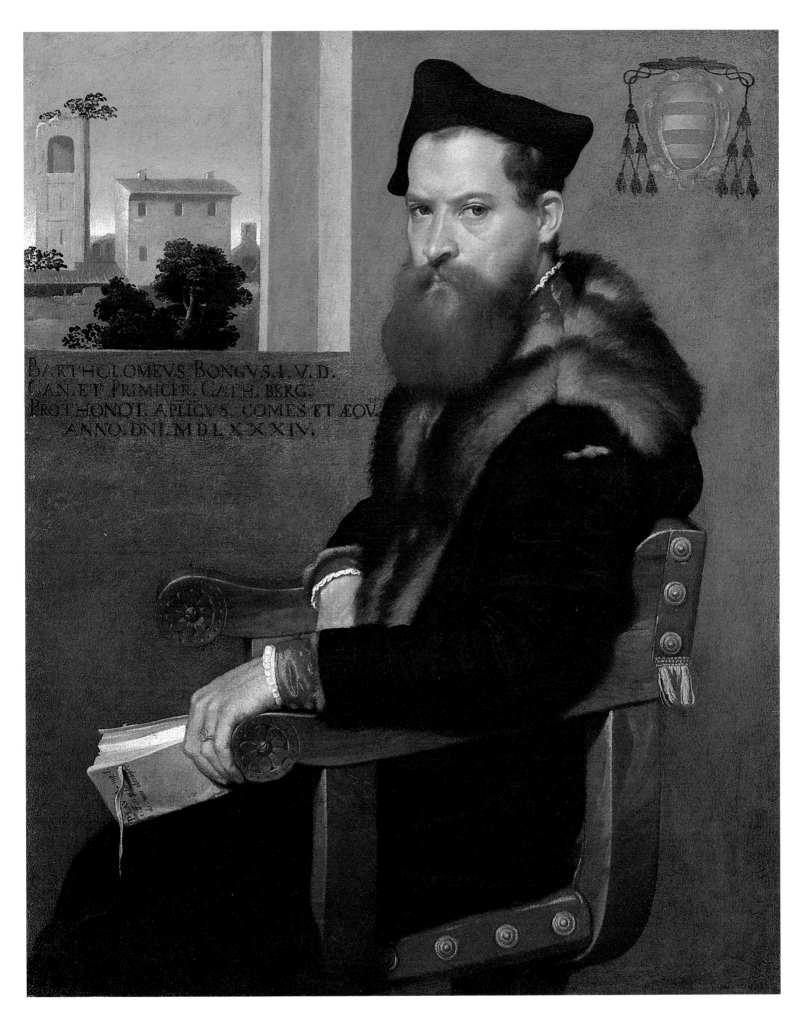

BARTHOLOMEVS BONGVS.I.V.D.
CAN.ET PRIMICER.CATH.BERG.
PROTHONOT.APLICVS.COMES ET ÆQV.
ANNO.DNI.M.D.L.X.X.X.IV.

137

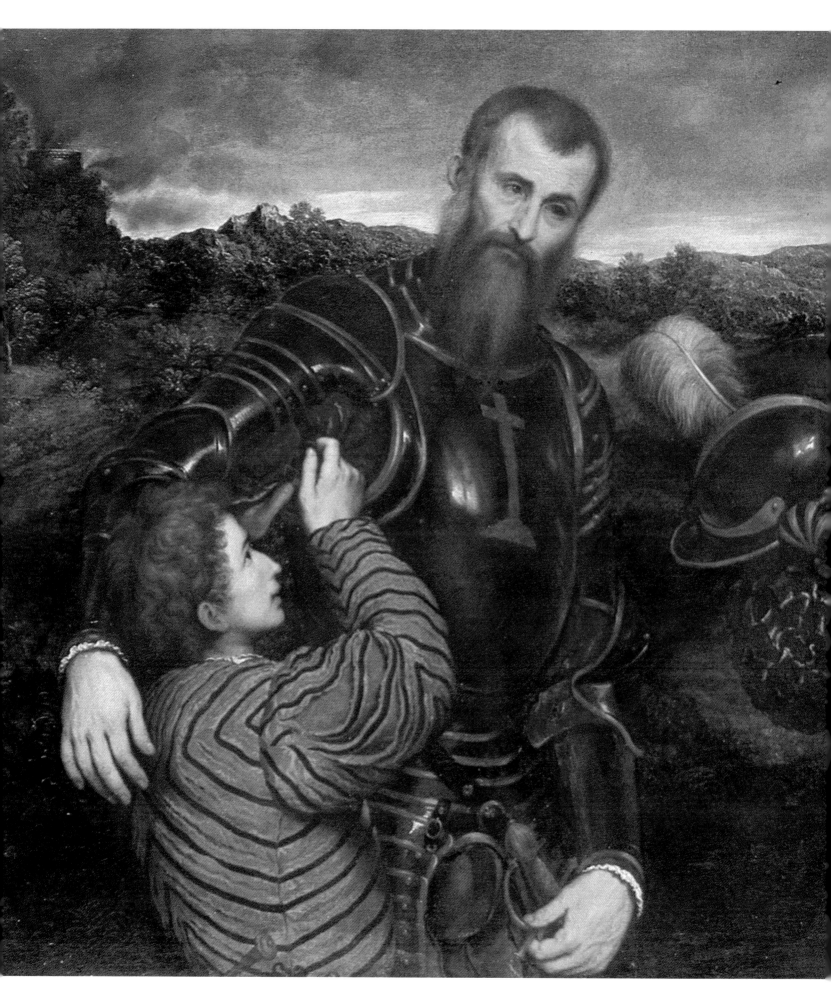

104 Portrait of a Man in Armor with Two Pages, ca. 1540
Paris Bordon
Venice, 1500–71
Oil on canvas; 46 x 62 in.
(116.9 x 157.5 cm.) Gift of
Mr. and Mrs. Charles Wrightsman,
1973 (1973.311.1)

PARIS BORDON

Portrait of a Man in Armor with Two Pages

This striking portrait shows a high-ranking officer on the field of battle with two pages, one of whom holds his helmet while the other fastens the armor on his right arm. It may be identical to a portrait of Carlo da Rho that Bordon painted in Milan about 1540. Carlo da Rho, who died in an expedition against the Turks in 1559, is known to have been a commander of foot soldiers rather than cavalry, and indeed foot soldiers are shown in the background. Although Bordon was trained by Titian, his paintings have a somewhat mannered quality and show an attention to detail that relates him to northern Italian traditions.

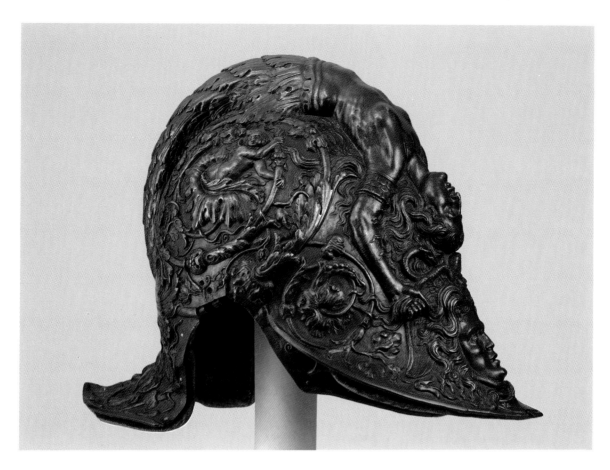

FILIPPO NEGROLI
Parade Helmet

The parallel development of functional armor and highly decorated pieces made purely for display reached a climax in the sixteenth century. This parade helmet was made in 1543 by one of the great Italian armorers of the period, Filippo Negroli of Milan.

The elaborate embossing of its decoration provides a good example of Negroli's skill. The rich brown patina of the surface makes the helmet look as if it were cast of ancient bronze, and the classicizing ornaments, hammered from a single piece of steel, display the Renaissance attempt to evoke the decorative vocabulary and taste of the ancients. The motifs are derived from the grotesque decorations of the then newly discovered ruins of Nero's Golden House in Rome. A mermaid, her fishtail scaly with acanthus, forms the crest of the helmet. Reclining, she holds in her uplifted arms a head of Medusa, which stares over the helmet's umbril.

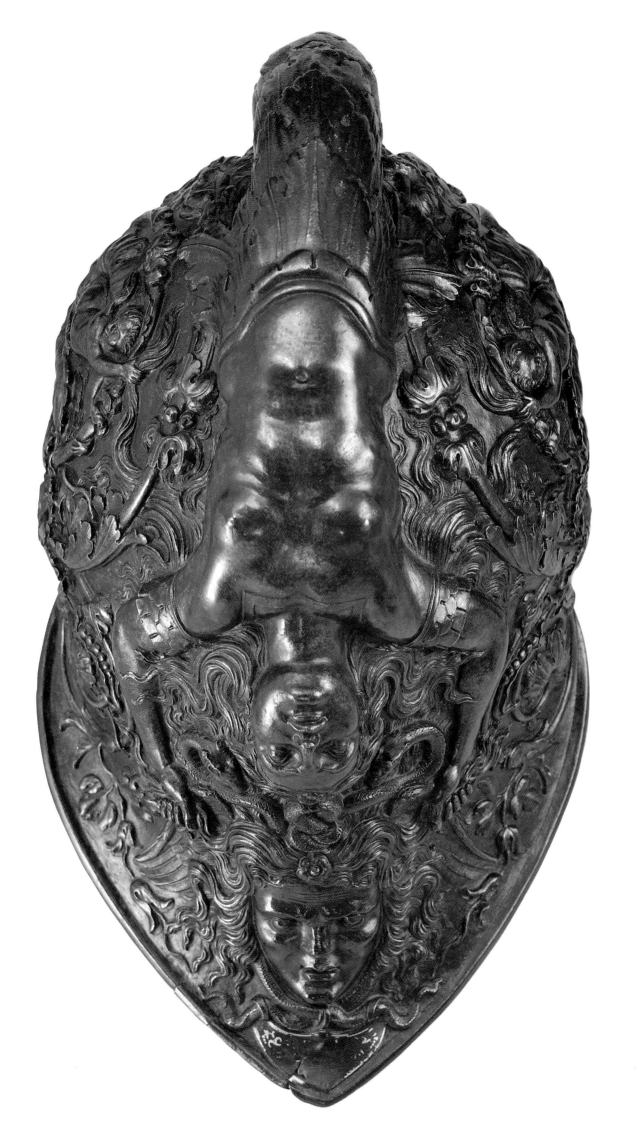

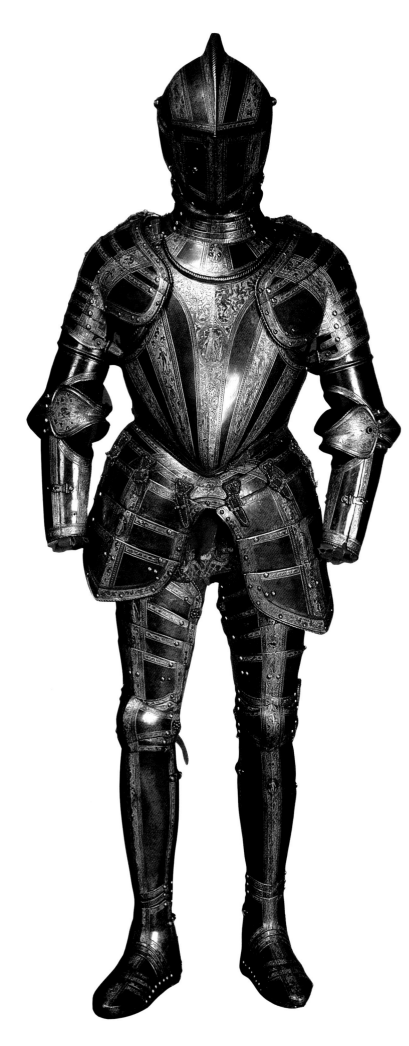

SUIT OF ARMOR

By the time this suit of armor was produced—toward the end of the sixteenth century—armor as a means of protection in battle was in danger of becoming obsolete. Firearms had progressed to a state that would soon require armor so heavy it would be impractical to wear. Armor continued to be made, however, as a sort of jewelry for the male, for display of wealth and rank in court ceremonies, sports, and tournaments. As the sixteenth century progressed, so did the degree of decorative attention lavished on the creation of armor. From the beginning of its use, plate armor had reflected the clothing styles of the day, since it had to cover them closely. As its practical purpose waned, the alliance of armor and fashion became closer; puffed sleeves with slashes were echoed in steel, and the textures of elaborate fabrics and embroideries were imitated in inlay on the surface.

The patterned steel of the upper section of this suit of armor mimics the ribbed construction of a contemporary Spanish doublet (Plate 107), and the tasset, or skirt, resembles the trunk hose worn at the time. The entire surface is etched and gilded in bands with oval and shield-shaped designs that enclose symbolical and mythological figures. They include Castor and Pollux, Venus, Mercury, Flora, Mars, and Perseus, while the borders are decorated with birds, dolphins, griffins, and grotesque animals. Part of the original scarlet velvet lining remains, and some of the original bright blue color can still be seen on the bowl where the chin defense overlapped. The rest, however, has turned a russet brown.

106 Suit of Armor
Italy, ca. 1580
Etched and mercury gilded,
also chiseled and overlaid
with gold and silver;
Wt. 52 lbs. (23.6 kg.) Gift of
Stephen V. Grancsay, 1942
(42.50.27)

MAN'S DOUBLET

Paintings, which are the primary visual source for research about costume before the eighteenth century, cannot furnish the kind of information that actual garments provide. For example, from a careful look at the front panels of this doublet, we learn that it is the use of the grain of the fabric, cut on the bias, that helps it to fit smoothly and that gives the doublet its fashionable elongated and protruding center front, called a peascod belly.

For several centuries, the doublet was an indispensable article of gentlemen's apparel. It evolved from the protective padded shirts worn under armor during the Middle Ages. To fit comfortably, particularly under plate armor, it had to be shaped closely to the body. For this reason, doublets are probably the earliest examples of "tailor-made" clothing. In the latter part of the seventeenth century, they grew longer and became waistcoats. Today's men's vests are descendants of the doublet.

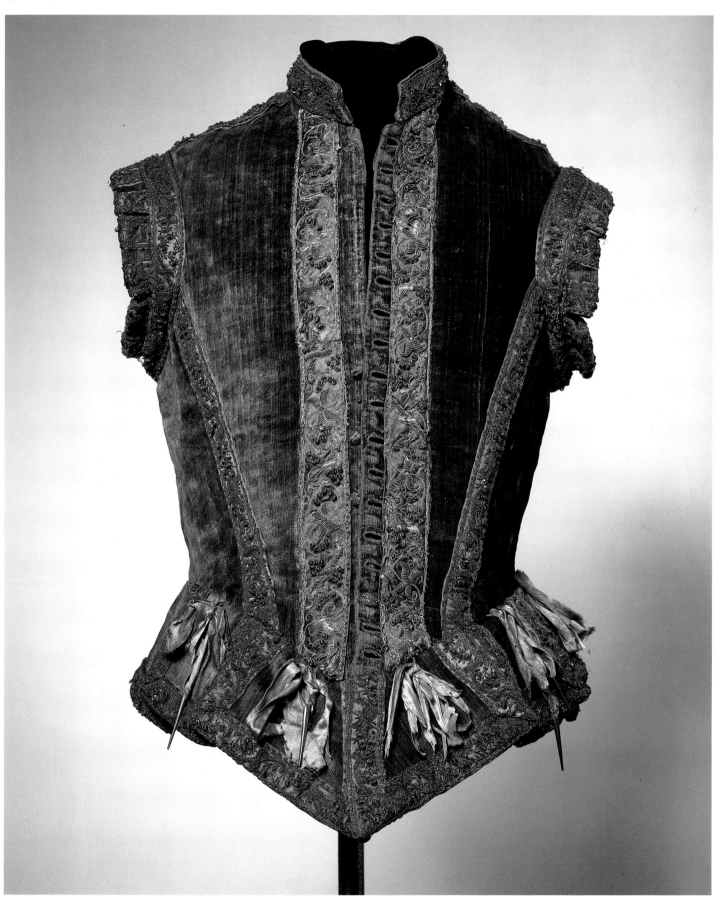

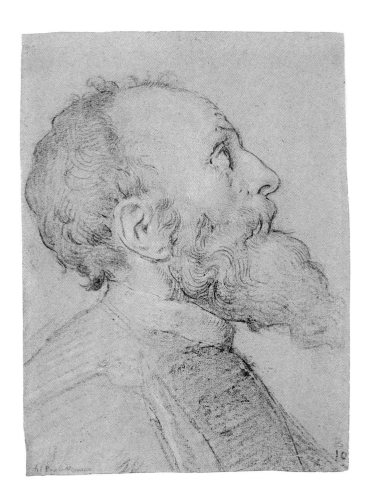

108 Head of a Bearded Man
Paolo Veronese (Paolo Caliari)
Venice, 1528(?)–1588
Black chalk on faded blue paper;
10¼ x 7⅞ in. (26 x 19.9 cm.)
Robert Lehman Collection, 1975
(1975.1.544)

PAOLO VERONESE
Mars and Venus United by Love

Painted in the artist's lush mature style, *Mars and Venus United by Love* is much more typical of the type of art generally associated with Paolo Veronese than is the gently dignified portrait of Alessandro Vittoria (Plate 111). The figures are life-size and filled with the robust animalism and zest for life that informs Veronese's large, animated canvases.

The picture, which dates from the 1570s, is one of five great paintings by Veronese that were owned by Emperor Rudolf II in Prague. All of these works, which were not necessarily conceived as a series, illustrate abstruse allegories, and there is no consensus as to the precise meaning of the Museum's painting. In addition to the identification of the subject as Mars and Venus united by Love (in the form of a cupid who is binding their legs together in symbolic unity), the female figure pressing milk from her breast has been interpreted as Chastity transformed by Love into Charity. The unsaddled horse, whose way is barred by a cupid wielding a sword, could be seen to symbolize Passion Restrained. Another interpretation identifies the scene as the adoption of Hercules by Juno. The uncertainty surrounding the subject of this work is itself indicative of Veronese's approach to allegory: He used it as a justification for the depiction of a beautiful female nude and as a vehicle for the unsurpassed brilliance of his technique. The exact identification of his subject matter was only of secondary importance.

PAOLO VERONESE
Head of a Bearded Man

Although Veronese was born in Verona, he settled, perhaps by 1553, in Venice, where his contact with Titian proved to be of crucial importance. Veronese specialized in monumental pictures of biblical, historical, and allegorical themes. His extraordinary capacity of observation, his sense of light, and the subtlety of his colors, as well as his grace, lightness, and richness of invention place him far above any of the other grand Venetian decorators. Veronese's numerous drawings, in various techniques, are related to the execution of his canvases. The drawing shown here represents the kneeling adorant in his well-known altarpiece in San Paolo, Verona, a work dated 1565. The delicate and beautifully modeled drawing gives evidence of the master's restrained but penetrating emotional expression.

109 Mars and Venus United by Love, ca. 1570
Paolo Veronese (Paolo Caliari)
Venice, 1528(?)–1588
Oil on canvas; 81 x 63⅜ in.
(205.7 x 161 cm.)
John Stewart Kennedy Fund, 1910 (10.189)

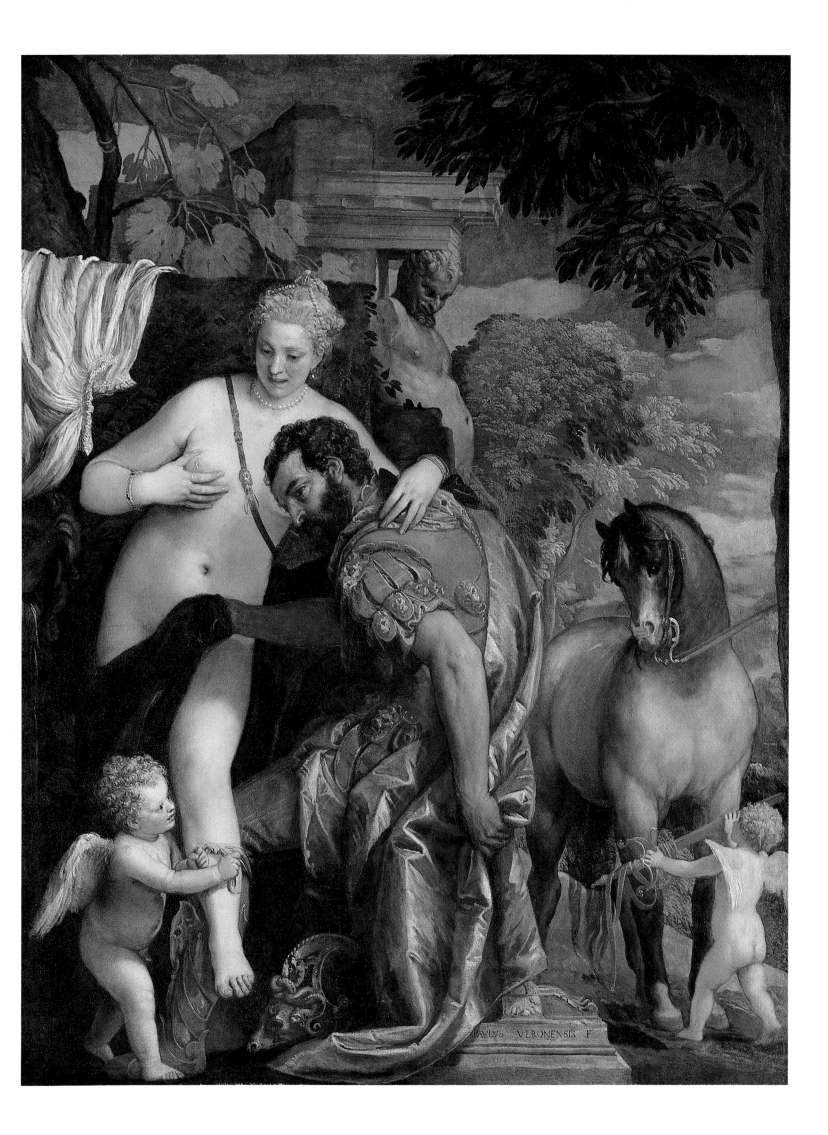

PAVLVS VERONENSIS F

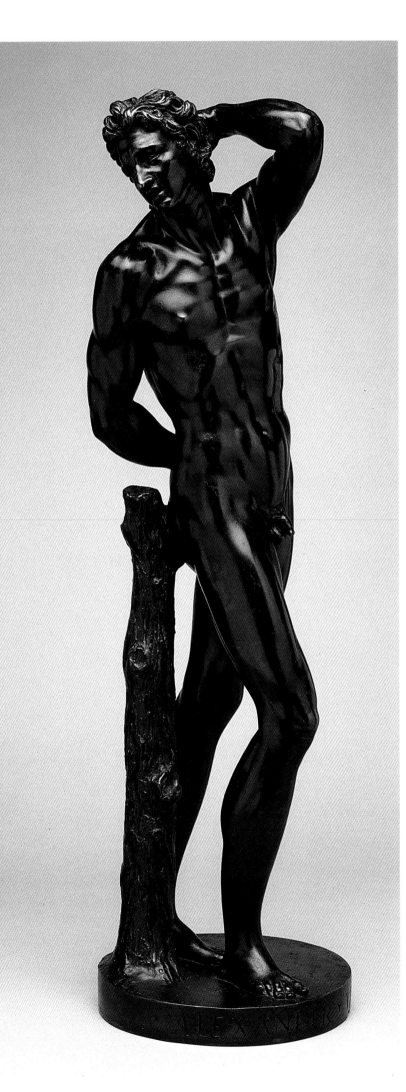

ALESSANDRO VITTORIA
Saint Sebastian

Alessandro Vittoria, the subject of Plate 111, was a distinguished Venetian sculptor of portrait busts as well as of the small bronze statuettes that were so greatly in demand during the Renaissance. As a result of his early studies with Jacopo Sansovino and his exposure to the work of Michelangelo, there are strong strains of Tuscan influence in Vittoria's work. His projects of architectural decoration include the caryatids that stand at the entrance to the Library of Saint Mark's and the stucco work of the Golden Staircase in the Doge's Palace.

The heroic pose of the statuette of Saint Sebastian closely resembles that of a marble statue that Vittoria carved for the church of San Francesco della Vigna in Venice in 1561–63. It is possible that the success of the large statue led to a demand for smaller replicas, since this statuette was cast by Andrea da Brescia within three years after the completion of the monumental version. The Metropolitan Museum's piece is signed, and there exists documentation to the effect that Vittoria paid Andrea for this first casting in December 1566 and for another in 1575.

110 Saint Sebastian, 1566
Alessandro Vittoria
Venice, 1525–1608
Bronze; H. 21¼ in. (54 cm.)
Samuel D. Lee Fund, 1940
(40.24)

111 Alessandro Vittoria, 1545–50
Paolo Veronese (Paolo Caliari)
Venice, 1528(?)–1588
Oil on canvas; 43½ x 32¼ in.
(110.5 x 81.9 cm.)
Gwynne Andrews Fund, 1946
(46.31)

PAOLO VERONESE
Alessandro Vittoria

The subject of this portrait, Alessandro Vittoria, was the greatest Venetian sculptor of the late sixteenth century. Paolo Veronese had collaborated with him from 1560 to 1562 on the decoration of the Palladian Villa Barbaro at Maser, outside Venice. This painting, which is notable for its sobriety in a body of work that is more often colorful and theatrical, dates from about 1570, and seems to record Veronese's admiration for his colleague. Vittoria is seen holding a model for one of his most renowned works, a statue of Saint Sebastian, made in 1561–63 for the church of San Francesco della Vigna in Venice. The figure, based on the so-called *Dying Slave* of Michelangelo, now in the Louvre, was reproduced by Vittoria as a bronze statuette in 1566, and again in 1575 (Plate 110). The fragmentary torso on the table is antique, and the imagery was selected as a reference to the two prime sources of Vittoria's sculptural style.

Early in his career, Veronese was praised by Titian as the best young artist working in the Doge's Palace. He went on to share with Tintoretto the position of preeminent artist in the Venice of his time. His work was supremely visual: He painted vast oils crowded with color, action, and people, whether the subject was historical or religious. Despite problems with the Inquisition, he never lacked for noble patronage—so much so that, in the later years of his life, he had a workshop that employed his two sons and his brother to carry out much of the work.

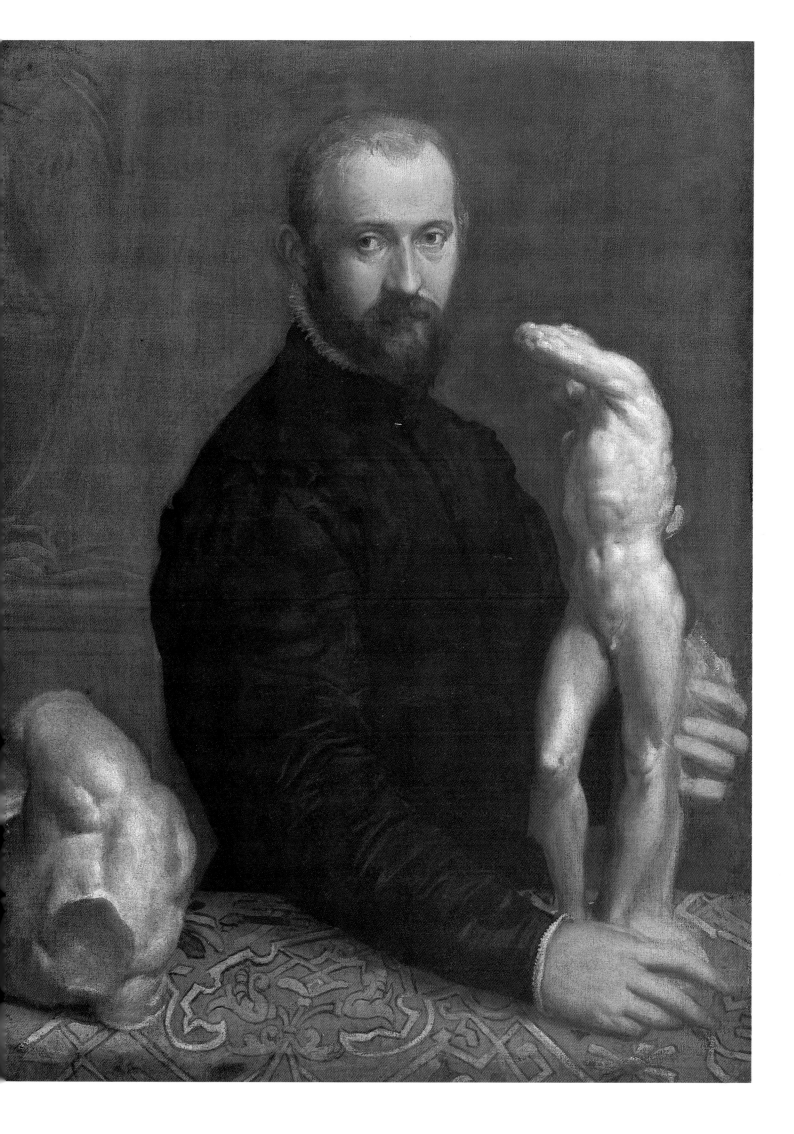

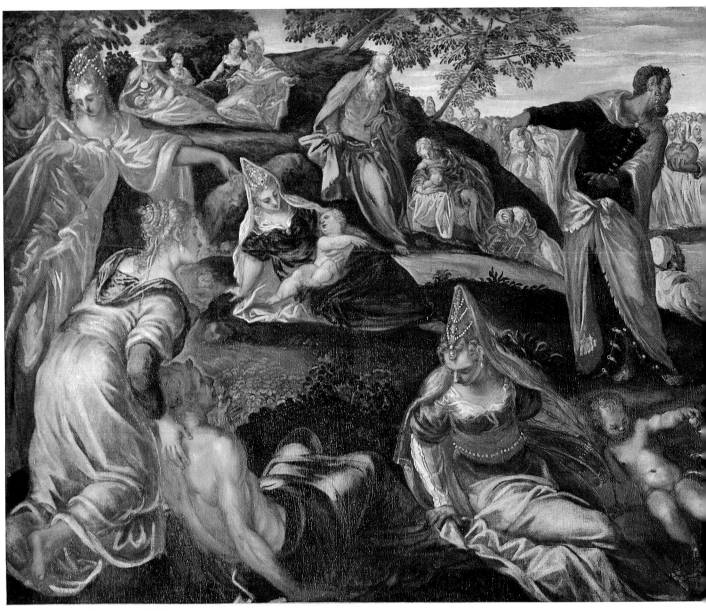

112 *The Miracle of the Loaves and Fishes,*
1545–50
Tintoretto (Jacopo Robusti)
Venice, 1518–94
Oil on canvas; 61 x 160½ in.
(154.9 x 407.7 cm.)
Francis L. Leland Fund, 1913 (13.75)

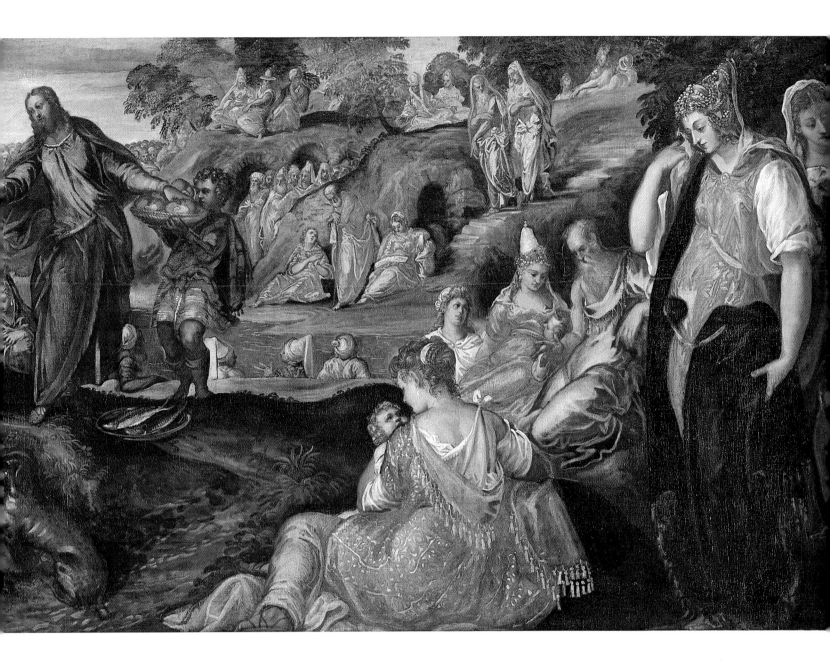

Tintoretto
The Miracle of the Loaves and Fishes

On two occasions, Christ fed an entire multitude with only a few loaves and fishes. This painting depicts the miracle as recounted in 6 John, and it shows Christ handing Saint Andrew one of the five loaves and two fishes to be distributed to the multitude. Throughout his career, Tintoretto was called upon to produce large, narrative canvases for the decoration of Venetian churches and confraternities, and there can be little doubt that this picture and its companion, a painting of Christ Washing the Feet of the Disciples in the Art Gallery at Toronto, were conceived for such a setting. They were, to judge from the angle at which the figures are

depicted, intended to be set rather high, above a decorative wainscoting. Such pictures were carried out in part by Tintoretto and in part by members of his workshop, but their execution was carefully supervised by the master.

Tintoretto drew upon an apparently inexhaustible repertory of gestures and poses that he recorded in numerous drawings; the effect of the Museum's picture is in no small measure due to his remarkable facility as a draftsman. The picture dates from about 1545–50; it is contemporary with Tintoretto's famous decoration of the Scuola di San Marco in Venice.

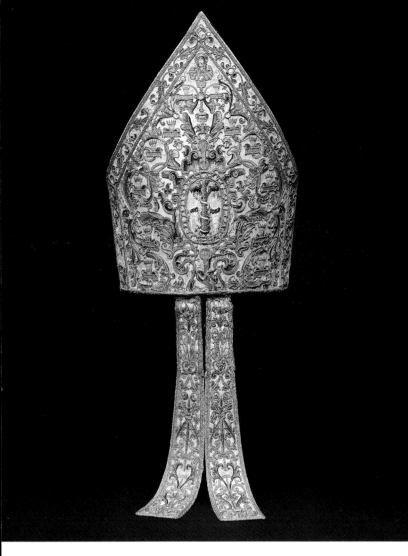

SPANISH MITRE

This mitre, from the Royal Convent of Toledo, dates from the sixteenth century and is a splendid example of ecclesiastical embroidery produced in Spain under the influence of the Italian Renaissance. It has been associated with Cardinal Francisco Jimenez de Cisneros (1436–1517), who, while archbishop of Toledo and primate of Spain, instigated the forced conversion of the Moors of Granada in 1500, and later, as cardinal, served as inquisitor general of Castile and León.

The elaborate design of the embroidery combines Old and New Testament motifs that, parallel in their symbolism, illustrate the redemption of man. On the back of the mitre, shown within a central medallion, is a depiction of the Fall from Grace, with Adam and Eve, now clothed, standing on either side of the Tree of Knowledge. Below is a figure of Jesse, from whom a tree issues forth sprouting twelve tendrils that end in the crowned heads of members of the house of David, ancestors of Christ. The tree culminates in a figure of the Virgin. On the front of the mitre, framed by an embroidered medallion, is the scene of the Annunciation. The crucified Christ is pictured directly below; twelve branches spring from the wood of the cross, terminating with the heads of the apostles. At the apex of the mitre, now partly obliterated, is Christ as the *Salvator Mundi*.

113 Mitre
Spain, 16th c.
Cream-colored silk embroidered with
metal thread and polychrome silks;
29⅛ x 12¾ in. (74 x 32.4 cm.)
Rogers Fund, 1917 (17.76)

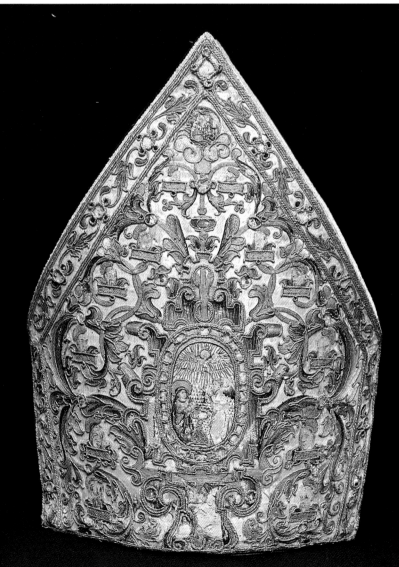

DIEGO DE PESQUERA
The Holy Family with Saints Anne and Joachim

Part of a retable made for the parish church in Ojíjares, near Granada, this panel remained in place from its creation in the mid-sixteenth century until it was sold in 1881. It was believed to be the work of Diego Silóee, but a record of its commission in 1567 establishes that the little-known Diego de Pesquera was the artist.

The surface is amazingly intact, and the relief is a model display of the Spanish *estofado* technique, in which gilding and polychromy interact in vibrant patterns. Brocaded fabrics are imitated with particular éclat.

The sculptor was in touch with manifold developments in Italian Renaissance art. There is an attractive naturalism in the broad forms of the healthy wriggling infant. No less striking is the elegantly mannered attenuation of the Virgin and Saint Anne.

*114 The Holy Family with Saints
Anne and Joachim*, 1567
Diego de Pesquera
Spain, act. 1567–68
Wood, painted and gilt;
62½ x 42 in. (158.8 x 106.7 cm.)
Bequest of Helen Hay Whitney,
1944 (45.128.5)

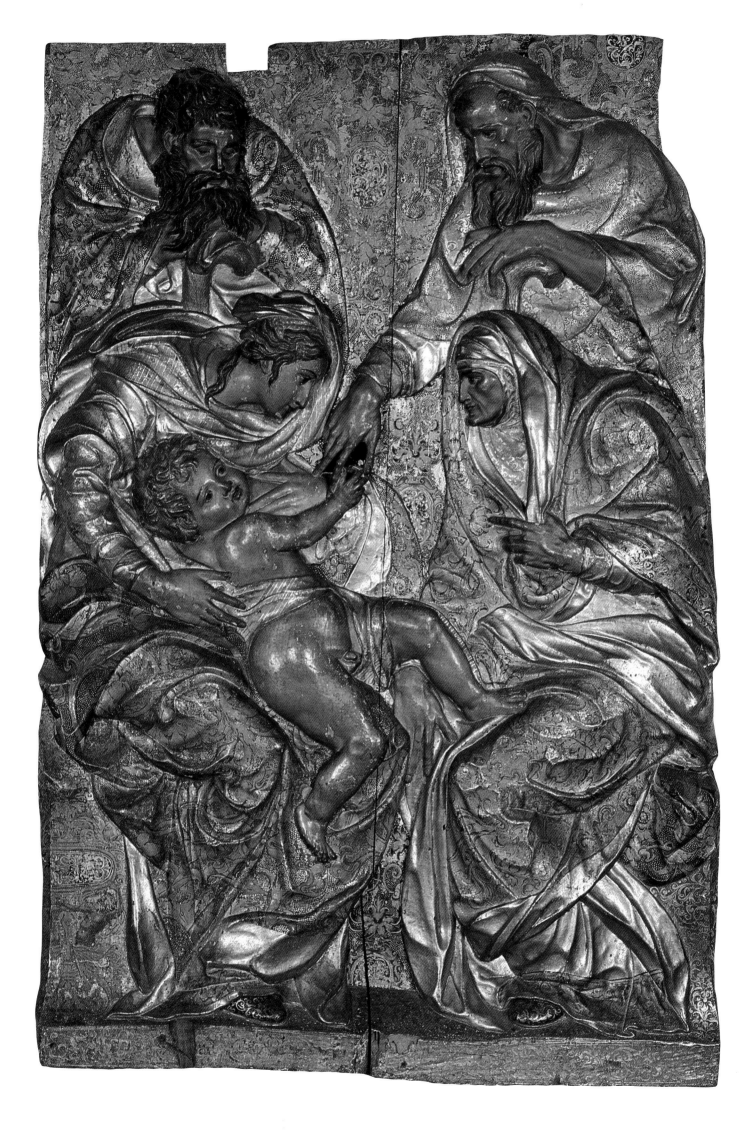

CAMEO WITH A PORTRAIT OF COSIMO I DE' MEDICI

This cameo has a profile portrait of Cosimo I de' Medici, duke of Florence from 1537 to 1569 and grand duke of Tuscany from 1569 to 1574. There are six surviving cameos that bear Cosimo's portrait; this is the only one executed in lapis lazuli, and it was identified in four inventories of the Medici collections made between 1588 and 1628. The first was an inventory of the Casino di San Marco, which was the great Florentine center for hardstone carving. From the entries in two of these inventories, it is known that the gem originally was set in an ebony frame.

Florentine artists often took part in a "contest" with antiquity that played a large role in gem cutting and may have had something to do with the use of lapis in this cameo. Pliny the Elder had written that lapis was no good for sculpture because it was too brittle, and this reputation must have posed a special challenge to later artists.

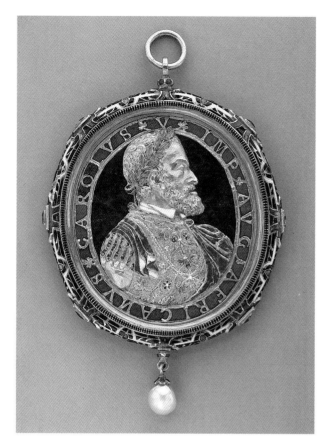

116 *Pendant Medallion with a Portrait of Emperor Charles V*, ca. 1535
Leone Leoni
Milan, 1509–90
Gold, enamel, bloodstone, lapis lazuli, and pearl; 4¼ x 2⅝ in. (10.8 x 6.7 cm.)
Gift of J. Pierpont Morgan, 1917
(17.190.863)

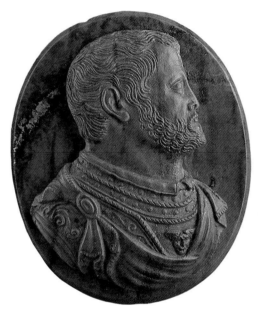

115 *Cameo with a Portrait of Cosimo I de' Medici*
Florence, 1567–86
Lapis lazuli; H. 2½ in. (6.4 cm.)
The Milton Weil Collection,
Gift of Ethel Weil Worgelt, 1938 (38.150.13)

LEONE LEONI
Pendant Medallion with a Portrait of Emperor Charles V

The face of Charles V, Holy Roman emperor from 1516 to 1556, is one of the most frequently encountered in Renaissance art. It was reproduced, for example, in paintings by Titian during his period as court painter, and in statues, busts, and medals by Leone Leoni. Leoni was known for his skill in the handling of metal, and his reputation and influence spread throughout Europe, carried via the network that made up the Hapsburg empire. Charles V made him master of the imperial mint in Milan, a post he held from 1542 to 1545 and again from 1550 to 1585. The medallion seen here was created by Leoni earlier, around 1535, to commemorate the recent victory over the Turks in Tunis.

GIOVANNI BOLOGNA
Bust of Francesco I de' Medici

Flemish by birth, Giovanni Bologna became the most influential sculptor in Italy after Michelangelo, and three successive Medici grand dukes showered commissions on him accordingly. He exercised a profound influence on the development of European sculpture, not only through the formal inventions embodied in his early bronze statuettes, but also through the new visual vocabulary and the official images that occupied him, especially after 1580.

Giovanni Bologna's gifts as a portraitist are evident in this noble likeness of Grand Duke Francesco I de' Medici (1541–87). Francesco is shown in contemporary ceremonial armor, wearing the chain of the Order of the Golden Fleece, which he received in August 1585. The bust shows Francesco's features as they were at that time, somewhat fuller than in the early years of his life, and it is between this date and that of his death, October 1587, that the bust must have been modeled.

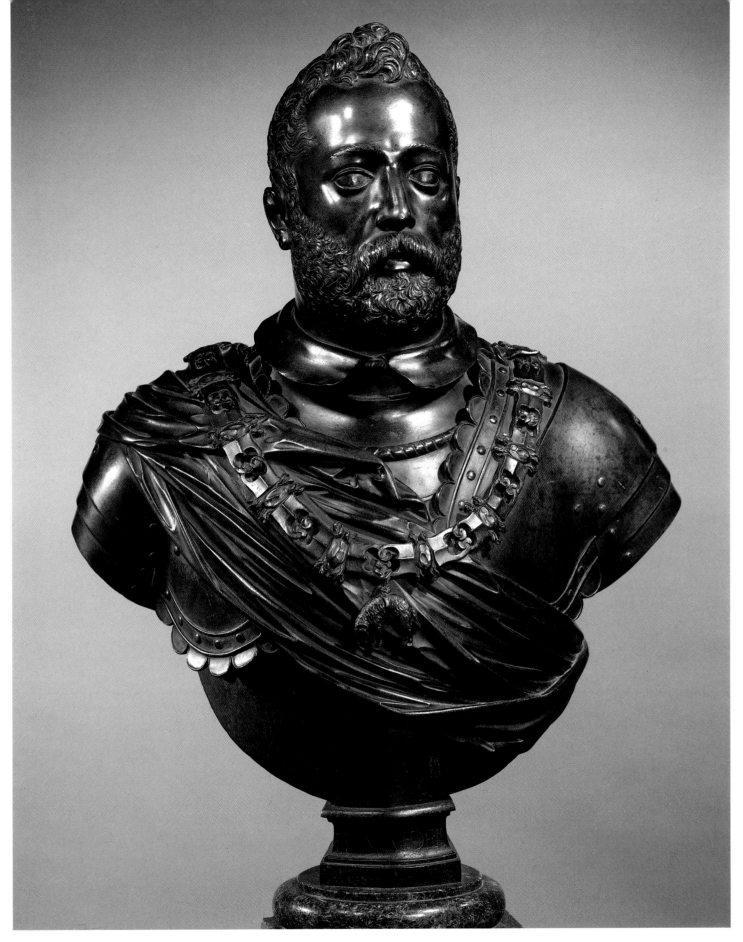

117 Bust of Grand Duke Francesco I de' Medici
Florence, modeled 1585–87, cast ca. 1611
Modeled by Giovanni Bologna
Flanders, act. in Italy, 1529–1608
Cast by Pietro Tacca
Florence, 1577–1640
Bronze, with golden reddish-brown
transparent lacquer; H. 30½ in. (77.5 cm.)
Purchase, Gift of Irwin Untermyer and

Bequest of Ella Morris de Peyster,
by exchange; Edith Perry Chapman Bequest;
Robert Lehman Foundation, Inc., Gift;
Edward J. Gallagher, Jr., Bequest, in memory
of his father, Edward Joseph Gallagher,
his mother, Ann Hay Gallagher, and his son,
Edward Joseph Gallagher III; and
Harris Brisbane Dick, Pfeiffer, Louis V. Bell,
and Dodge Funds, 1983 (1983.450)

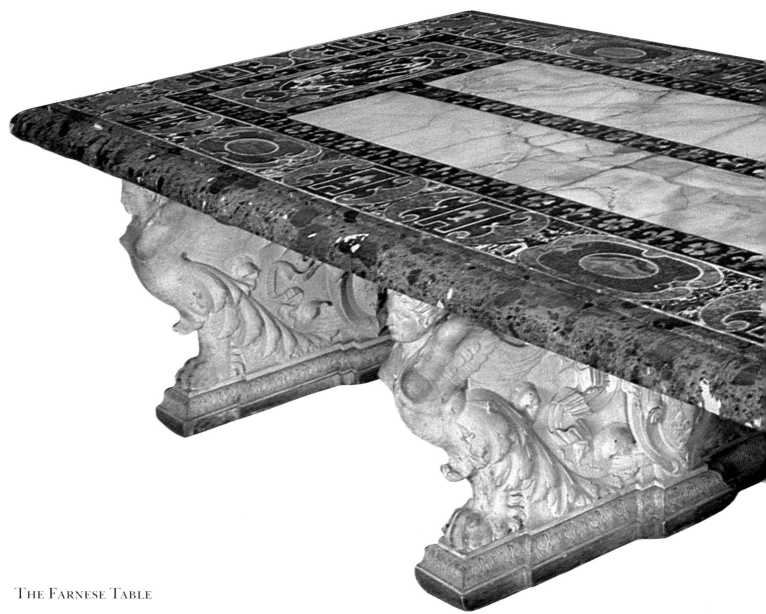

The Farnese Table

The Farnese Table, with its massive marble supporting piers, qualifies as monumental architectural sculpture. Indeed, it was designed by Jacopo Barozzi da Vignola (1507–73), architect of Saint Peter's after the death of Michelangelo, and best known for his designs of the Villa Farnese at Caprarola and the church of the Gesù in Rome. The table was intended as part of the furnishings for the state apartment of the Palazzo Farnese in Rome.

The top of the table, lightened by two alabaster "windows," is inlaid with decorative patterns in rare stones, including lapis lazuli for the fleurs-de-lis, which are the main emblem of the Farnese family. The vast influence of the family dates from 1534, when Alessandro Farnese was crowned Pope Paul III. His son became the duke of Parma and Piacenza. The arms on the pier supports belong to the pope's grandson and namesake, Cardinal Alessandro Farnese, whose patronage of the arts was so generous it reached nearly legendary proportions.

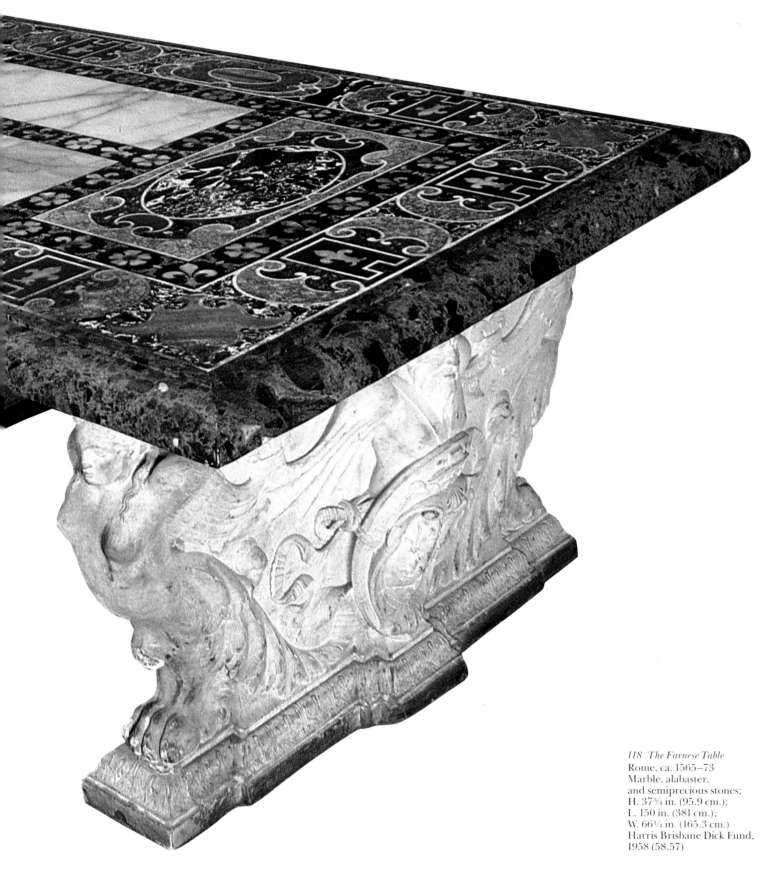

118 *The Farnese Table*
Rome, ca. 1565–73
Marble, alabaster,
and semiprecious stones;
H. 37¾ in. (95.9 cm.);
L. 150 in. (381 cm.);
W. 66¼ in. (165.3 cm.)
Harris Brisbane Dick Fund,
1958 (58.57)

MEDICI PORCELAIN

The China trade is generally spoken of in connection with the commercial enterprises of the eighteenth century, when the exchange between East and West was at its height. But the flow began two and a half centuries earlier, when Vasco da Gama discovered the sea route to China. There had been the odd trickle of objects before this, taken by overland route as prized gifts for kings and patrons, but the early 1500s saw the first real impact of Chinese taste on the West, with increased importation of cargoes. By such means, the blue-and-white Chinese ware began to be known more widely in Europe, especially in Italy, where ships from the Far East offloaded their goods in Genoa and Venice.

Grand Duke Francesco I de' Medici (1541–87), attracted by the imported Chinese porcelain, opened a factory in Florence to create his own version. The wares produced there are the earliest existing examples of European porcelain. They were modeled on designs from other western cultures, the Near East, and China. Surviving examples of Medici porcelain are exceedingly rare. The Metropolitan Museum owns four pieces, including this small ewer and broad dish.

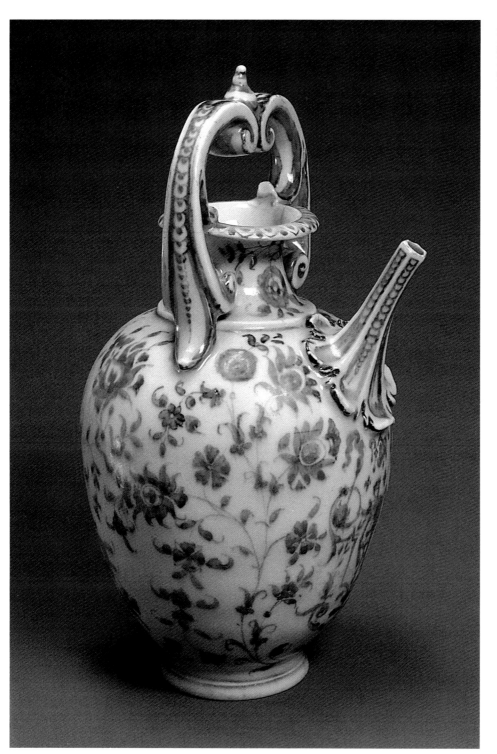

119 Porcelain Ewer
Florence, 1575–87
Soft-paste porcelain;
H. 8 in. (20.3 cm.) Gift
of J. Pierpont Morgan,
1917 (17.190.2045)

120 Porcelain Dish
Florence, 1575–87
Soft-paste porcelain;
Diam. 13⅛ in. (33.3 cm.)
Samuel D. Lee Fund,
1941 (41.49.6)

Opposite below: Medici *palle* and
coronet, from back of dish

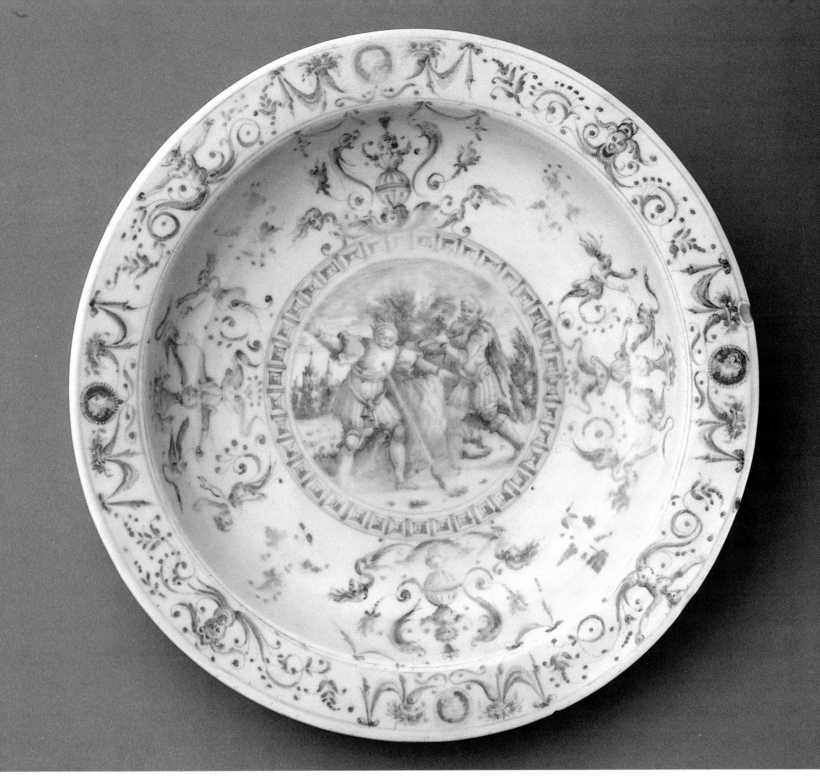

TADDEO ZUCCARO
Standing Nude Male

This standing nude male, with raised arms and twisted torso, was probably drawn from life. It is thought to be a preliminary study for an exterior fresco decoration in imitation of classical bas-relief, a practice for which Taddeo Zuccaro is known. This theory is strengthened by the fact that the figure reappears in another drawing by Taddeo that is clearly a study for a Roman palace facade.

121 Standing Nude Male
Taddeo Zuccaro
Rome, 1529–66
Red chalk, heightened
with a little white;
16⁹⁄₁₆ x 11⁵⁄₁₆ in.
(42.9 x 28.7 cm.)
Rogers Fund, 1968 (68.113)

CRISTOFORO STATI
Orpheus

In Greek mythology, Orpheus was the poet-musician whose skill with the lyre was so great that he charmed not only people and animals, but the trees and rocks as well. When Orpheus's wife, the wood nymph Eurydice, was pursued by a would-be lover, she was bitten by a serpent and died. Grief stricken, Orpheus descended into Hades to get her back and, by the power of his music, convinced Pluto to let Eurydice follow him back to earth, on the condition that Orpheus would not look back at her before they arrived. Just before the end of their journey, however, the poet did look back at his wife, who disappeared. His only solace thereafter was the sound of his lyre.

In this statue, made for the Palazzo Corsi in Florence, Orpheus is depicted not in a narrative way but as the embodiment of music, playing a *lira da braccio* and wearing a laurel crown—the award given in ancient Greek contests of poetry and music. With its fine network of triangulated limbs and its smooth lapidary finish, *Orpheus* exemplifies the refinement and sophistication of late Mannerist art.

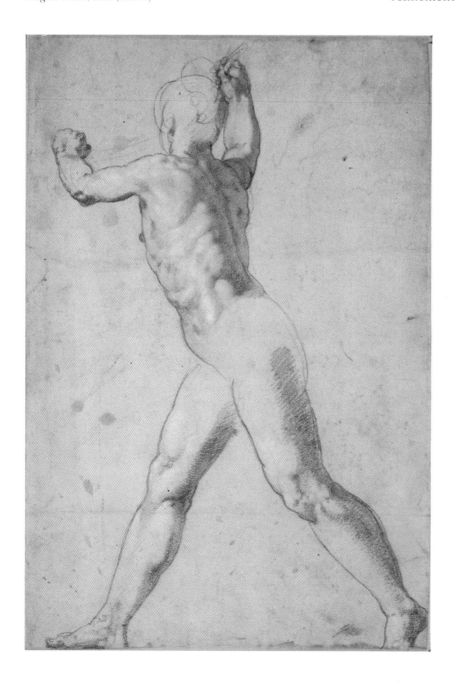

122 Orpheus, before 1607
Cristoforo Stati
Rome, 1556–1619
Marble; H. 76½ in. (194.3 cm.)
Gift of George Blumenthal, 1941
(41.100.242)

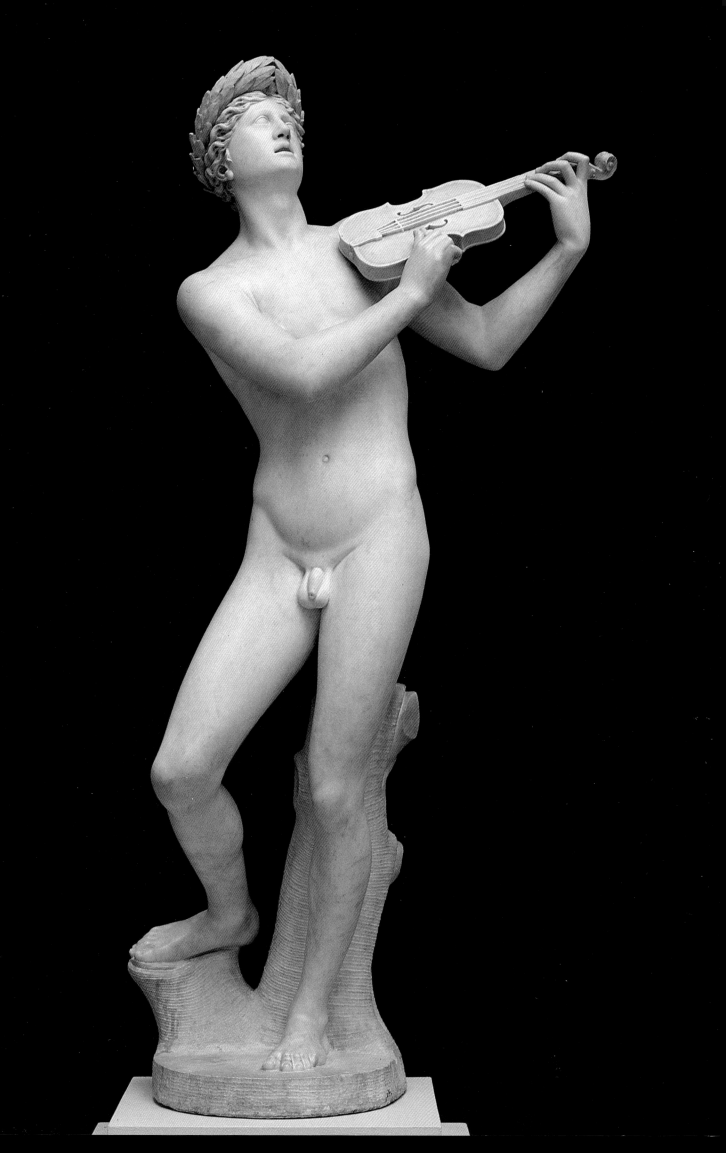

INDEX

ITALY AND THE IBERIAN PENINSULA IN THE RENAISSANCE

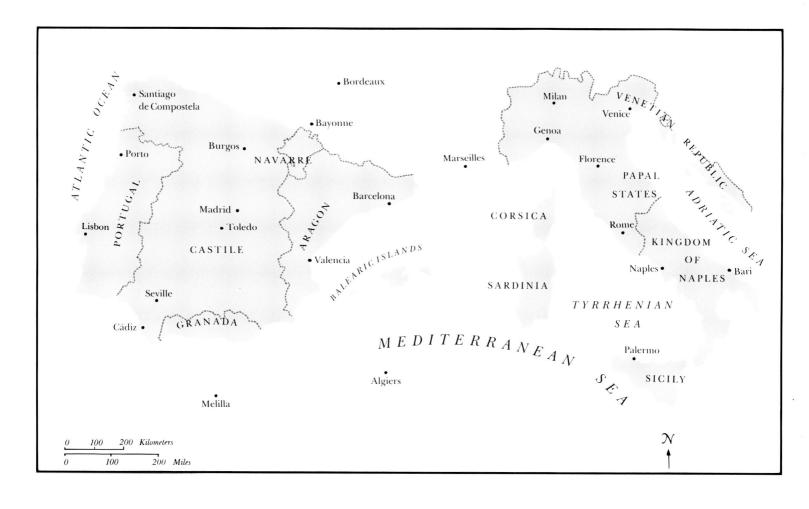

ATLANTIC OCEAN

• Santiago de Compostela

• Bordeaux

• Porto

• Bayonne

Burgos •

NAVARRE

PORTUGAL

Madrid •

• Toledo

Barcelona •

ARAGON

Lisbon •

CASTILE

• Valencia

BALEARIC ISLANDS

Seville •

Cádiz •

GRANADA

Melilla

Milan •

VENETIAN

Venice •

Genoa •

REPUBLIC

Marseilles •

Florence •

PAPAL

STATES

ADRIATIC SEA

CORSICA

Rome •

KINGDOM

OF

Naples •

NAPLES

• Bari

SARDINIA

TYRRHENIAN

SEA

MEDITERRANEAN SEA

Algiers •

Palermo •

SICILY

0 100 200 Kilometers

0 100 200 Miles

N

f BARTOLO DI FREDI BATTILORI
Adoration of the Magi

1401	*Sacrifice of Isaac* by Lorenzo Ghiberti (1378–1455), winning entry in competition for north doors of Florence Baptistery
1403–24	Ghiberti's Baptistery doors executed
1414–19	*Coronation of the Virgin* by Lorenzo Monaco (1370/72–1425/26)
1421	S. Lorenzo, Florence, by Filippo Brunelleschi (1377–1446)
1420–36	Dome of Florence cathedral by Brunelleschi
1423	*Adoration of the Magi* by Gentile da Fabriano (d. 1427)
ca. 1425–30	*David* (bronze) by Donatello (1386–1466)
1425–52	*Gates of Paradise*, east doors of Florence Baptistery, by Ghiberti
1425	*Holy Trinity with the Virgin and St. John* by Masaccio (1401–28)
1425–28	Frescoes in Brancacci Chapel, S. Maria del Carmine, Florence, by Masaccio
ca. 1430	Pazzi Chapel, S. Croce, Florence, by Brunelleschi begun

1431–38	Cantoria for the Florence Duomo by Luca della Robbia (1399–1482)
1435	*Treatise on the Art of Painting* by Leon Battista Alberti (1404–72)
1438–45	Frescoes in monastery of S. Marco, Florence, by Fra Angelico (1387–1455)
1445–50	*Equestrian Monument of Gattemelata*, Piazza del Santo, Padua, by Donatello
1445–50	Tomb of Leonardo Bruni, S. Croce, Florence, by Bernardo Rossellino (1409–64)
1446–51	Palazzo Rucellai, Florence, by Alberti
1447	*Last Supper* by Andrea del Castagno (1390–1457)

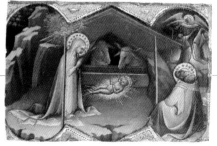

j LORENZO MONACO
The Nativity

e Man of Sorrows

1400–10	Rupert (Wittelsbach), German king and Holy Roman Emperor
1404–06	Pope Innocent VII, in Rome
1406–15	Pope Gregory XII, in Rome
1409–10	Alexander V, antipope of Pisan line
1410–15	John XXIII, antipope of Pisan line
1410–37	Sigismund (Luxembourg), German king and Holy Roman Emperor
1412	Jan Hus excommunicated for heresy (executed 1415)
1413–22	Henry V, king of England
1414–18	Council of Constance; ends Great Schism
1415	English defeat French at Agincourt

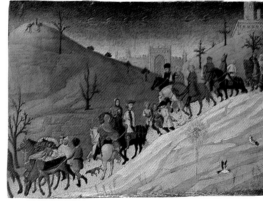

h SASSETTA
Journey of the Magi

1416	Death of Jean de France, duc de Berry
1417–31	Pope Martin V, in Rome
1419–67	Philip the Good, duke of Burgundy; greatly expands Burgundian possessions in France and Low Countries
1420	Henry V of England marries Catherine of France; English enter Paris
1422–61	First reign of Henry VI, king of England
1423–29	Clement VII, antipope in Avignon
1425–30	Benedict XIV, antipope in Avignon
1429	Charles VII of France crowned at Rheims (reigns to 1461), accompanied by Joan of Arc
1430	Salonika falls to Ottoman Turks led by Sultan Murad II
1431–47	Pope Eugene IV, in Rome
1431–49	Council of Basel
1434	Cosimo de' Medici establishes the preeminence of his family in Florence
1438–39	Albert II, first Habsburg German king and Holy Roman Emperor
1440–93	Frederick III, German king and Holy Roman Emperor
1447–55	Pope Nicholas V
1450–66	Francesco Sforza, duke of Milan

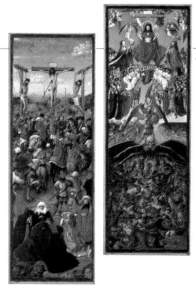

i JAN VAN EYCK
The Crucifixion; The Last Judgment

ca. 1400	*Chronicles* by Jean Froissart
1416	Last work on *Très Riches Heures* of the duc de Berry by Limbourg brothers (act. before 1399–ca. 1439)
ca. 1418	*Rohan Hours*, Paris
ca. 1425	*Annunciation Altarpiece* by Robert Campin (act. by 1406–d. 1444)
ca. 1427	*Imitation of Christ*, ascribed to Thomas à Kempis
1432	Dedication of Ghent altarpiece by Jan (act. by 1422–d. 1441) and Hugo (ca. 1370–1426) Van Eyck
1434	*Arnolfini Wedding Portrait* by Jan Van Eyck
1444	*Altarpiece of St. Peter* by Konrad Witz (ca. 1400–ca. 1445)
1446	*Edward Grymestone* by Petrus Christus (act. by 1444–d. 1472/73)
1447	*Presentation* by Stephan Lochner (act. 1410–51)

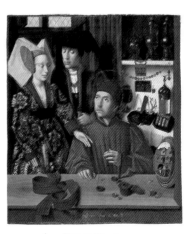

k PETRUS CHRISTUS
Saint Eligius

THE ARTS IN ITALY AND SPAIN

1302	Pulpit, Pisa cathedral, commissioned from Giovanni Pisano (ca. 1248–d. after 1314)
1305	Fresco cycle in Arena Chapel, Padua, by Giotto di Bondone (1266/67–1337)
1307–21	Dante Alighieri's *Divine Comedy*
1308–11	*Maestà* by Duccio di Buoninsegna (ca. 1255–ca. 1318)
1310	*Ognissanti Madonna* by Giotto
1315–28	Frescoes in Palazzo Pubblico, Siena, by Simone Martini (act. by 1315–d. 1344)
1334	Giotto made chief architect of Florence cathedral; begins campanile
1336	South doors, Florence Baptistery, by Andrea Pisano (ca. 1290–1348)
1338	*Good and Bad Government*, frescoes in Palazzo Pubblico, Siena, by Ambrogio Lorenzetti (act. 1319–47)
1341	Francesco Petrarch crowned with laurels in Rome
1348–53	Giovanni Boccacio's *Decameron*

a GIOTTO
The Epiphany

1359	*Mystic Marriage of St. Catherine* by Lorenzo Veneziano (d. 1372)
ca. 1390	Cennino Cennini's *Libro d'Arte*

d LORENZO VENEZIANO
Madonna and Child

SOCIETY, RELIGION, AND POLITICS

1304–14	Pope Clement V
1306–29	Robert I ("the Bruce"), king of Scotland
1307	Edward I, king of England, succeeded by Edward II (to 1327)
1308–13	Henry VII (Luxembourg), German king and Holy Roman Emperor
1309–78	Papacy resides at Avignon (the "Babylonian Captivity")
1314	Philip IV ("the Fair"), king of France, succeeded by Louis X ("the Quarrelsome"); to 1316
1314–47	Louis IV (Wittelsbach), German king and Holy Roman Emperor
1315–18	Edward Bruce, king of Ireland
1316	John I ("the Posthumous"), king of France
1316–34	Pope John XXII
1317–22	Philip V ("the Tall"), king of France
1322–28	Charles IV ("the Fair"), last Capetian king of France
1323	Thomas Aquinas canonized
1327–77	Edward III, king of England
1328–30	Nicholas V, antipope
1328–50	Philip VI, first Valois king of France
1330	Edward (the "Black Prince") born to King Edward III of England
1334–42	Pope Benedict XII
1337	Edward III of England claims French throne, beginning the Hundred Years War (to 1453)
1342–52	Pope Clement VI
1346	English defeat French in Battle of Crécy
1348–49	Black Plague reaches England

b GIOVANNI PISANO
Pilaster with Angels

1350–64	John II ("the Good"), king of France
1352–62	Pope Innocent VI
1355–78	Charles IV (Luxembourg) Holy Ror Emperor; issued Golden Bull of 135 settling election of German kings
1362–70	Pope Urban V
1364–80	Charles V ("the Wise"), king of Fran
1369	Philip the Bold, duke of Burgundy, marries Margaret of Flanders
1370–78	Pope Gregory XI
1371–90	Robert II, first Stuart king of Scotlan
1377–99	Richard II, king of England
1378	Great Schism begins (to 1417): Two elected: Urban VI (to 1389) in Rome Clement VII (to 1394), antipope in A
1378–1400	Wenceslaus (Luxembourg), German and uncrowned Holy Roman Empe
1380–1422	Charles VI ("the Mad," or "Well Bel of France
1381	Peasant revolt in England led by Wa'
1389–1404	Pope Boniface IX, in Rome
1394–1423	Benedict XIII, antipope in Avignon
1398	Tamerlane invades India
1399–1413	Henry IV, first Lancastrian king of !

THE ARTS IN NORTHERN EUROPE

1323–26	*Belleville Breviary* by Jean Pucelle (act. ca. 1300–50)
1325	*Hours of Jeanne d'Evreux* by Jean Pucelle

c JEAN PUCELLE
Book of Hours of Jeanne d'Evreux

ca. 1350	*Sir Gawain and the Green Knight*
1362	*Piers Plowman* by William Langland
1387–1400	*Canterbury Tales* by Geoffrey Chauc
1394–99	*Retable de Champmol*, by Melchior Broederlam (act. 1385–1400) and Ja de Baerze (act. ca. 1375–1400)
ca. 1395	John Purvey's edition of Wycliffe's English translation of the Bible

g Reliquary Shrin

NORTHERN ITALY

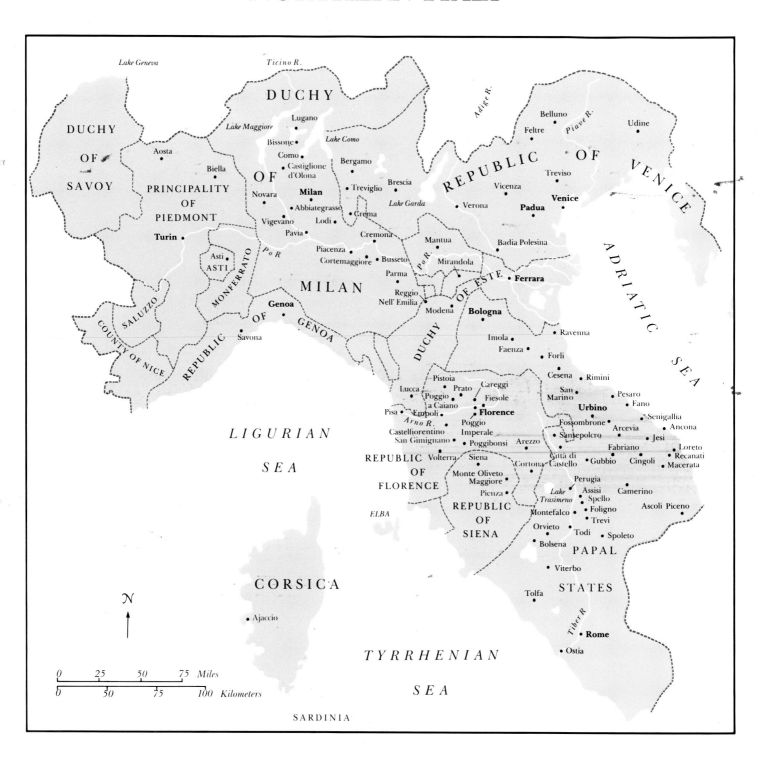

Lake Geneva

Ticino R.

DUCHY

Adige R.

Belluno

Lugano

Lake Maggiore

Lake Como

Feltre

Piave R.

Udine

DUCHY

Bissone

Aosta

Como

Castiglione d'Olona

Bergamo

OF

Treviso

OF

Biella

OF

Milan

Treviglio

Brescia

Vicenza

REPUBLIC

OF

VENICE

Novara

SAVOY

PRINCIPALITY

Verona

Venice

OF

Abbiategrasso

Lake Garda

Padua

PIEDMONT

Vigevano

Lodi

Crema

Pavia

Cremona

Mantua

Badia Polesina

Turin

Po R

Piacenza

Asti

ASTI

Cortemaggiore

Busseto

Po R.

Mirandola

Ferrara

MONFERRATO

MILAN

Parma

DUCHY

ADRIATIC

SALUZZO

Reggio Nell' Emilia

OF ESTE

COUNTY OF NICE

Genoa

Modena

Bologna

REPUBLIC

OF

GENOA

Imola

Ravenna

SEA

Savona

Faenza

LIGURIAN

Forlì

Cesena

Rimini

Pistoia

Lucca

Prato

Careggi

San Marino

Pesaro

SEA

Poggio a Caiano

Fiesole

Fano

Urbino

Pisa

Empoli

Florence

Senigallia

Arno R.

Poggio Imperale

Fossombrone

Arcevia

Ancona

Castelfiorentino

Sansepolcro

San Gimignano

Poggibonsi

Arezzo

Jesi

Loreto

Volterra

Siena

Città di Castello

Gubbio

Cingoli

Recanati

REPUBLIC

Cortona

Fabriano

Macerata

OF

Monte Oliveto Maggiore

Perugia

FLORENCE

Lake Trasimeno

Assisi

Camerino

Pienza

Spello

ELBA

REPUBLIC

Montefalco

Foligno

Ascoli Piceno

OF

Trevi

SIENA

Orvieto

Todi

Spoleto

Bolsena

PAPAL

Viterbo

CORSICA

STATES

Tolfa

Ajaccio

TYRRHENIAN

Tiber R

Rome

N

Ostia

SEA

0 25 50 75 *Miles*

0 50 75 100 *Kilometers*

SARDINIA

SOUTHERN ITALY

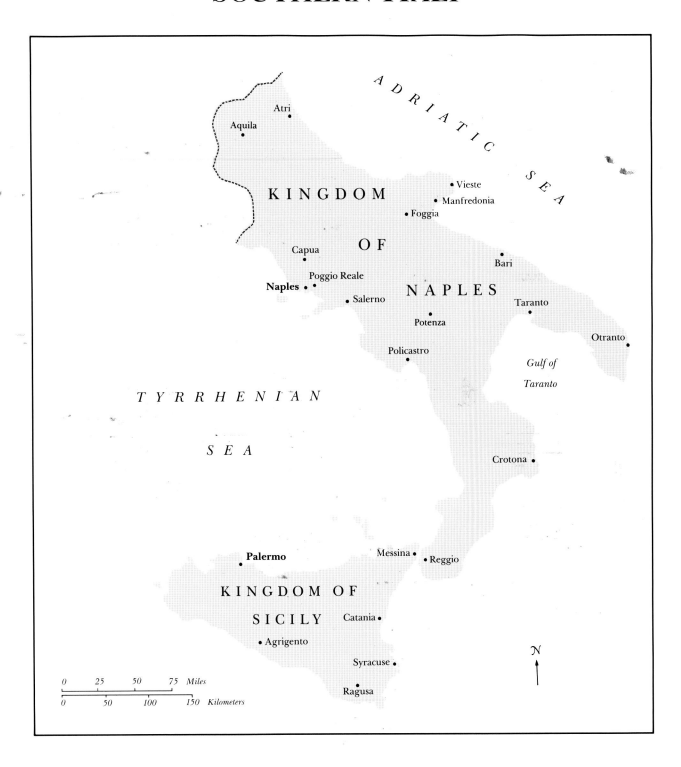

A D R I A T I C S E A

K I N G D O M

Atri
Aquila

• Vieste
• Manfredonia
• Foggia

O F

Capua
Poggio Reale
Naples • •
• Salerno

Bari •

N A P L E S

Taranto

Potenza

Otranto

Policastro

Gulf of
Taranto

T Y R R H E N I A N

S E A

Crotona •

Messina • • Reggio

Palermo •

K I N G D O M O F

S I C I L Y

Catania •

• Agrigento

Syracuse •

Ragusa

0 25 50 75 *Miles*

0 50 100 150 *Kilometers*

N

ca. 1525	*The Assumption*, fresco on dome of Parma Cathedral by Correggio (1489/94–1534)
1526	*Descent from the Cross*, S. Felicità, Florence, by Jacopo da Pontormo (1494–1556)
1527	*The Book of the Courtier* by Baldassare Castiglione (1478–1529) published (written 1514)
1527–34	Palazzo del Tè, Mantua, by Giulio Romano (1492/9–1546)
1534–41	*Last Judgment*, fresco in the Sistine Chapel, by Michelangelo
ca. 1535	*Madonna with the Long Neck* by Parmigianino (1503–40)
1536	Library of S. Marco, Venice, begun by Jacopo Sansovino (1486–1570)
1539–43	*Saltcellar of Francis I* by Benvenuto Cellini (1500–71)
ca. 1546	*Venus, Cupid, Time and Folly* by Bronzino (1503–72)
1546–64	Remodeling of St. Peter's by Michelangelo

n PAOLO VERONESE
Mars and Venus United by Love

1550	*Lives of the Painters* (first edition), by Giorgio Vasari (1511–74) published
ca.1567–70	Villa Rotunda, near Vicenza, by Andrea Palladio (1508–80)

1551	Palestrina (1526–94) appointed conductor at St. Peter's, Rome
1560	Uffizi, Florence, by Vasari, begun
1563	Escorial in Spain begun
1566–67	*Christ before Pilate*, Scuola di San Rocco, Venice, by Tintoretto (1518–94)
ca.1555–64	*Rondanini Pietà* by Michelangelo
1565	S. Giorgio Maggiore, Venice, by Palladio
1568	Il Gesù, Rome, begun by Vignola
1570	*Christ Crowned with Thorns* by Titian
1573	*Christ in the House of Levi* by Paolo Veronese (ca. 1528–d. 1588)
1581	Torquato Tasso's *Gerusalemme Liberata*
1583	*The Rape of the Sabine Women*, by Giovanni Bologna
1585	*La Galatea* by Cervantes
1597–98	*The Calling of St. Matthew* by Caravaggio (1571–1610)
1597–1604	Frescoes in Palazzo Farnese, Rome, by Annibale Carracci (1560–1609)

517	Martin Luther posts his 95 theses on door of castle church at Wittenberg
519–58	Charles V, Holy Roman emperor; as Charles I, king of Spain (1516–56)
521	Martin Luther excommunicated
522–23	Pope Adrian VI
523–34	Pope Clement VII
524–26	Peasants War in Germany
527	Sack of Rome by French
532	Francisco Pizarro begins conquest of Peru
533	Catherine de' Medici marries future French king Henry II
533–84	Ivan IV ("the Terrible"), grand duke of Moscow, first Russian ruler to adopt title of czar
534	Act of Separation makes Henry VIII head of Church of England
534–49	Pope Paul III
535	Sir Thomas More beheaded for refusing to accept Act of Separation
536	John Calvin's *Institutes of the Christian Religion* completed in Basel
537	Cosimo I de' Medici duke of Florence; in 1569 becomes grand duke of Tuscany (to 1574)
540	Ignatius of Loyola founds Jesuit order
13	*De revolutionibus orbium coelestium* by Nicholas Copernicus published
543	*De humani corporis fabrica* by Andreas Vesalius
545–63	Council of Trent; confronts crisis of Protestantism
547–53	Edward VI, king of England
547–59	Henry II, king of France

1550–55	Pope Julius III
1553–58	Mary, queen of England
1554	Queen Mary of England marries future King Philip I of Spain, restores papal supremacy in England
1555	Pope Marcellus II
1555	Charles V succeeded as emperor by Ferdinand I (to 1564); in 1558 succeeded as ruler in Low Countries and Spain by Philip II (to 1598)
1555–59	Pope Paul IV
1558–64	Ferdinand I, Holy Roman Emperor
1558–1603	Elizabeth I, queen of England
1559–60	Francis II, king of France
1559–65	Pope Pius IV
1560–74	King Charles IX of France
1561	Mary Queen of Scots, arrives in Edinburgh from France
1562–98	Huguenot wars in France
1564–76	Maximilian II, Holy Roman Emperor
1566–72	Pope Pius V (Saint Pius)
1568	Mary Queen of Scots, flees to England; imprisoned by Queen Elizabeth
1571	Battle of Lepanto ends Turkish naval supremacy
1572	Huguenots massacred on St. Bartholomew's Day in Paris
1572–85	Pope Gregory XIII
1574–89	Henry III, last Valois king of France
1576–1612	Rudolf II, Holy Roman Emperor
1580	Spanish conquer Portugal
1581	Northern provinces of the Netherlands, under William ("the Silent") of Orange, declare independence from Spain

p Celestial Globe with Clockwork

1582	Gregorian Calendar introduced
1584	William of Orange, stadtholder of the Netherlands, assassinated; succeeded by Maurice, prince of Nassau
1585–90	Pope Sixtus V
1587	Mary Queen of Scots, executed at Fotheringay
1588	British defeat Spanish Armada
1589–1610	Henry IV, first Bourbon king of France
1590	Pope Urban VII
1590–91	Pope Gregory XIV
1591	Pope Innocent IX
1592–1605	Pope Clement VIII
1598	Edict of Nantes gives Huguenots political equality
1598–1603	Boris Godunov, czar of Russia
1598–1621	Philip III, king of Spain

519	Chateau of Chambord begun
526	*Last Judgment* by Lucas Van Leyden (1494–1533)
527	Francis I begins artistic program at Fontainebleau
525–30	*Francis I* by Jean Clouet (act. by 1516–d. 1541)
29	*The Battle of Issus* by Albrecht Altdorfer (ca. 1480–d. 1538)
532	*Pantagruel* by François Rabelais
536	*Prodigal Son* by Jan van Hemessen (act. ca. 1524–d. ca. 1564)
539	*Henry VIII* by Holbein
46	Court of Louvre, designed by Pierre Lescot (1515–78), begun
548	*Fountain of the Nymphs* by Jean Goujon (ca. 1410–d. 1564/68)

o PIETER BRUEGEL THE ELDER
The Harvesters

1550	*Odes* by Ronsard
1553	*Tristan and Isolde* by Hans Sachs
1553	*Manners and Customs of the Turks* by Pieter Coeck (1502–50) published
1558	*Heptameron*, tales by Margaret of Navarre, published
1563	*Tomb of Henri II* by Germain Pilon (ca. 1530–90) and Francesco Primaticcio (1504–70)
1559	*Carnival and Lent* by Pieter Bruegel the Elder (act. by 1551–d. 1569)
1566	*Wedding Dance* by Bruegel
1588	*A Young Man Among Roses* by Nicholas Hilliard (ca. 1547–1619)
1595	*Romeo and Juliet* by William Shakespeare

ca. 1453 *Story of the True Cross*, S. Francesco, Arezzo, by Piero della Francesca (1410/20–92)

ca. 1461 *Commentaries*, treatise on architecture by Antonio Filarete (ca. 1400–69)

1470 Sant' Andrea, Mantua, designed by Alberti

1474 *Arrival of Cardinal Francesco Gonzaga*, Camera degli Sposi, Palazzo Ducale, Mantua, by Andrea Mantegna (ca. 1430–d. 1506)

l BOTTICELLI
The Annunciation

1475 *Crucifixion* by Antonello de Messina (1430–79)

1475 *Martyrdom of St. Sebastian* by Antonio Pollaiuolo (1429–98)

ca. 1478 *Primavera* by Botticelli (1444/5–1510)

1481 *Giving of the Keys to Peter*, Sistine Chapel, Vatican Palace, by Pietro Perugino (act. by 1469–1523)

ca. 1483–88 *Equestrian Monument to Bartolommeo Colleoni*, Campo SS. Giovanni e Paolo, Venice, by Andrea del Verrochio (1435–88)

1495–98 *Last Supper*, S. Maria della Grazie, Milan, by Leonardo da Vinci (1452–1519)

1496 Juan de Flandes (act. 1496–1519) court painter in Spain

1498–1500 *Pietà*, St. Peter's, Rome, by Michelangelo Buonarroti (1475–1564)

1496 *Procession of the Relic of the True Cross* by Gentile Bellini (1429/30–1507)

1499 *La Celestina* by Rojas

1501–04 *David*, Accademia, Florence, by Michelangelo

1502 *Tempietto*, S. Pietro in Montorio, Rome, by Bramante (1444–1514)

1503–05 *Mona Lisa*, by Leonardo da Vinci

1505 *Modonna and Saints*, S. Zaccaria, Venice, by Giovanni Bellini (ca. 1430–1516)

1506 Excavation of the *Laocoön* in Rome

1508–12 Frescoes in Sistine Chapel, Vatican, by Michelangelo

1509–12 Frescoes in Vatican *stanze* by Raphael (1483–1520)

ca. 1510 *The Tempest* by Giorgione (ca. 1477–1510)

1513 *The Prince*, by Niccolò Machiavelli

1516 *Orlando Furioso* by Ludovico Ariosto

1519–26 *Pesaro Madonna*, S. Maria Gloriosa dei Frari, Venice, by Titian (ca. 1488–1576)

1519–34 Medici Chapel, New Sacristy of S. Lorenzo, Florence, by Michelangelo

1521 *Deposition from the Cross* by Rosso Fiorentino (1495–1540)

1451–81 Mohammed II ("the Conqueror"), Ottoman sultan

1452–93 Frederick III, German king and Holy Roman Emperor

1453 Ottoman Turks capture Constantinople, completing conquest of Byzantine Empire

1455–58 Pope Calixtus III

1455–85 Wars of the Roses between Lancaster and York for the throne of England

1458–64 Pope Pius II

1461–70 First reign of Edward IV, king of England

1462–1505 Ivan III ("the Great"), grand duke of Moscow, consolidates the Russian state

1464–71 Pope Paul II

1461–83 Louis XI, king of France

1467–77 Charles the Bold, last reigning duke of Burgundy

1469 Ferdinand II ("the Catholic") of Aragon marries Isabella I of Castile; in 1474 they jointly rule all Christian Spain

1469–92 Lorenzo de' Medici ("the Magnificent") de facto ruler of Florence

1470–71 Second reign of Henry VI, king of England

1471–83 Second reign of Edward IV, king of England

1471–84 Pope Sixtus IV

1477 Maximilian I marries Mary of Burgundy, acquiring most of Low Countries for Habsburgs

1478 Spanish Inquisition established

1483 Edward V, king of England

1483–85 Richard III, king of England

1483–98 Charles VIII, king of France

1484–92 Pope Innocent VIII

1485 King Richard III killed by Henry Tudor

(Henry VII to 1509) at Bosworth Field

1488 Bartolomeu Días is first European to round Cape of Good Hope at tip of Africa

1491 Girolamo Savonarola becomes prior of S. Marco in Florence

1492 Spanish seize Granada from Moors, completing Christian reconquest of Spain

1492 Christopher Columbus discovers New World

1492 Jews expelled from Spain

1492–1503 Pope Alexander VI

1493–1519 Maximilian I, German king and Holy Roman Emperor

1494 Spain and Portugal divide the New World (Treaty of Tordesillas)

1494–99 Ludovico Sforza ("the Moor") formally created duke of Milan

1494–1559 Italian Wars for control of independent Italian states begin with French invasion of Italy

1495 Poyning's Law promulgated by Henry VII, placing Irish parliament under British rule

1495 Diet of Worms establishes court to adjudicate princely disputes (the Perpetual Peace)

1496 Philip I ("the Fair"), son of Maximilian, marries Juana, heiress of Spain

1498–1515 Louis XII, king of France

1498 Savonarola burned at the stake for heresy

1499 Amerigo Vespucci explores mouths of Amazon River

1499 Emperor Maximilian grants Swiss autonomy

1499 French expel Ludovico Sforza from Milan; he dies a prisoner in France (1500)

1503 Pope Pius III

1503–13 Pope Julius II

1505–33 Vasily III, grand duke of Moscow

1509–47 Henry VIII, king of England

1513–21 Pope Leo X

1515 Thomas Wolsey made cardinal and lord chancellor of England

1515–47 Francis I, king of France

m RAPHAEL
Madonna and Child Enthroned

1452–60 *Hours of Etienne Chevalier* by Jean Fouquet (1415/20–1480)

1456 Gutenberg Bible printed at Mainz

1456 *Le Petit Testament* by François Villon

ca. 1460 *Francesco d'Este* by Rogier Van der Weyden (ca. 1400–d. 1464)

1464 *Last Supper Altarpiece* by Dieric Bouts (act. by 1457–d. 1475)

1465 First printed music, Germany

1471 *St. Wolfgang Altarpiece* by Michael Pacher (1435–98)

1471 *St. Matthew's Passion* by Jacob Obrecht

1473 *Madonna and Child in a Rose Arbor* by Martin Schongauer (ca. 1445–91)

1474 William Caxton prints first books in

English in Bruges

1476 *Portinari Altarpiece* by Hugo Van der Goes (act. by 1467–d. 1482)

ca. 1477 *Dormition Altarpiece* by Veit Stoss (ca. 1447–d. 1533)

1486 *St. John Altarpiece* by Geertgen tot Sint Jans (ca. 1465–95)

1487 *Diptych of Martin Niewenhoven* by Hans Memling (act. ca. 1465–d. 1494)

1497/98 *Apocalypse* woodcuts by Albrecht Dürer (1471–1528)

1498 *Moulins Triptych* by Master of Moulins (act. last quarter 15th c.)

1498 *Last Supper Altar* by Tilman Riemenschneider (ca. 1460–d. 1531)

ca. 1500 *The Garden of Delights* by Hieronymus Bosch (act. 1488–1515)

1500 *Self-Portrait* by Albrecht Dürer

1504 *Adam and Eve* by Dürer

1504 *Rest on the Flight to Egypt* by Lucas Cranach the Elder (1472–1553)

1511 *In Praise of Folly* by Desiderius Erasmus

1512 *Coronation Altarpiece* by Hans Baldung Grien (1484/85–1545)

1514 *Money Changer and His Wife* by Quentin Massys (1465/66–1530)

1515 *Isenheim Altarpiece* by Matthias Grünewald (1470/75–1528)

1516 *Jacob Meyer and Wife* by Hans Holbein the Younger (1497/98–1543)

1516 *Utopia* by Thomas More

THE IBERIAN PENINSULA

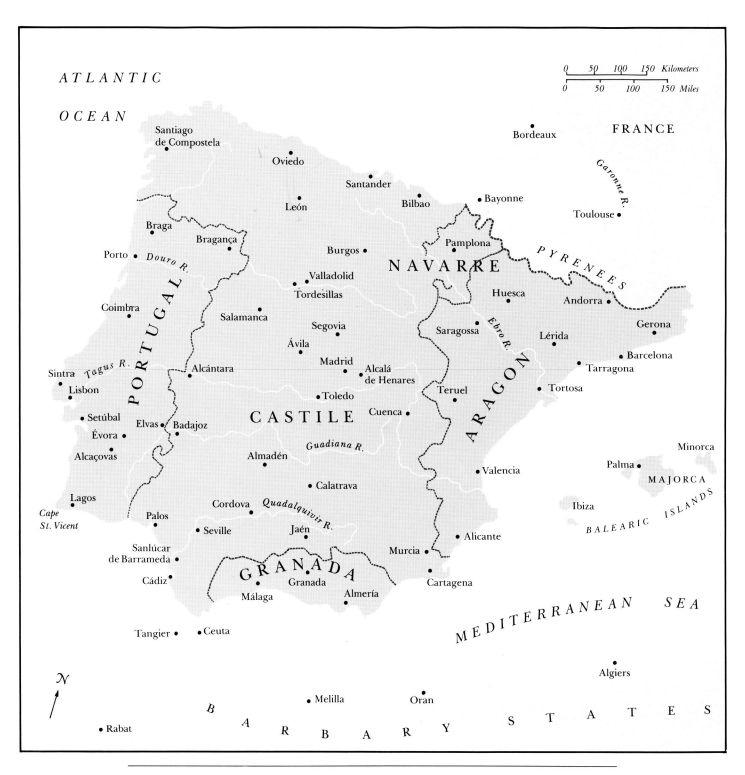

ATLANTIC

OCEAN

FRANCE

Santiago
de Compostela

Bordeaux

Garonne R.

Oviedo

Santander

Bayonne

Toulouse

León

Bilbao

Braga

Pamplona

PYRENEES

Bragança

Burgos

NAVARRE

Porto • *Douro R.*

Valladolid

Huesca

Andorra

Coimbra

Tordesillas

Saragossa

Ebro R.

Gerona

Salamanca

Segovia

Lérida

Ávila

Barcelona

Sintra *Tagus R.*

Alcántara

Madrid

Alcalá
de Henares

Teruel

Tortosa

Lisbon

Toledo

Tarragona

Setúbal

Elvas • Badajoz

CASTILE

Cuenca

Évora

Almadén

Guadiana R.

Valencia

Minorca

Palma

Alcaçovas

Calatrava

Ibiza

MAJORCA

Lagos

Cordova *Quadalquivir R.*

BALEARIC ISLANDS

Cape
St. Vicent

Palos

Seville

Jaén

Alicante

Sanlúcar
de Barrameda

Murcia

Cádiz

GRANADA

Granada

Almería

Cartagena

Málaga

MEDITERRANEAN SEA

Tangier • • Ceuta

N

Algiers

B

• Melilla

Oran

A R B A R Y S T A T E S

• Rabat

CREDITS

a John Stewart Kennedy Fund, 1911 (11.126.1); *b* Frederick C. Hewitt Fund, 1910 (10.203.1,2); *c* The Cloisters Collection, 1954 (54.1.2); *d* Robert Lehman Collection, 1975 (1975.1.78); *e* Gift of George E. Seligmann, in memory of his wife, Edna, his father, Simon Seligmann, and his brother, Rene, 1982 (1982.480); *f* Robert Lehman Collection, 1975 (1975.1.16); *g* The Cloisters Collection, 1962 (62.96); *h* Maitland F. Griggs Collection, Bequest of Maitland F. Griggs, 1943 (43.98.1); *i* Fletcher Fund, 1933 (33.92ab); *j* Robert Lehman Collection, 1975 (1975.1.66); *k* Robert Lehman Collection, 1975 (1975.1.110); *l* Robert Lehman Collection, 1975 (1975.1.74); *m* Gift of J. Pierpont Morgan, 1916 (16.30ab); *n* John Stewart Kennedy Fund, 1910 (10.189); *o* Rogers Fund, 1919 (19.164); *p* Gift of J. Pierpont Morgan, 1917 (17.190.636).